"I believe everyone will certainly tilt his or her head when reading this excellent work! Brian Nixon, a trained theologian and profound artist, combines his skills and offers insights on beauty (not only in art, but in all of nature) and its origin (namely God himself) in an unusual but brilliant and somehow very personal way. This book is a journey that leads us through the world of art and Christianity and gives food for mind and soul. Marvelous!"

—**Peter Zöller–Greer**, mathematician and musician

"The range of reflections in *Tilt* opens up a wide conversation about the nature of theology, the arts, poetry, and meaning. From C. S. Lewis to Georgia O'Keeffe to Billy the Kid, from trains to typewriters, from mountains to mathematics, the invitation by Nixon to think creatively and constructively is a welcomed voice in the landscape of theopoetics. Finding depth and richness of language, readers are rewarded with an awareness of Christ in culture throughout the world around us."

—**Steven Schweitzer**, Academic Dean and Professor,
Bethany Theological Seminary

"As a journalist, poet, musician, and artist, Brian is a rare individual, a human being with varied interests and gifts. And compounded with a Christian worldview, Brian's voice is grounded in truth, beauty, and goodness. . . . Brian has an artist's spirit, a head for logic, and a minister's heart. I am glad that others will get the opportunity now to read Brian's observations, get inspired, and join the dialogue."

—**Jeff LeFever**, artist, author of *Consecrated Space*

"From musician Tom Waits and artist Max Cole to composer Warner Hutchison, each profile is rich with detail. More importantly, Nixon demonstrates that God can be found in the most unlikely of places. In *Tilt*, Nixon mines for the spiritual and finds pure gold."

—**Lori Cameron**, Editor, *The Penwood Review*

"With all the negative news-bites about how culture no longer reflects Christian values, Brian has proved them wrong with *Tilt*! In the most unlikely places, he highlights many encouraging examples of Christ in culture. How refreshing it is to read a book like this one that dispels Nietzsche's notion that 'God is dead.' Brian has shone a brilliant light on culture for those with eyes to see! *Tolle Lege* (take up and read)!"

—**Joseph Holden**, President, Veritas International University

"I count it an honor to introduce you to a fine thinker, writer, musician, and journalist. Together we've had many journeys, and I'm honored to introduce some of these adventures to you through *Tilt: Finding Christ In Culture*. I highly recommend this book."

—**Dan Wooding**, journalist, founder of Assist News Service

"In *Tilt: Finding Christ In Culture*, you'll find a mind engaged with culture, looking for Christ within her midst. A must read."

—**John Warwick Montgomery**, author of *Always Be Ready*

"Not only is Brian passionate about Christ but reaching our culture with Christ. I recommend this book."

—**Todd Hunter**, Bishop, Anglican Church in North America

"Awaiting you here is a journey of artistic exploration and joyful discovery through insightful dialogue with artists about the meaning and context of their creations. Highly recommended!"

—**Frederick Frahm**, composer

"Brian represents the motto of Alcuin of York well: 'For the love of learning.' As Alcuin of York said, 'Man thinks, God directs.' Let the thoughts of one man, Brian, allow God to direct you to impact our culture for Christ. I recommend this book."

—**Peter Riola**, St. Alcuin's House Seminary and Oxford Graduate School

Tilt

Tilt

Finding Christ
in Culture

Brian C. Nixon

CASCADE *Books* · Eugene, Oregon

TILT
Finding Christ in Culture

Cascade Books
An Imprint of Wipf and Stock Publishers
199 W. 8th Ave., Suite 3
Eugene, OR 97401

www.wipfandstock.com

PAPERBACK ISBN: 978-1-5326-9141-6
HARDCOVER ISBN: 978-1-5326-9142-3
EBOOK ISBN: 978-1-5326-9143-0

Cataloguing-in-Publication data:

Names: Nixon, Brian C., author.

Title: Tilt : Finding Christ in culture / by Brian C. Nixon.

Description: Eugene, OR: Cascade Books, 2020 | Includes bibliographical references.

Identifiers: ISBN 978-1-5326-9141-6 (paperback) | ISBN 978-1-5326-9142-3 (hardcover) | ISBN 978-1-5326-9143-0 (ebook)

Subjects: LCSH: Popular culture—Religious aspects—Christianity. | Christianity and culture. | Mass media—Religious aspects—Christianity.

Classification: BR115.C8 .N60 2020 (print) | BR115.C8 .N60 (ebook)

"For Riley and the Angels," "A Culture to Itself," "Blink," and "To Be is To Belong" by Brian Nixon, all taken from *The Penwood Review*. Used with permission.

Kahn, Michaela. "Max Cole: The Long View." Used with permission.

"Reading the Big Weather" taken from *A Scripture of Leaves*, by William Stafford, copyright © 1989, 1999 Brethren Press, Elgin, Illinois. Used with permission.

"Conversation" taken from *The Consecrated Space. A Mosaic. An Essence. Deluxe Edition* by Jeff LeFever, copyright 2018. Used with permission.

Manufactured in the U.S.A. 05/15/20

To my wife, Melanie: The greatest is love.
And I thank you for it.

To our children, Brendan Isaiah, Sutherland Raquel,
and Cailan Tomas: you're the best thing your mother
and I could possibly give the world. And for the
memory of Riley: our lungs still sing.

To my parents and siblings: couldn't have
done it without you—literally!

Because—

"In the beginning God created the heavens
and the earth . . . and it was good."

—Genesis 1:1–2b

And

"In the beginning was the Word, and the Word was with
God, and the Word was God . . . And the Word became
flesh and we beheld His glory . . ."

—John 1: 1; 14a

Consequently—

"There is nothing that does not participate in beauty . . ."

—Thomas Aquinas

And

"God's love causes the beauty of what He loves . . ."

—Jacques Maritain

Therefore—

"Man is not a mind that thinks, but a being who knows
other beings as true, who loves them as good and who
enjoys them as beautiful. For all that which is, down to the
humblest form of existence, exhibits the inseparable privi-
leges of being, which are truth, goodness, and beauty."

—Étienne Gilson

Contents

Foreword

Sometimes I gaze out the back window of my house, lost in thought, stunned as to where I am in life and where I have been. Through this thought, I'm reminded of two things that I'm passionate about, Christ and art. Both are a part of my daily life, and for that I could not be more grateful. Through music I am able to share my journey, my fears and hopes. Through music I am able to share my feelings, bare my soul, and worship God. On my path I have been able to perform around the world. And whether in Europe or Australia I often take a moment during the concert to look into the faces of the crowd. I wonder about their lives, their challenges, their society, their aspirations and regrets. For me it's an intensely intimate moment, one where community and a cohesive group of people share something special, celebrating what it means to be a human.

My friend Brian Nixon does something similar in these collected article-essays. He brings together culture, Christ, and community in a unique way. I've known—and worked alongside—Brian for years. And I can honestly say this: he's a creative and original thinker. It is not often you find a trained theologian and educator weighing in on people like Cormac McCarthy, artists like Andy Warhol, musicians like Tom Waits, and subjects like art—all celebrating life. In all the subjects Brian address, he touches upon a host of topics with skill and insight! It's a mammoth vision he paints (and yes, he's a real painter), showing us how to tilt our heads, finding Christ in culture.

In this book he offers fresh ideas in his article-essays, not just a monotonous recap of an event. I remember him talking through the concept of Icon Numbers during Christmas one holiday season not too long ago. He was like the absent-minded professor at a party. Many of us were catching up and enjoying the night, but Brian was thinking about numbers. And his argument for beauty is, well, beautiful.

These essays are personal, practical, and penetrating, which make *Tilt: Finding Christ in Culture* more than just casual reading. Like all good narrative journalism, it's a journey of exploration and education, of learning and letting God lead you in understanding of people, places, things, and ideas.

If you appreciate life, and life more abundantly, I challenge to explore this book.

<div style="text-align: right">

Stephen Christian

Lead Singer, Anberlin

</div>

Acknowledgments

Without vision people perish. I'd like to start by thanking Rodney Clapp for his vision. Rodney took a chance with a book that draws outside the lines, and I'm thankful for it. Narrative journalism has found a home in the broader market, but seldom in the Christian sphere. I'm thrilled Cascade has opened the door for it within their abode.

As with all books, *Tilt* is a team effort. From the fine editorial work at Cascade, including Daniel Lanning and Matt Wimer, to my colleagues Lorin Bentley and Quentin Guy: your eyes, input, and editorial expertise came to the rescue! Quent and Lorin: you brought friendship into the fray. I'm so thankful for you, not only in publishing but football (the Beautiful Game)!

For Mark Berch: your reading-sensibility was greatly appreciated. Thank you!

To all the people I interviewed—Cole, Jackson, Hutchison, Frahm, Nichols, Hoagland, Collins, Kelman, Bresett, Zöller-Greer, and many others: you make this book tick. Thanks for allowing me access to your life and work. But particularly Jeff LeFever; we've had many artistic adventures learning how to tilt our heads together.

A special shout-out to Stephen Christian for the foreword. While you were touring the world with Anberlin, I was hard at work on this book. We both had fun, but I bet you had a tad more.

Thanks to *The Penwood Review* for the use of my poems, and cheers for publishing them in the first place. And Brethren Press for the use of William Stafford's poem, my first poet-fascination.

I'm grateful for journalist Dan Wooding for opening the door of journalism. Narrative journalism has been an adventure, a writing repose. Consequently, most of these articles were birthed through ANS News. Furthermore, I'm indebted to the various pastors—Jeff, Cal, Chuck, and Skip (and more)—who I've served alongside. It's been a privilege.

Finally, for the many practitioners of narrative journalism—from Ernie Pyle, John Steinbeck, George Orwell, Edward Abbey, Tom Wolfe, Joan

Didion, to Calvin Tomkins, Lawrence Weschler, and Susan Orlean; thanks for leading the way.

Concerning the inspiration behind this book: The works of author and theologian Dr. James Wm. McClendon, through his *Biography as Theology* model, have influenced me in that I yearn to understand a person's beliefs by taking a look at the person's life and work. Moreover, the work of author Dr. John Inge has reminded me that there is a Christian theology of place. Likewise, I'm indebted to former academic mentors at a few schools I attended: Dr. John Warwick Montgomery—who taught me to look at history evidentially; Dr. Norman Geisler, who tantalized us with Thomistic thought; and Dr. Peter Riola, who reminded me to work, study, and pray along the way.

Introduction

Experience

Wait, wait—not yet! I'll tell you in a minute.

For now, I'm watching a woman, the one standing by the abstract painting on the wall of the museum. She's wearing sophisticated-looking blue pants and has small, round glasses on top of her head.

She's staring at the painting on the wall, a Franz Kline. She keeps walking horizontally in front of the painting, then backwards and forwards toward the black and white abstraction. She puts her left hand to her hip, taps the side of her leg. She looks at the brochure in her right hand, then back at the painting. She follows this routine for a few minutes, mumbling to herself.

And then she does it: she tilts her head.

I knew it was coming; I pegged her: she's a head tilter.[1]

I've seen it many times before: a man or woman standing in front of a painting at a museum—or maybe digesting an idea someone just shared—contemplating, wondering, nodding. Then it happens. Curiosity arises. They tilt their head.

The tilt of the head is a universal sign that indicates interest and shows awareness.[2] It's a position of inquisitiveness or an indication of uncertainty. Tilting the head conveys that a person is observing and interpreting, assimilating something. In some societies, a head tilt is a form of submission

1. This event occurred at the Museum of Contemporary Art Chicago. The woman was looking at *Vawdavitch*, 1955.
2. Mehrabian, *Nonverbal Communication*, 36.

and humility: by exposing their neck, a person symbolically offers their life to another. Even animals—most notably dogs—tilt heads.

And even when we don't tilt our head physically, we do it metaphorically: we ask, search, and contemplate. The head tilt is connected to a heart tilt, bridging our mind to our emotions, our brain to our body, and showcasing the common human characteristic of interest and inquiry about life.

The head tilt is part of the human condition. And I'm a self-confessed head tilter. Hopefully that helps explain the title of this book, *Tilt: Finding Christ in Culture*.

Explanation

The definition of *tilt* is simple. The *Oxford English Dictionary* refers to it as a "sloping position or movement," as in "the tilt of the earth." The verb form means to "cause to move into a sloping position."[3] To tilt requires movement from one position to another. Someone who tilts his or her head, for instance, moves it from an upright position to an offset position.

It's this offset position that's fascinating to me.

The body language conveyed by an offset head indicates observation and interest. It's a gesture of discovery. An offset head can signal agreement or disagreement, a movement in consideration or empathy. In short, the person who tilts their head is trying to comprehend the object before them with a deepened curiosity.

But curiosity about what? I propose that the head tilt is a movement toward understanding, a yearning to grasp the stuff that makes up life. And the things that make up life are found in culture: cities, science, people, the arts, and civilization—all the material that comprises human, and dare I say, divine, achievement.

Tilt: Finding Christ in Culture provides snapshots of the stuff that makes up culture, undercurrents that help craft—and keep—culture flowing. The undercurrents discussed in this book are best summed up by the four streams that define what a noun is: people, places, things, and ideas.

3. Oxford English Dictionary, "Tilt."

To take it deeper, God—in Christ—is present in people, places, things, and ideas. His fingerprints are extant throughout creation and culture, leaving signs of his interaction and interest in individuals and things. And, like a good forensic scientist, humanity can discover those fingerprints grazed upon the world.[4]

So, for the Christian, a head tilt should in part be about finding Christ in culture, locating his manifest truth, beauty, and goodness in creation and civilization.

If God is the Creator—the uncaused cause, pure actuality[5]—then all of his creation is open for discussion: birds, bees, trees, music, art, cities, towns, rivers, the color green, machines, microbes . . . you name it. It's all game for investigation.

Thus, *Tilt: Finding Christ in Culture* offers an eclectic collection of articles that describe the fingerprints of God found upon the world. Though these short articles are not theology proper—the study of God's moral and non-moral attributes—they do point to the God who has these characteristics. By studying creation, concepts, and culture, we get insight into the mind and thought process of the Creator.

Example

You'll notice right off the bat that some of the people and topics I address in this book are not necessarily Christian in the sense that they prescribe to a certain set of beliefs about God. But all are worthy of discussion from a Christian point of view as recipients of what we call God's common grace. Let me explain what common grace is.

Back in the mid to late 1980s, I was in a post-punk band that called San Jose, California, home. We were signed to a small independent label based in the Bay Area. As is the case with any young band trying to hone their live performance chops, we'd try to get gigs around town at various venues.

4. Properly understood, God does not have fingers or fingerprints. This is anthropomorphism—attributing human characteristics to God. God is, however, omnipresent: he is everywhere at the same time, constantly encountered.

5. "Pure actuality" is a term that refers to God's innate existence. There is no possibility for God not to exist or to be something other than what he is, namely, God.

One of our band members was also an artist who made silkscreen prints. After he created posters, we'd go downtown and put them on walls, on lampposts, in windows, and anywhere we could promote our recordings and the performances we drummed up. Other bands and performers put up posters as well.

One such performer was Chris Isaak.

I remember seeing his posters next to ours. His were professionally made; we printed ours at a local copy store. His posters displayed an Elvis-looking crooner with nice skin; our posters had a chicken next to Albert Einstein. You couldn't get two polar opposites. But both Chris Isaak and our band were out to make an impact in the musical world.

Isaak wasn't originally from the Bay Area, but he made great strides, playing at all the hip places our band was trying to get gigs at. Our band's scene was underground. Isaak was playing the respectable places, real gigs where he got real money (I'm sure not a lot, but more than us).

Our band eventually dissipated, becoming an underground flash in the pan, but Isaak went on to make it in the music business, accumulating hit records and touring the globe.

His first inroad to music stardom consisted of two songs used in David Lynch's movie *Blue Velvet*. His crooning voice was a perfect match for the film. And his first hit song was the 1989 tune "Wicked Game," from the album *Heart Shaped World*.

The rest is, if you will, history.

Isaak went on to record many albums, host an HBO TV show, act in several movies, and star in a PBS broadcast dedicated to one of his recordings, *Beyond the Sun*. He was even a featured guest on *American Idol*.

I attended a Chris Isaak concert, years after his Bay Area start. The show was a marvelous mix of old and new, combining his own music with fifties and sixties classics from Jerry Lee Lewis, Johnny Cash, and Roy Orbison. For a moment I thought I was back in San Jose, Isaak's voice still strong and young.

As is the case with most people I watch or listen to, I wondered what his worldview is. Does Isaak have a faith? Does he prescribe to any religious system? The answer to that question is unknown to me. He has been in a movie that portrays Buddhist themes (*Little Buddha*), but that doesn't make him Buddhist any more than someone playing Jesus in a movie makes them Christian.

Beyond his personal belief, I began to wonder about the place of secular music in culture. Though I'm of the disposition that the divide between secular and sacred music isn't as expansive as most think, I do recognize that there is a divide. Yet for me, all music is a testament to God's grandeur.

Now, I recognize that some music has anti-Christian themes, particularly in its lyrics. But at its root, musical creation is an indicator of something bigger and more profound. Creation implies a creator. A score means there was a composer, and a song, a songwriter. We see this in the technological field as well: a smartphone means there was an engineer and inventor.

So, when I think of music—or any of the arts—my mind turns to the theological principle of common grace. Common grace refers to the gifts given by God for all of humanity to use and enjoy. These gifts include creation (the natural world and science) and culture (the humanities, arts, and civilization).

Common grace is different from saving grace in that the latter concerns salvation and redemption. Common grace is God's gift to all; saving grace is God's gift to those who receive and believe. But we all benefit from common grace, whatever the medium, due to the fact that God is the ultimate cause and architect of all.

I'm glad God has imparted both graces. For when I hear Isaak sing the opening verse to one of his popular love songs, crooning about someone he adores, I can't help applying it to God.

And common grace is the reason why I touch on so many topics some people deem un-Christian. For me, it's all about grace, and culture is a marker that can help us respond to grace. If anything, *Tilt: Finding Christ in Culture* is a portrait of God's grace upon the world as well as a call for the world to experience that grace, offering the tantalizing truth that there is a God and he loves us.

When it comes to this type of grace, I think a head tilt is appropriate.

Elucidation

Because the vignettes found in these pages are varied, covering a number of subjects, I've categorized them under the aforementioned labels: people, places, things, and ideas. As you read, you'll begin to notice that each vignette can be read independently or as a section. Some sections are longer than others; I suppose I had more to say about certain topics. All, however, began as articles, not academic works.

Deep in the undercurrent of these stories are glimpses of God's work upon the waves of history; they are biographical, theological, and journalistic. The book acts as evidence of actual events that happened in the world. Thus, *Tilt* is one part travel log, one part theology book, one part history, and one part narrative journalism.

That being said, you'll find various interactions packed in the pages of this book. You may or may not be familiar with some of the people, places, and things discussed. If you're not familiar with some of these topics, then I count it my privilege to introduce you to them. And if you are familiar with certain subjects, possibly even an expert in a relevant field, I simply invite you to read what a curious writer has to say about these cultural currents.

Whatever your position toward the topics discussed, I invite you to read with an open mind, joining me on a journey of encounter and exploration, seeking transcendence and God's presence along the way. My hope is that you'll have a head-tilting experience.

I've selected the following stories based on three criteria: First, the story must be something I covered as a narrative journalist, such as a place I visited, an idea I conceived, or a person I met. Second, the story must have a biblical or broader Christian tie-in. And third, the story needs to be both educational and enlightening, both informational and inspirational. What you have before you are the results of that selection process.

Now, translating culture into words can be a daunting task, if not impossible for some topics (such as music or beauty). I acknowledge that my experience and insight is limited. And you may disagree with my thoughts or interpretation of a topic. That's okay. My intention is to bring you along

on a journey of discovery, eliciting intelligent discussion and critical think-
ing while encountering a complexity of issues and ideas. When it comes
down to it, I hope the stories in this book cause you to think, a theo-cultural
means to inspire your imagination.

Embark

Before you embark on this journey of discovery, I want to explain why I
began each section of *Tilt: Finding Christ in Culture with* a poem I wrote:
First, the poems provide a moment of pause to help you ponder the broad-
er topic at hand.

Second, the narrative journalist Joan Didion began her famous book *Slouch-
ing Towards Bethlehem* with a poem by W. B. Yeats. The poem brings a pen-
sive moment to the book, focusing her thoughts and providing a theme to
her work. I want to follow suit.

And third, the poems are articles in and of themselves that address each
section's topic. The first poem is about a person: my son Riley. I buried him
as an infant. Because of Riley, I found out what Potter syndrome is and ex-
perienced deep loss. The second poem is about a place: an old-school bar-
bershop in Modesto, California. The third poem is about a thing: a flower.
And the fourth poem is about an idea: being and belonging.

My hope is that all four poems will prompt a head tilt in whoever reads
them.

Encouragement

If you're inclined to believe the imagination of the famous Dutch painter
Rembrandt van Rijn, Jesus may have tilted his head while teaching or praying.
In several paintings, Rembrandt portrayed Jesus with head askew, his eyes
fixed in a gaze of—love? Forbearance? Contemplation? We can only guess.

But we do know that Christ tilted his head on the cross. As John 19:30 con-
veys, Christ bowed his head and gave over his spirit to death. In this, he
submitted himself to his Father, humbly fulfilling his will.

Then, at the resurrection, Jesus fully accomplished what he came to do:
bring new life and a new vision for the world in the form of the good news.

This theology of the cross, to use a term Martin Luther coined, brought power from the pain, hope for the hurting, and life for the lost. A new world was birthed, out of which came a Christian worldview that helped craft our character, define our domains, and provide a cultural plan.

We are the recipients of that new world. And though the Judeo-Christian culture has wavered the past few decades, we can't escape the fact that we inherited something grand. Cathedrals and hospitals, literature and music, and paintings and poems all dot our landscape like flowers in a field.

Can we find Christ in the midst of this fading Christian culture? I submit to you that we can. We just need the eyes to see that Christ is alive and well in the most unexpected places. Like the basic inductive method of studying the Bible, we need to learn to observe our culture, interpret it through the lens of Christ, and apply it to our lives when necessary.

So, the next time you visit a museum and see someone tilt their head at a painting, thank God, and then tilt your head with them.

Part 1

For Riley and the Angels[1]

Mors autem in porta

When I held you, my infant child
Of death, did the angels weep as
Your mother and I? In their
Plurality was there unity of

Sorrow? In their essence did
They foretell your short material
Existence, an accident in
Metaphysical language like
Blue to the sea?

But this is charity, O child:
To hold you but for a moment,
Letting your last breath be the
Song my lungs breathe in to sing.

People

Look around: people are everywhere. From the coldest climates to the hottest deserts, from bustling cities to rural regions, people inhabit this planet with poise, pleasure, and pain. Some people live with enterprise and determination, others with emptiness and discomfort. Over seven billion people of different nationalities, colors, creeds, and social classes share the earth—the place we call home.

1. *The Penwood Review*, 22.

Despite our great diversity, we have many things in common. Here are a few odd facts most people share:[2]

- The average person produces enough saliva in their lifetime to fill two swimming pools.

- Every minute, your red blood cells do a complete circuit of your body.

- Most Westerners consume fifty tons of food and 50,000 liters of liquid in their lifetime.

- It can take your fingers and toes half a year to grow an entirely new nail.

- The muscles that control your eyes contract about 100,000 times a day (that's the equivalent of giving your legs a workout by walking fifty miles).

- Sixty percent of men and 40 percent of women snore.

- The human sneeze can travel 100 miles per hour.[3]

- The *Live Science* website states that people do fifteen basic things each and every day: sleep, die, hiccup, blush, kiss, pass gas, laugh, blink, cry, zone out, see in 3-D, get physical sensations (like "pins and needles"), shave, take risks, and have sex.[4]

Of course, there is more to us than just our bodily functions and common habits. We have trials, tribulations, and temptations. We praise, use profanity, and think profound things. We ponder our existence, practice our beliefs, and presume lots of things about the world. People really are complex, fascinating, and unique, "fearfully and wonderfully made," as King David declares.[5]

But here's the most amazing fact about humans: God loves each and every one of us. If there is one truth the Bible clearly teaches, it's that God loves people.[6] God created us and cares for us.[7] Furthermore, God yearns for a relationship and clear communication with us through his Son, Jesus.[8]

2. Viral Nova, "These 20 Facts About You Are Pretty Strange, But Also Fascinating."
3. Publications International, LTD, "16 Unusual Facts About the Human Body."
4. Wolchover and Peterson, "15 Weird Things Humans Do Every Day, and Why."
5. Psalm 139:14.
6. John 3:16.
7. Matthew 5:45.
8. Hebrews 1:1–2.

Even with God's love for us, people aren't perfect. Far from it. We're imperfect, missing the mark of our true identity. This imperfection—the willingness and ability to do things wrong—is what the Bible calls sin. I don't need to unpack what theologians call hamartiology—the doctrine of sin—but I do want to state that people have two natures.

Our two natures can be summarized as image-bearers and image-breakers. On one hand, God created us in his image, loves us, and yearns that all people have a relationship with him.[9] God desires to conform us into the image of his Son, Jesus.[10] To help do this, God extends an invitation to follow Christ. But on the other hand, all people have the propensity to do dreadful things. Because of this, the image of God is broken in our lives, like a cracked mirror distorting our true identity in God. A proper understanding of humanity includes seeing that all of us fall short of God's perfection.

And here's where culture comes into the picture. Because people aren't perfect, culture—the place where people reside and create—is not perfect. Therefore, culture can be corrupt as well. We need to keep this in mind when dealing with people and culture.

But this is also where it gets interesting. In the midst of this confluence of saint and sinner, God—by his Spirit working through grace—continues to invite and inform, prod and probe, touching and tying us to his truth. And what God touches, he tethers, leaving fingerprints for us to see and experience in wonderful ways. God's truth can be found everywhere, from the tiniest atoms that make up our bodies to the titillating triumph of a symphony. The marks of God's grace are found everywhere, even in our corrupt culture.

As we begin to look at the people within this section, we are like participants watching a compelling play in a theater, finding Christ on the stage of life's great drama—not only as playwright and producer, but as a performer, speaking his lines through the language and lives of people, communicating his presence and purposes in culture and creation through truth, beauty, and goodness.

I've elected to highlight several people in whose work I've found glimpses of God's grace—including the opening poem about my son. A few people

9. Genesis 1.
10. Romans 8.

are from the present and a couple are from the past. Let me be clear. I'm not saying that the people I'm highlighting are Christians or represent Christ in a full, biblical manner. They may or may not. Nor are the treatments meant to be a comprehensive analysis of the person's life and work. Rather, I see these articles as demonstrations that God's grace and truth can be found in unexpected places; a vignette of wonder. In the midst of our culture, signs of Christ can be sought in the script of life. And when we begin to read the script carefully, we hear Christ's soliloquy on the stage of our existence. Like luminous lines in a play, glances of God's grace are found in the work and wisdom of people.

And it's to people I now turn.

Cormac McCarthy: The Biblicist

The first word I remember hearing from Cormac McCarthy's forthcoming novel *The Passenger* was the name Plato. Read by Caitlin Lorraine McShea, the line was archetypal McCarthy: a confluence of philosophy, science, and dare I say, theological teasing—all beautifully writ.

The opening lines were read in front of roughly 1,000 people—a mixture of artists, scientists, literature buffs, and the curious. Together we were gifted with excerpts from McCarthy's impending work. But the evening was so much more than a reading. It was a union of the beautiful and true (at least on scientific and artistic levels).

In a program entitled *Drawing, Reading and Counting (Beauty and Madness in Art and Science),* the event was co-sponsored by the Lannan Foundation and the Santa Fe Institute.[11] To call the evening a success would be an understatement: it was majestic, an aesthetic and intellectual ride through mathematics, art, literature, and marvelous conversation.

Hosted by Dr. David Krakauer, President of the Santa Fe Institute, the hour-and-a-half program consisted of conversations with artist James Drake and readings from McCarthy's work, as read—in an almost dramatic fashion—between Krakauer and McShea.

Interspersed between the conversations and readings were slides of Drake's artwork projected on a large screen, sometimes accompanied by the musical

11. Lannan Foundation, "Drawing, Reading and Counting."

compositions of John McCarthy (Cormac's son), and audio recordings of McCarthy reading from the book or telling stories.

At the end of the evening, Cormac McCarthy got up to address the crowd. McCarthy said (and I summarize), "In no other city would you get a gathering like this to listen to something as cerebral and engaging as discussion on beauty, madness, art, and science."[12]

Though it is extremely rare for McCarthy to give a public statement, it was classic McCarthy—a merging of various engaging concepts, teasing us with what's to come. The evening caused a stir of activity, with news agencies giving it attention.[13]

Born July 20, 1933, as Charles McCarthy in Rhode Island, McCarthy's family moved to Tennessee where his father worked as a lawyer.[14] McCarthy attended the University of Tennessee in the 1950s. But his real education began with the commencement of his writing career in the 1960s. After writing his first four novels (*The Orchard Keeper, Outer Dark, Child of God,* and *Suttree*), McCarthy moved to El Paso, Texas, whence began his Southwest-influenced works (*Blood Meridian, All the Pretty Horses, The Crossing, Cities of the Plain, No Country for Old Men,* and *The Road*). During this period, McCarthy moved from Texas to Tesuque, New Mexico. His novels became instant classics, winning the Pulitzer Prize, National Book Award, and an Oscar for the movie adaptation of *No Country For Old Men.* McCarthy became a living legend.

The question arises: Why the excitement from the press, critics, and people over his novels? Why do some consider him to be one of the greatest living authors, his work commanding study and deliberation uncommon among modern novels? There's a society in his honor and people gather from across the globe to discuss his works.[15]

Other than his unique writing style (highlighted by peculiar use of punctuation and language), his work has a philosophical tone, as the opening of *Drawing, Reading and Counting* attests. Simply put, there's brilliance in his books. Beneath the river of McCarthy's pen lie sinuous theological fluxes.

12. Derk, "A Tiny Peek At Cormac McCarthy's New Novel."
13. Martinez, "New Cormac McCarthy Book 'The Passenger,' Unveiled."
14. Official Web Site of the Cormac McCarthy Society, "Biography."
15. Official Web Site of the Cormac McCarthy Society, "Biography."

6

TILT

McCarthy was raised Catholic by a Catholic family, and attended a Catholic school in Knoxville, Tennessee. Beyond this, little is written about his personal faith. McCarthy probably likes it this way; the silence keeps the mystery of his belief unsolved, the search for answers alive. But his novels are chock full of inferences and imagery taken from faith, Christianity in particular.

Often, I've wondered how McCarthy's religious worldview influences his novels. Sitting in Santa Fe, listening to selections from *The Passenger*, piqued my interest even more. If McCarthy is a practicing Catholic, what sort is he?

He seldom gives interviews and has never to my knowledge addressed the topic openly. Other than one TV interview given to Oprah Winfrey (who picked *The Road* as one of her Book Club choices) and a smattering of magazine and newspaper interviews, Mr. McCarthy lives a private life, dedicating his time to the Santa Fe Institute, and presumably, his writing and family.

But I'm not the only nosy person interested in his religious beliefs, especially as they are portrayed in his masterful works. A book by Manuel Broncano called *Religion in Cormac McCarthy's Fiction: Apocryphal Borderlands* shows others are seeking answers as well.

Broncano's book "addresses the religious scope of Cormac McCarthy's fiction, one of the most controversial issues in studies of his work. Current criticism is divided between those who find a theological dimension in his works, and those who reject such an approach on the grounds that the nihilist discourse characteristic of his narrative is incompatible with any religious message."[16]

The description continues: "McCarthy's tendencies toward religious themes have become increasingly more acute, revealing that McCarthy has adopted the biblical language and rhetoric to compose an 'apocryphal' narrative of the American Southwest while exploring the human innate tendency to evil in the line of Herman Melville and William Faulkner, both literary progenitors of the writer."

As Broncano shows, many see a connection between belief and unbelief in McCarthy's works, which are infused with biblical imagery. Concerning the Bible, Broncano argues that this "apocryphal narrative is written against the background of the Bible, a peculiar Pentateuch in which *Blood Meridian*

16 Broncano, *Religion in Cormac McCarthy's Fiction*, 1.

functions as the Book of Genesis, the *Border Trilogy* functions as the Gospels, and *No Country for Old Men* as the Book of Revelation, while *The Road* is the post-apocalyptic sequel."[17]

Beyond the broad reaches of religion, Broncano finds a parallel between the Bible and the corpus of McCarthy's novels, with the former acting as a guide to the later.

The literary geek in me gets excited when I read a description like this. Manuel Broncano has taken the time to unravel the biblical underpinnings of McCarthy's work, albeit a postmodern rendering.[18] I'm intrigued by Broncano's framework: Genesis, Gospels, and Revelation as they relate to McCarthy's later Southwestern books. It's a fascinating way to categorize McCarthy's novels, bringing up the larger themes of law/sacrifice (Genesis), love/grace (Gospels), and judgment/redemption (Revelation).

So, what type of Christianity does McCarthy portray in his books?

Edwin T. Arnold, in his essay "McCarthy and the Sacred," understands McCarthy's works as having a unique Christian vision. He writes, "Expressed largely in Christian terminology—sin, guilt, grace, and redemption—in the so-called southern novels . . . these concerns have taken on a broader, more metaphysical quality in later works, those set in the American Southwest and Mexico."[19]

An article by professor John Rothfork of Northern Arizona University provides further insight. In "Redemption as Language in Cormac McCarthy's *Suttree*," Rothfork makes an interesting comment concerning McCarthy's religious portrayal in the book, *Suttree* (1979).

Rothfork writes, "If Suttree is a Christ figure, it is Christ crucified. And if God heals, it seems to be with a knife: 'beyond the flayed man dimly adumbrate another figure paled, his surgeons move about the world even as you and I.' Looking through a family photo album, a 'picture book of the afflicted,' Suttree wonders, 'what deity in the realms of dementia, what rabid

17. Broncano, *Religion in Cormac McCarthy's Fiction*, 14.

18. Mundik, "Religion in Cormac McCarthy's Fiction," 1.

19. Lilley, *Cormac McCarthy*, 215.

god decocted out of the smoking lobes of hydrophobia could have devised a
keeping place for souls so poor as is this flesh?'" [20]

Rothfork sees suffering as the main motif within *Suttree*, focusing on the
mortification of the flesh. Rothfork expands his thought more concern-
ing *Suttree*, commenting on another writer addressing the issue, William
Prather.[21] Rothfork writes:

> Certainly not the omnipotent and transcendent potter of *Gen-
> esis*. Among the several clergy in the novel, the most familiar is
> a housebound cripple in a wheelchair who calls Harrogate the
> "spawn of Cerberus, the devil's close kin" and wishes "all on to
> a worse hell yet." William Prather believes these characters and
> experiences indicate that "the universe depicted in *Suttree* is ex-
> istential and absurd." He thinks that "Like Camus, *Suttree* clearly
> rejects the recourse of religion." But Prather has only conven-
> tional notions of religion, evident for example, when he says
> that "religion is presented in the novel in two distinct forms:
> one a primitive brand of Protestantism and the other, orthodox
> Roman Catholicism." Kierkegaard's atheist and his musings on
> the would-be child killer, Abraham, suggest that religion may
> not be so easily elucidated or dispelled.[22]

What do comments like Broncano and Rothfork's tell us about McCarthy's
faith? The answer: it's hard to tell. But they do give us clues as to how Mc-
Carthy blends Christian thought in many intricate and intriguing ways
throughout his works, both clear and complicated. This is part of the allure
of McCarthy's writing: the rich reference to biblical narratives mixed with a
foggy application of their meaning keeps a person in no-man's-land, but one
engaging enough to keep us scratching our heads, asking for more.

Todd Edmondson doesn't see a clear Christian ideal in McCarthy's works.
In his "Priest, Prophet, and Pilgrim: Types of Distortions of Spiritual Voca-
tion in the Fiction of Wendell Berry and Cormac McCarthy," Edmondson
writes, "McCarthy's characters, in their pursuit of various goals, embody
the opposite of Christian vocation in the ways that they relate to the flesh,

20. Rothfork, "Redemption as Language in Cormac McCarthy's *Suttree*," 5.

21. Prather, "Absurd Reasoning in an Existential World."

22. Quoted in Rothfork, "Redemption as Language in Cormac McCarthy's *Suttree*,"
5.

to community, and to creation. Rather than humbly seeking and encountering God in these contexts, they strive always to transcend them, to overcome creaturely limitations, and to become, in the words of the serpent in the garden, 'like God.'"[23] For Edmondson, McCarthy's characters adhere to a type of anti-Christian (that is, opposing) thought, traits more man-centered than God-centered.

When one turns to McCarthy's Pulitzer Prize-winning book *The Road*, biblical comparisons are manifold. From the apocalyptic setting of the book (a post-Armageddon–type world) to biblical allusions ("Word of God" used as a reference to the man's son), to symbolic overtones of a Christ figure (the father) dying to provide life for his child (the church?), *The Road* is seen as a deeply moral, though dark, spiritual work. Even the title of the book has biblical overtones. Is the road a path toward death or life? Both? Is the journey alluded to one of moral certainty, like Moses's law, or a journey of suffering, like those of Job or Jesus? All of the above?

In discussing *The Road*, Tom Ryan, professor of religious studies at St. Thomas University, writes about McCarthy's use of the Bible in his article, "Cormac McCarthy's Catholic Sensibility." Ryan, interested in how *The Road* relates to an end-times (eschatology) understanding, writes: "Thus, *The Road* differs from popular eschatologies that discount the present by making it an instrument for discerning a nonexistent future. Instead, it exploits the eschaton on behalf of us today and so resembles Catholicism with its regard for creation and the time being. Like biblical prophets and apocalypticists, it hints at Jesus' final words, 'Behold, I am with you always' (Matthew 28:20) and pleads for the perspicuity to see the suffering and exploited not as empty pointers but as vessels of God's presence now."[24]

Again, McCarthy's work is like a prism, showing various colors of theological spectrums, eliciting questions. But his novels don't provide a clear answer as to how the theological colors of his novels match McCarthy's personal belief.

Is McCarthy the product of the orthodox Roman Catholicism of his childhood? Is his belief a well-thought out biblical framework, incorporating elements of Genesis, the Gospels, and Revelation, as Broncano alludes? Is it the harsh God of Rothfork's analysis? The anti-Christian vocation of

23. Edmondson, "Priest, Prophet, Pilgrim," 1.
24. Ryan, "Cormac McCarthy's Catholic Sensibility," 2.

Edmondson? Or the biblical eschaton of Ryan? Is McCarthy's fiction a world of existentialism, void of meaning, as suggested by Shane Moon?[25] Or maybe a sacramental theology proposed by Matthew Potts in his book *Cormac McCarthy and the Signs of Sacrament*. In this work, Potts attempts to establish some sort of moral system in light of "metaphysical collapse," that "McCarthy's routine and extensive use of sacramental imagery means to deploy precisely this cruciform logic toward the development of a distinct moral vision, a sacramental ethics."[26] For Potts, McCarthy's work is best understood in light of the sacrament of the eucharist, portraying the death of Christ.

If left up to me, I'd say all of the above. Why? Because McCarthy's works, like all great tomes, don't fall easily into one nicely wrapped package. Instead, the collective works of McCarthy encompass the scope of human experience, delving into a variety of worldviews, opinions, mental configurations, and yes, spiritual pursuits.

Come to think of it, they resemble the collective works found in the Bible, where a variety of people confront life and God from very human perspectives and divine yearnings. Though about God's pursuit of man, the Bible is a very human work, portraying the full extent of human foibles and actions. But whereas the Bible has a scarlet thread to its nature—God's works of redemption within the world and his people—McCarthy's works have blurred lines, following a crooked path.

But even within this warped journey, McCarthy's road has a destination.

This serpentine sojourn may best be portrayed in his novel *The Sunset Limited*. Two men, White and Black, discuss the purpose of life. Black is an ex-druggy but now a Christian. White is a professor and atheist. Black saved White from attempted suicide when White tried to throw himself in front of a train. In a short time together, the two men debate suffering, God, and meaning.

The book ends with White's words: "I'm sorry. You're a kind man, but I have to go. I've heard you out and you've heard me and there's no more to say. Your God must have once stood in a dawn of infinite possibility and this is what he's made of it. And now it is drawing to a close. You say that I want God's love. I don't. Perhaps I want forgiveness, but there is no one

25. See Moon, "Meaning and Morality in the Works of Cormac McCarthy."
26. Potts, *Cormac McCarthy and the Signs of Sacrament*, 2.

to ask it of. And there is no going back. No setting things right. Perhaps once. Not now. Now there is only the hope of nothingness. I cling to that hope. Now open the door. Please." Black responds, "Don't do it." Then later, "Professor? I know you don't mean them words. Professor? I'm goin to be there in the mornin."[27]

Presumably, the professor leaves and commits suicide.

Within *The Sunset Limited* one finds two worldviews: one of complete trust in God's providence and one in denial of God's existence. Black believes there will be a "mornin," a new beginning. For Black there is hope. White has denied God and God's love, reverting to "nothingness," a lack of hope, as he calls it in his despair.

To a certain extent the two worldviews prominent in *The Sunset Limited* underscore most of McCarthy's work. Even more, the worldviews of belief and unbelief accentuate all of life: in a bottom-line sense, either one believes in God or one doesn't believe in God. That's it.

For me, the power of McCarthy's works lies not only in the power of his words but also in the dance between belief and unbelief. Though many can debate McCarthy's use of the Bible and theology, the truth is that all great written work, whether literature, poetry, or nonfiction, asks similar questions: Why is there something rather than nothing? What's the meaning of life? Is there purpose? Is there a God? If so, how do I know God?

After all, the questions are very biblical and worth posing. Leave it to a master like McCarthy to ask them with the prose of a poet, the doubt of a philosopher, and the heart of a prophet.

I was reminded of these truths as I sat through *Drawing, Reading and Counting (Beauty and Madness in Art and Science)*. I couldn't help but think that the program reminded me what it means to be an alert human—a person asking questions, seeking answers, finding friends and foes along the way. If beauty, madness, art, truth, and science (and may I add, theology) converge in such a forum surrounding the work of McCarthy, then it's great to be reading a Cormac McCarthy novel and know I'm not alone in my journey of discovery.

27. McCarthy, *The Sunset Limited*, 141.

To this extent, McCarthy is a biblicist—one who portrays life as it is. And because of this, we're the better for it, humans seeking not only beauty but being.

Tom Waits: Dark Hymns of the Christian Life

Napoleon's Pizza House in National City, ten miles south of San Diego, is a restaurant like many others: worn red and brown chairs, a seasoned juke box, a pool table, a large white painting of a lonely bridge over a body of water, and, of course, pizza.

The floor is checkered white and red; around the corner of the building there is a screaming yellow wall reading, "US Save Rentals." You can read the sign from inside Napoleon's. A policeman sits across from me, keeping a keen eye on the three rooms that have apparently been around since the restaurant's founding in 1958. The ceiling fans are turning, and I sit down to eat, looking for shadows of Tom Waits.

Born Thomas Allen Waits on December 7, 1949 in Pomona, California, Waits moved to San Diego county with his family as a child, working at Napoleon's in the late 1960s. He was a busboy and dishwasher. He even wrote a song about the pizza joint on his second album, *The Heart of Saturday Night.*[28]

As his ambitions progressed, so did his work location: he moved up the coast to Mission Beach and worked as a doorman at the Heritage, a coffeehouse and performance spot (which I'll get to shortly). In the early 1970s, Waits gravitated even farther north toward Los Angeles, finding his home in old hotels and bars.[29]

Now those of you who know Tom Waits' music (or the people that cover his songs: The Eagles, Rod Stewart, the Ramones, etc.) are probably scratching your head and asking, *What in the world is this guy doing writing about a musician who throughout his career has written more bar and prostitute songs than there are bars?*

To many people, Tom Waits' music represents the disenfranchised, the drivel of the world—late night drunken binges, postcards from prostitutes,

28. See Jacobs, *Wild Years,* 28–29, 71.
29. See Hoskyns, *Lowside of the Road,* 40–53.

and weird-as-all-get-out songs, sung in a graveled, Louis Armstrong meets Hobo John voice.

True, Mr. Waits does have a slight propensity to accentuate the underground of barflies and the down and out, particularly in his early work. But beyond this, Waits is really not too bad of a theologian; hence my interest and great respect for the musician and storyteller.

I came into contact with Tom Waits' music in 1987, the year *Frank's Wild Years* came out. At first, I was scared: his voice! The songs! Waits' voice was harsh, gravely, and unkempt. The songs were odd, off-kilter, almost out of touch with the broader music scene. But the more I listened, the more I loved it. I realized I was hooked. Genius. His songwriting transcended the conventional forays of popular music, entering the realm of Tin Pan Alley, Surrealism, Americana, and world music. To my great surprise, this wasn't some new guy, but a seasoned troubadour whose career stretched back to the early '70s. It was then that I started on my Waits journey.

As a Christian teenager attending a Church of the Brethren, I thought that I could never bring this music to my pastor, Jeff Neuman-Lee (a Bruce Cockburn and Bruce Springsteen fan). I thought, *this music is too wild, too unorthodox.* However, as I began to investigate the words, I noticed that Mr. Waits did have a sense of the spiritual.

As an example, in the song "Way Down in the Hole," Waits touches on a host of theological themes, from resisting temptation (sanctification) to salvation (soteriology), from omnipotence (God's power) to omnipresence (God's presence).[30]

True, as one listens to Waits, there are many songs that offer a strange and metaphorical view of the Christian life ("Chocolate Jesus"), as well as songs that ask God big questions about suffering ("Little Drop of Poison") and war ("Road Map to Peace," a song about the Middle East crises).

But the totality of Waits's music is quite biblical, offering songs of sin and salvation, losers, down-on-their-luck-type folks, heroes, lovers, and people seeking something larger in life: love, God's presence, and heaven. It's like Tom read the Bible, found themes, characters, and insights from it, and began using it as an outline for his corpus of songs.

30. For a listing of Tom Waits songs and lyrics, go to http://www.tomwaits.com/.

On his album *Orphans*, Waits sings a beautiful song—taken from a believer's
vantage point—about trusting family and belongings to the Lord at the time
of death. "Take Care of All My Children" is hymn-like, with organ, brass,
stand-up bass, and drums carrying the majority of piece—rather like encoun-
tering a Salvation Army marching band. The main character is seemingly an
old or injured person (note the use of the walking cane) who is about to die
or to leave on an unknown journey. However, this character has a steadfast
faith that if he or she dies, the Lord will take care of his or her children, even
asking him not to let them roam (perhaps away from the faith?).

In "Take Care of All of My Children," Waits deals with providence and the
power of Jesus' name. Waits turns his attention to the evil in the world,
rightly describing its origin—the devil—even suggesting that a continued
pursuit of evil will lead to harm.

Now let me say that not all of Tom Waits' songs are as hymn-like as "Take
Care of All of My Children." Many songs do use the occasional expletive
(though very few), and many more songs are surreal characterizations of
a life of less than upstanding characters. But other songs glow with marital
love, longing for heaven, and the eccentricities of humanity. But one thing is
clear: Tom Waits understands brokenness. As David Halliday writes for *Rel-
evant Magazine*, Waits's "songs seem to emerge from lives lived knee-deep
in the guts and grime of everyday experience. Waits populates his songs
with a swirling broth of vagrants and bohemians; the losers and the no-
hopers, the lovelorn and world-weary, the deadbeats at dead ends."[31]

In all, Waits' music has a similarity with the Bible. Does not the Bible portray
figures and characters that live lives of sin and rebellion, of love, hope, and
heaven? Is not the Bible the master book for understanding the despicable
notions of humanity? The Bible is redolent with tale of lovers, haters, he-
roes, and troubadours, all in need of a Savior. If we're looking, we ourselves
among the lost and deplorable, seeking for life and love. The Bible is a rich
compendium of life, a divine delight wrapped up in inspired flirtations with
man. The Bible is God-breathed yet aches with human need. It seems Waits
finds its themes compelling.

A few years later, I sought out Waits' second place of employment: The
Heritage.

31. Halliday, "What Tom Waits Can Teach Us About Brokenness."

The Heritage was housed in a building now called Single Fin Surf Grill. The atmosphere is what you'd expect from a beach restaurant—open patio, fish tacos, casual, and beach-chic. I asked the waiter if he knew much about the early years of the building. He didn't. The Heritage closed in 1973, the year Tom Waits' first album, *Closing Time*, was released. The only thing the waiter could tell me is that musicians from the early days recently got together to celebrate the coffee house.[32] Waits didn't attend.

Since my visit to Napoleon's Pizza House, Waits' album release rate has slowed. To be exact, he's released only one album since 2006, 2011's *Bad as Me*. It was his sixteenth album and was nominated for a Grammy Award.[33] As one would expect from Waits, the songwriting is stellar, touching on a host of topics and themes—from politics to love and loss. And like most of Waits' work, biblical and spiritual themes are addressed.

In the title song, "Bad as Me," Waits recognizes the depth of evil in the world. And in an extra track, "After You Die," Waits questions life after death. It's a question he doesn't answer within the song. And though *Bad as Me* is not as saturated with Christian themes as previous albums, there's enough to indicate that Waits is still wrestling with deeper, spiritual subjects.

Other writers have addressed the theological themes found within Waits's works. In an article entitled "Theologian of the Dysangelion," Ben Myers writes, "I don't think it's too much of an exaggeration to describe Tom Waits as a theologian—as long as we add that he's a theologian of the dys-angelion, the 'bad news.' His songs conjure up a swirling chaos of monsters and madness, devils and despair—and on the horizon of this dark world we glimpse the first faint glow of dawn, the surprising appearance of grace 'de profundis' (Psalm 130:1)."[34]

Jeff Dunn on the *Internet Monk* writes, "Waits sings about life as he sees it. His world is not pretty or safe. He doesn't pull punches. Why use a nice word when three profanities will do the job so much better? But he is not just whining for whining's sake. Right when you think things can't any worse, God comes breaking through in his lyrics."[35]

32. Jenkins, "44 Years After Closing, Heritage Musicians Muster For MB Hoot."
33. See Recording Academy, "Grammy Awards."
34. Myers, "Tom Waits."
35. Dunn, "Tom Waits and Theology."

And Dr. Dan Van Voorhis describes Waits's music as such: "Waits wants to pen the songs with beautiful melodies and lyrics dark as sin. Whatever his church background, he sings 'the big print giveth, and the small print taketh away.' Waits sees the free cheddar, but he's felt the spring of the trap. He knows that a world that looks like Disneyland is Las Vegas waiting to grow up."[36]

To say the least, Tom Waits has written some amazing music addressing the entire range of human life; spirituality, faith, and religion included. What I appreciate about Waits is that he doesn't appropriate a general transcendence—an elusive spirituality—but hits the nail on the head with specifics—Jesus, the Bible, sin, and salvation. It's nothing or all for Waits.

And like the Bible, Tom Waits's music is a mirror on society and humanity, played out in unique and artistic ways through the themes Waits portrays in his songs. It's like he is saying, "Here, gaze at yourself; this is how you act and look as human beings! A mixed-up group of creatures; a little lower than angels, but not much higher than devils—beauty and ugliness mixed in one."

Yet, the Bible teaches that the Lord can make beauty out of the ugly and Waits portrays it better than most.

And though sitting at Napoleon's Pizza House or the old Heritage Coffee House has provided me only a little insight into the life of the man and his music, there is one thing that is certain: Waits has left a heritage of his own—a biblical view of humanity—warts, wounds, wisdom, and wonder. I hope he continues to do so for years to come. I say, *Sing on, Mr. Waits; sing on.*

Sam Shepard: Meaning in the Madness

I love libraries. So, when Rhonda walked me to the library at the Santa Fe Institute,[37] the stroll morphed into a memorable moment. Sitting in a chair at a desk with a lamp nearby was Pulitzer-winning playwright and Academy-award nominated actor Sam Shepard. Shepard was going through mail.

As we were standing amidst the books, Rhonda, my host, was telling me about the types of works found in the room. A view outside the window looked out to beautiful scenery. A typewriter sat on a desk.

36. Voorhis, "The Gospel According to Tom Waits."

37. Santa Fe Institute is dedicated to complex systems. Pulitzer-winning writer Cormac McCarthy describes SFI as a place where people are "pushing creativity."

Unexpectedly, Rhonda asked, "Brian, have you met Sam, yet?"
"No, I haven't," I replied, trying to sound as if I should have met him.

Rhonda rattled off some information about Shepard's position at the Institute—a Miller Scholar.

I walked over to shake his hand. "Nice to meet you, I'm Brian Nixon."

Shepard looked up from his mail, glasses on the edge of his nose, his eyes inquisitive, searching my face for any type of familiarity.

"Nice to meet you," he said, extending his hand. We shook.

Rhonda continued with the tour, taking me to the back of the library, pointing out books, the fireplace, and some art. Shepard quietly walked out.[38] I stood glazed. Meeting a man whose books I've checked out in libraries was quite surreal.

A few years later, Sam Shepard was dead.[39]

With the death of Sam Shepard, the world lost one of the most engaging playwrights in recent generations. Fortunately, the Pulitzer Prize-winning author left us a prodigious amount of work to read, keeping our minds absorbed with insight into our common humanity, particularly as it relates to familial brokenness.

Born in Fort Sheridan, Illinois, during World War II, Shepard went on to become what *New York Magazine* called "the greatest American playwright of his generation."[40] Both parents were teachers, and when the family moved to Los Angeles county, young Shepard took an interest in music, art, and literature, particularly the work of American playwright Eugene O'Neill and Irish playwright Samuel Beckett.[41]

38. You can watch Sam Shepard at the Santa Fe Institute in the documentary *Shepard and Dark*.

39. Sam Shepard died at his home in Kentucky from complications of Lou Gehrig's disease (amyotrophic lateral sclerosis). He was married twice: O-Lan Jones (divorced 1984) and Academy Award–winning actress Jessica Lange (divorced 2009). He is survived by three children.

40. Westzsteon, "The Genius of Sam Shepard," 23.

41. Winters, *Sam Shepard*, 43.

While attending Duarte High School, Shepard began taking theater classes. Later at the community college he attended, Mt. San Antonio, Shepard began to hone his skills as an actor and writer. Due to relational difficultly with his alcoholic father, Shepard left home.[42] One day he read an announcement in a local newspaper seeking actors for a traveling repertory company. It was Shepard's way out of town. But the repertory wasn't an ordinary one. It was the Bishop's Company Repertory, an acting troupe that received its initial funding from Methodist Bishop Gerald Kennedy, author of the book *I Believe*.[43]

Born in Michigan but raised in California, Gerald Hamilton Kennedy attended the College of the Pacific, the Pacific School of Religion, and Hartford Theological Seminary. After a series of pastoral posts across the country, Kennedy was assigned to the Los Angeles area, becoming a Methodist bishop in the 1950s. Kennedy went on to write over twenty books and the hymn "God of Love and God of Power."[44] It was during his time as both pastor and bishop (something unusual for the Methodist church) that he and founder Phyllis Beardsley Bokar encouraged the young people of the church to engage the community through the arts. Shortly after, the Bishop's Company Repertory was born, with the encouragement to perform "Broadway-caliber productions . . . of spiritual or social significance."[45]

In an early photo of Sam Shepard with the Bishop's Company, the theater group is standing in front of a sign by a Methodist Church. The sign reads "The Great Divorce." Sam Shepard was acting in a production of one of C. S. Lewis's books.[46] Written in 1945, *The Great Divorce* is a novel about Lewis's concepts of heaven and hell. What Shepard intimately thought of his time with the Bishop's Company—or the content of the plays performed—I don't know. However, in his book *Rolling Thunder Logbook*, Shepard gives a glimpse. Shepard writes, "I remember this gypsy life now. It all floods back from days when I was acting in a traveling road show. Doing one-nighters on Protestant church altars. Sleeping in strange families' empty bedrooms. Packing up and heading out again. Just the mobility of it brings the pulse of high adventure."[47] Though I wouldn't call all church services a "road show,"

42. Shepard's father died in New Mexico, struck by a truck in Bernalillo.
43. See "Bishop Gerald Kennedy."
44. "Bishop Gerald Kennedy," 39.
45. Winters, *Sam Shepard*, 50.
46. Winters, *Sam Shepard*, photo section, 3.
47. Shepard, *Rolling Thunder Logbook*, 122.

I admire his exploratory spirit. What is known is that Shepard readily gave credit to the Bishop's Company for his launch into professional theater, mentioning it in interviews and writings.[48]

As the Bishop's Company traveled through New York, Shepard left the company, never to return. New York offered new inspiration. But once again, Shepard connected with a church. After finding an old acquaintance that was living in New York—Charlie Mingus, son of the famous jazz bassist Charles Mingus—the two became involved with a new theatre group meeting at St. Mark's Church-in-the-Bowery. St. Mark's had a long history with the arts, going back to the nineteenth century. But with the hiring of rector Michael Allen in 1963,[49] the church encouraged plays to be staged at St. Mark's, joining religion with art and kick-starting the Off-Off Broadway movement.[50]

Shepard would receive multiple Obie Awards for his plays written for St. Mark's. The first company formed during this time at St. Mark's was called Theater Genesis, founded by director Ralph Cook. And though Theater Genesis was not overtly Christian in its output, the plays were conducted in accordance with a broadly defined social ethic. It was at St. Mark's that Sam Shepard wrote his first two notable plays, *Cowboys* and *Rock Garden*. When questioned about the abusive language—and adult content—in some of Shepard's early works, Rev. Michael Allen stated, in essence, that the language was beside the point, that the play "was really an attack on the pornography of American life."[51] Then Allen privately told Shepard, "One day you will be recognized as America's greatest Christian playwright." Shepard later reflected, "He hoped he was right."[52]

Shepard moved back to California in 1975, becoming the playwright-in-residence at the Magic Theater in San Francisco. It was in San Francisco that Shepard wrote his critically acclaimed *Family Trilogy* plays, *Curse of the*

48. SamShepard.com, "About Sam."

49. Originally a journalist for *Look Magazine*, The Rev. J. C. Michael Allen (1927–2013) was an activist Episcopal priest who considered himself nonreligious before coming to faith under the leadership of progressive clergyman James Albert Pike. After his baptism, Allen attended seminary and was ordained into the Episcopal Church. Allen worked steadily on both social (homeless, AIDS activism, etc.) and artistic outreaches. And more than providing space for budding artists, Allen got involved himself, marching with Martin Luther King, Jr. and visiting Hanoi during the Vietnam War with singer Joan Baez. Allen officiated Shepard's first wedding to O-Lan Jones in 1969.

50. See Bottoms, *Playing Underground*.

51. Winters, *Sam Shepard*, 77.

52. Winters, *Sam Shepard*, 46.

Starving Class, Buried Child, and *True West*. Shepard won the Pulitzer Prize for *Buried Child* in 1979. According to Matthew Roudané, some scholars consider the three plays part of a broader grouping, including *Fool for Love* (1983) and *A Lie of the Mind* (1985).[53]

Many scholars see allusions to the Bible in Shepard's play *True West*, a Cain-and-Abel–type sibling rivalry, but there are also hints in his other works—from his Pulitzer-winning play *Buried Child* to *Curse of the Starving Class*, both of which show spiritually famished characters in need of redemption.[54]

Concerning *Buried Child*, Dr. Seyed Vahdati sees Shepard using religion in a postmodern way, mythic and revealing. According to Vahdati, "Myth of religion is an important myth in *Buried Child* which Shepard tries to subvert by depicting the characters of Halie and Father Dewis. Halie seems to be a religious person. She treats and speaks like a true Christian in the first act. Gradually, we notice that her faith is just a fake and she does not act what she speaks. Religion is a game for both Halie and Father Dewis. Halie seeks refuge to religion in order to escape all her miseries and thoughts. She does not fulfill her duties as a mother. She is like a guest in her home."[55]

Another Shepard play that has biblical overtones is *Kicking a Dead Horse*, a play I saw a few years ago.

Originally written for the Abbey Theater in Dublin, Ireland, in 2007, *Kicking a Dead Horse* follows a man, Hobart, who is stranded in the desert due to the death of his horse. As a former art dealer, Hobart—in an eighty-minute monologue—reviews events in his life: his failing marriage, art, money, and adventure, all while coming to terms with himself and his current predicament.

Throughout the play, a mysterious woman appears and speaks to Hobart—often only heard in his head but at times in person. Though we don't know who she is, one suspects she is representative of his conscience, or maybe an unnamed family member. It's not clear, but this woman inserts herself in Hobart's mind with bits of wisdom, questions, and personal challenges.

53. See Roudané, *The Cambridge Companion to Sam Shepard.*
54. See Bradford, "Themes of Sam Shepard Plays."
55. Vahdati, "The Postmodernist Rendition of Myth in the Selected Plays of Sam Shepard," 253.

The only other person in the play is God, alluded to at a time of trouble through Hobart's prayer. During a storm that Hobart is attempting to avoid, he speaks to God. The result is that God answers the prayer—sort of—with the tent Hobart's trying to erect providing some shelter from the storm.

The overall narrative structure of *Kicking a Dead Horse* begins with Hobart digging a grave for his dead horse and ends with Hobart falling in the grave, with the horse dropping on top of him—resulting in Hobart's death.

Though full of humor, *Kicking a Dead Horse* does cause one to ponder, asking the big questions of life: Why am I here? What have I done with my life? Is there more to life than just making money? What happens when I lose family members and a zest for community, people, and existence? Hobart is asking questions of transcendence and meaning.

Shepard may or may not have meant *Kicking a Dead Horse* to be a treatise on anthropological and theological subjects, but the play surely includes those elements.

Now let me say that Shepard's involvement with Christian theater does not mean he was a believing Christian. I don't know if he was. Much in his life does not match a biblical worldview, particularly his involvement with Armenian spiritual teacher G. I. Gurdjieff. Gurdjieff used "various strains from other religious and philosophical systems."[56] What I do know is that Sam Shepard did touch upon themes of biblical significance in his work, alluding to familial fallout and the reality of sin throughout the corpus of his plays, novels, and poetry. To a certain extent, Shepard did get one thing right in providing a Christian worldview: Sin is a reality. But what is not touched on much in Shepard's work, clearly, is the answer to sin: Redemption.

Maybe Shepard was just a guest in the Christian community, finding inspiration from the church and the Bible as an observer. Or perhaps he was a struggling believer, trying to come to terms with the reality of sin in himself and the world, not wanting to portray a fake faith. Who knows? Only God. What we do know is that Shepard shared with us his vision of a world saturated in strife, a world seeking something beyond itself, trying to find meaning in the madness. My hope is that in the midst of the shattered lives Shepard portrayed on the printed page and on stage, he found peace on the page of his soul, discovering the rest and respite his wandering heart craved.

56. Winters, *Sam Shepard*, 147.

Max Cole: Artist Paints Greek Crosses

The first thing I said to artist Max Cole is that I liked her lines. In other contexts, she might have taken offense. But Ms. Cole knew exactly to what I was referring—her art. The eighty-one-year-old with piercing blue eyes grabbed my hand, smiled, and said, "Thank you so very much." And over the next twenty minutes Max gave me a sweeping overview of her life and work.

Born in 1937 in Kansas, Cole is considered one of the greatest living minimalist artists on the planet. Her work has been featured in most major museums across the globe. She has met with both popes and premiers. But from her perspective, she's nothing more than a "hermit seeking transcendence through art."

After graduating from the University of Arizona in 1964, Cole moved to the Los Angeles area, where she developed as an artist in the burgeoning California art scene. In 1978, she moved to New York, where she lived until 2002, then the Catskill Mountains until 2011. Her most recent move brought her to California, then New Mexico, living, she says, "Where I can walk all day without seeing a car or a person."

In the midst of all these moves, she has exhibited around the world and exudes the life of a pure artist—fixed, firm, and focused on her work, taking little note of the ever-changing fads in contemporary art. With her vertical, horizontal, and diagonal lines painted in beautiful, finely rendered strokes, Max encompasses the deep intellectual and spiritual values of an artist. For those of us who appreciate minimalist art, she's a living legend.

I was pleased to have met Cole at the opening of her exhibit *The Long View*, held at the Charlotte Jackson Fine Art Gallery in Santa Fe, New Mexico.

Before I talked with Cole, I touched base with Charlotte Jackson, a fellow admirer of contemporary art. After I thanked her for the exhibit, Jackson said, "Brian, you're not going to believe this. Max rented a U-Haul, packed her paintings, and drove to Santa Fe from Northern California." I asked, "All by herself?" Charlotte replied, "Yep, all by herself. She's that type of woman. She even chops her own wood." Even before meeting Cole, I was impressed.

After my opening statement about her lines, I asked Cole about the inspiration of the new exhibit—Greek crosses.

"It all began in 1958 with an exhibit I attended as an undergraduate art student. At the exhibit I saw works by Russian Suprematism artist Kazimir Malevich (1879–1935). After seeing some of his crosses and geometric Suprematism art, my course as an artist forever changed. Kazimir Malevich based some of his own work on the Greek Cross in 1915."

What enticed you to Suprematism, I asked. Cole said, "I was attracted to its mysticism, allowing for a spiritual and intellectual quality to come through. Kazimir was able to reduce objects to their essential forms, a modern icon, of sorts."

I ask, were you brought up in a religious family? "Yes. I attended church as a child. This is something my father stressed. I went to many churches. But as influential was the deep spirituality of my grandfather. He was half-Native American and had an abiding love for nature. I'd say I'm religious, but not necessarily traditional in my beliefs."

I asked Max, so, if the transcendental qualities in art appealed to you—particularly the work of Malevich—why the crosses? Max nodded, anticipating my follow-up. "The Greek cross has both an intellectual and spiritual quality to it, as well as an abstract property. I believe one must approach art with humility, and the cross represents that. And more so, I don't use much color in my art, shades of blacks, grays, whites, and browns. For me, color conveys great emotion. And I don't want my ego—my emotions—to get in the way. Emotions aren't as significant as spirituality. And it's spirituality that I seek, a universal approach to art and life."

I mentioned her visit with Pope Benedict in 2009. "Yes. Pope Benedict invited several artists to visit with him in Italy. I was very impressed with him. He has a profound love of art and beauty. After shaking his hand, I said something like, 'Thank you for embracing the spirit of art and the artist.' I think we believe a similar thing: there is something greater than ourselves, and our role is to seek transcendence. Benedict recognized art as a spiritual experience, something I share."

Were you the only artist? I asked. "Oh, no. There were many others—painters, filmmakers, and poets. I was invited by the Vatican to exhibit my work. Mr. Giuseppe Panza, an Italian art aficionado, collected my work. Panza died in 2010 but was instrumental in connecting me to a broader audience in Italy, including the Pope. The whole experience was quite a treat."

I then confirmed that Max's work had been exhibited in several churches. "Yes, I've been fortunate to exhibit in a cathedral in Milan, as well as Cologne, Germany. My exhibit in Milan was in juxtaposition with ancient cruciform pieces. And in Cologne, I did a one-person show at the Cologne Cathedral. I've had an enduring relationship with people in Germany, traveling back and forth often. A book, *To the Line,* was published in Germany, showing my work in the church."

After more discussion about her lines—precise and pristine—someone standing next to me asks how the lines are made. Cole's reply: "I just work hard at it." I sense other people wanting to talk with Max. But before I leave her, she ran to the back and returned with a catalog of her work, alongside the book she referenced. She hands them to me before she's swept away by other admirers.

I turn my attention back to Charlotte Jackson, who walks me over to one of Cole's Greek Cross paintings, pointing out the intricate brush strokes, noting that the display of the "artist's hand at work." Jackson informs me that Cole builds her surface with layers of paint, creating a relief-type surface. I study the lines and exacting work in deep appreciation, mumbling that I've spent years trying to create lines and edges like this in my artwork, but nothing this meticulous. I was especially impressed with three black images. One in particular, *Greek Cross XXIII*, 2016 acrylic on canvas, caught my fancy.

To augment what she's saying, Jackson has her assistant bring me a short article written by Dr. Michaela Kahn. I open the folder and read,

> In 2015—one hundred years after Malevich's painting of the Greek Cross, Max Cole was invited to participate in a portfolio of prints honoring Malevich's "*Black Square.*" Cole made a print based on Malevich's "*Greek Cross,*" which had inspired her and served as a leaping off point for her own work back when she was an art student. It felt like a natural step to return to her beginnings and revisit the form—honoring both his work and coming full circle with her own.
>
> Geometrically, the Greek Cross is a square cut into thirds both horizontally and vertically—creating a perfect equilibrium of form. Each of Cole's paintings is on a square format. The cross form is sometimes quite clear—for example, a bold black form bisecting the canvas vertically and horizontally. In other instances, however, the form is only implied—black blocks hovering above and below a gray band, bands of black ghosting

beneath an over-layer of white. In addition to Cole's signature use of minute, intricate hand-drawn vertical lines, she also uses areas of thick paint with various surface textures. These layered areas work architecturally to create additional lines of light and shadows across the canvas.

Cole's work, though based on the geometry of the Greek Cross and Malevich's original, upsets the inherent equilibrium of the form by gently distorting its perfect symmetry, creating tension. As with Cole's horizontal band pieces, the strain between vertical and horizontal are here resolved in an intuitive and visceral balancing of tensions rather than in a perfecting of the form itself . . .

Each piece, with its delicate balance and aura of calm focus, works its slow magic upon the viewer: Drawing in, reaching out. Quieting the mind until the viewer is able to breathe in the rhythm of the painting, to feel the essence, the solitude and poise, that exists behind each brushstroke.[57]

Wonderful summary Dr. Khan provides, I muse.

I later look through books Cole and Jackson gifted me. I marvel at the lines; the dedication and time it must take to render line after line—in small and large fashion—is breathtaking. It's a meditative practice: stroke upon stroke. Furthermore, there's something profound about art that draws one in, and helps one to reach out, as Kahn infers above. It reminds me of love. Love draws you in and causes you to reach out in love to others. Max Cole's art has that effect; it pulls you in and affords you an opportunity to tell others about it: line upon line elicits love upon love.

Robert Redford and N. Scott Momaday: Earth Dialogues[58]

I enjoy the experience of watching something transform before my eyes into an occasion akin to a fine theater performance, where all the contributors assume a role, giving the moment depth and deep human interest.

57. Kahn, "Max Cole." Used with permission.

58. A version of this article was first published in *The Green Fire Times*, February 2018.

With the CONNEXT event held at the St. Francis Auditorium in Santa Fe, New Mexico we had just this: a grand expression under the name *Earth Dialogues*.

The leading roles were played by Oscar-winning actor and director Robert Redford, Pulitzer-prize–winning author N. Scott Momaday, and director, actress, and CONNEXT co-founder Jill Momaday, N. Scott's daughter. All three loom large, respected people in their given fields. When Redford came over to say hello to the press, I couldn't help but think The Sundance Kid looks pretty good for being in his eighties.

But it was the supporting cast—the 450 plus people that gathered at the sold-out event—that gave the evening breath. The one thing this cast of characters had in common was that we were standing on the same stage: planet Earth. If there was one real star of the evening, it was she.

With the characters cast for the evening in place, the real performance began. One might think of *Earth Dialogues* as a two-act play. Act one consisted of a spoken-word piece written by Momaday and Redford, first performed a few weeks prior at Carnegie Hall. Act two comprised a question and answer session hosted by Jill. Both acts provided deep thought, but more importantly, practical action points for the pursuit of community, creativity, and environmental conservancy.

Act I

The spoken-word dialogue was originally part of a larger multi-disciplinary piece called *The Way of the Rain*, conceived by artist Sibylle Szaggars Redford, Robert Redford's wife. *The Way of the Rain* illustrates "crucial environmental dilemmas through performance art."[59]

With murals in the Saint Francis Auditorium by the Portuguese American artist Carlos Vierra acting as a backdrop to the reading—showing a confluence of faith, culture, and nature, Momaday reminded those of us gathered that we were meeting in Santa Fe, "the city of holy faith." The dialogue lasted roughly twenty-five minutes in a call-and-response format between Redford and Momaday.

59. See "The Way of the Rain: A Live Multidisciplinary Performance."

Ideas highlighted in Momaday's monologue included "the harmony of na-
ture," "beauty," and the "destruction of nature," possibly leading to "extinc-
tion." Questions were asked: "What is our responsibility?" Some answers
were provided: live in harmony with humanity and nature, pursue humility
with the earth, and reverse our history with the environment by seeking
to heal and not to harm. Redford interjected, "Nature is our brother, an
essential part of our existence."

The reading was both poetic and practical, providing moments of contem-
plation and consideration for further thought. The moral could be summed
up as follows: People must assume the responsibility to care for the earth,
because the earth is sacred and in need of specific attention.

Act II

Act II consisted of questions posed by Jill Momaday. The first was, "When
did you become aware of the vastness of the universe?" Redford responded
by telling a story about when he was three years old riding a tricycle around
his Los Angeles neighborhood. His parents gave him the boundaries in
which he could ride. While riding, he'd go far enough so his tire went just
beyond the boundary. He learned at a young age the world is vast, beyond
his imagination. Later, he'd stare at the stars, asking "Where am I in this?"

For Momaday, it was seeing the stars while living on the Navajo reservation.
He remembers hearing the Navajo ceremonies, surrounded by fires. On a
particular night he was struck by the vastness of the night and the immen-
sity of the universe.

The second question was, "What inspired you to become an artist?" Moma-
day talked about his family. His mother was a writer, and his father an artist.
He wanted to be like them. Early, he gravitated toward writing, but later
picked up art while teaching abroad in Russia. In the loneliness of a differing
culture, Momaday learned art could console.

For Redford, it began in third grade. His teacher quickly learned he'd bore
easily. So, the teacher gave him creative tasks, allowing him to draw out his
ideas. As Redford stated, "In a way she saved me. She gave me life. From her
I learned art is essential."

After some comments about a common love of horses between the two men, Jill's next question was, "What qualities do you look for in creative endeavors, and how do you choose your projects?" Redford was specific: one, a good story; two, characterization; and three, the story conveys emotion. Picking up on the importance of story, Momaday elaborated on the significance of narrative, likening it to a story of which all humans are a part, a quest for something or someone that has been with us since the beginning of time. Momaday alluded to the biblical story of Adam and Eve.

The final question revolved around the love of nature and the environment. For Redford his love of nature derived from a trip he took to Yosemite—after a minor bout with polio—and later working at the park during summer months for three years. He said, "I don't want to just look at nature, I want to be in it." And Momaday shared an experience on the Jemez reservation that captured his respect and awe of nature.

Finally, when asked what people can do to offset the environmental trials faced on Earth, the answers were as engaging as well. Redford said, "Don't let technology rule our lives. Instead go out and engage in nature, experience it. With knowledge comes respect." Redford also felt the polarization within our country and world has been demoralizing. His hope was that people can come together to stand for something that is important to us all—the very ground we walk upon. Momaday thought the deadliest factor facing earth is pollution, the corruption of the earth: from plastic in the oceans to the smog in the atmosphere.

With that, the *Earth Dialogues* came to a completion. But the performance is not over. It requires a finale—you and me.

Finale

I gleaned a few items from the event, a culmination to the performance. My walk-away points were as follows:

Community: Community matters. With people gathered from various places to learn about the artists and earth, a community communed, conversed, and connected around a certain cause—the environment. When properly conducted with respect and understanding, community is compelling, acting as an allure for others to join the conversation. The *Earth Dialogues* did just this.

Creativity: Creativity is a key to the environmental crises. Sometimes a creative dialogue goes further than brute facts. With humor, poetic insight, and personal testimony, the *Earth Dialogues* helped put a face to the facts concerning the destruction of the earth, affording us to hear from the soul of people impassioned by the cause.

Call to action: It's not just information that is needed today; it's transformation. We need to articulate and act, know and go, digest and do, read and repair. Action must follow the accumulation of knowledge. We must enact the impulse and work for change. On a personal level, I've yet to regret switching our household energy to solar, our lawn to xeriscape, ramping up our recycling program, and finding other cost—and earth-efficient means—to be a good guardian of creation. Individual actions affect our community and world. The challenge provided by Momaday and Redford will hopefully help put my feet on firmer ground. After all, when we see creation repair as part of our calling as citizens on earth, we'll find that stewardship is a type of prayer with care.

After the *Earth Dialogues*, I found myself asking a larger question: How is a Christian to respond to the environment, the prevalent theme discussed?

To help answer this question I turned to Christian thinker Francis Schaeffer. In his book, *Pollution and the Death of Man*, Schaeffer gives fascinating insight into the role of humanity and the demise of our planet, asking, "How did we get to this point? And where should we go from here?"

For Schaeffer, the answer to the ecological problem is not to see nature as God, but as a gift from God, to be tended, cared for, and respected. Schaeffer wrote, "It is the biblical view of nature that gives nature a value in itself; not to be used merely as a weapon or argument in apologetics, but of value in itself because God made it."[60] Schaeffer notes the reality of the fall: people sinned, wreaking havoc on Earth. Because of the fall, a problem was manifest, one that needed a solution.

Later in the book, Schaeffer brings us to the solution of sin, and consequently, the ecological problem: Christ. For Schaeffer, Christ brought redemption to all creation: humans and nature. For Schaeffer, Christians should work to bring healing and restoration to both, working as stewards of God's creation and working as participants in Christ's kingdom. The two-go hand in hand.

60. Schaeffer, *Pollution and the Death of Man*, 47.

As a Christian, I must recognize that nature—including humankind—is not the complete answer to the environmental problems facing the world. Christ is—working in and through people. Christ's continual work of building his kingdom "on earth as it is in heaven" is the Great Solution. And as a Christian I must be a co-laborer in the efforts to restore that which God called "good."[61] It is a walk of obedience to his kingdom. True, one day a new heaven and earth will stand,[62] but we must do our part to walk faithfully and fruitfully until that day comes.

When we do, then, as far as the environment is concerned, our aim is the same as that of the environmentalist: concern, stewardship, and protection of the Earth. For in the beginning, God said that it was good. If it is good enough for God, it is for me.

We're on the same planet—people, animals, plants, ecosystems—all of nature. Let's ride it with care, recognizing its beauty, its relationship to ourselves, and its source: our gracious God. As John Muir reminds us, "Oh, these vast, calm, measureless mountain days, days in whose light everything seems equally divine, opening a thousand windows to show us God."[63] I'm glad Redford and Momaday gave me a glimpse of God's handiwork in the world, a window to remind me of his loving attention.

Warner Hutchison: Discovering a Treasure

As a kid, I loved treasure maps. I studied maps, looking for routes to where X marked the spot, the place where untold adventures awaited, and treasures abounded. Not much has changed for me as an adult: I still seek out treasures. But unlike the fictional maps of my childhood, I look for cultural treasures in the form of people. I've recently discovered one of those treasures: composer Warner Hutchison, PhD.

How I met him is a story worth telling.

During a church service in New Mexico, a lady fainted after a service. She was carted off to a side room; I was there to provide a presence for the

61. See Genesis 1.
62. See Revelation 21–22.
63. Muir, *My First Summer in the Sierra*.

paramedics. As it turned out, the lady was from a local retirement community. She turned out to be fine.

While I was waiting for the paramedics to complete her health checks, a few of the other residents stood around, watching the events transpire. Their director introduced me to a few of them.

The first person introduced to me was a musician.

"Brian, I'd like you to meet Warner. He's a musician just like you," the man said.

"Nice to meet you," I replied. "What instrument do you play?"

"Well," Warner began, "I used to play French horn, but mostly I compose now."

A light went on in my head. "Composition?" I asked.

"Yes. I was department chair at New Mexico State University and resident composer," came the answer, somewhat humbly.

"Is your music available online?" I followed.

"Oh, yes," he said with a smile.

Therein lay the map: the quest to discover the music of Warner Hutchison.

I enjoyed a brief chat with Dr. Hutchison, though as soon as he left, I quickly headed off to a computer to look for his music, which was an uncharted domain for me. Lo and behold, there were dozens of pieces, several CDs, and multiple sites discussing his work.

I had discovered a treasure!

I ordered some CDs; *Apocalypse I* and *Apocalypse V* were the first to arrive. I was smitten on first listen. I made a point to visit Warner at the retirement community. We began a long, enriching friendship.

Hutchison (b. 1930) began his musical journey at age seventeen as a horn player and composer in his hometown of Denver. After a brief stint as a

church musician, Hutchison went on staff at Houghton College in New York. It was during his years at Houghton that he met and studied with Roy Harris. Harris is linked to the larger Lost Generation of composers, Aaron Copland and Samuel Barber. Harris's *Symphony No. 3* (1939) is considered one of the great American musical works.

Concerning his upbringing, Hutchison told me he was nurtured "in the evangelical, dispensational, and even fundamental faith." Yet, Warner's compositions encompass a far-reaching biblical worldview unlike any other evangelical composer I know of.

In 1967 Hutchison was hired at New Mexico State University as the French horn teacher. Later promoted to department chair, he remained at NMSU for the remainder of his career as the composer-in-residence. Warner has written over 270 works since 1949, many of which adhere to Christian themes.

During one of our visits, I ask Hutchison about the composers that influenced his writing.

"There are so many composers I'm indebted to. But the first that comes to mind is Krzysztof Penderecki. I gleaned from his ideas and methodology. He was one of the first composers I was listening to that introduced new tonalities to me. Historically, I appreciated Charles Ives. Many thought Ives and his father, George, were nuts. Ives's father used to have two bands play in two different keys at the same time, stretching the bounds of harmony. Charles later picked up on his father's experimentation and helped define a uniquely modern, American musical sound.

"I also was impressed with Milton Babbit. He had an incredible mind; he remembered everything. I met Babbit at a conference for composers, I think at MIT. After meeting him, he was able to rattle off my compositions, stating the date and name. I was thunderstruck. I haven't met someone quite like him.

"Back in the late 1960s and early 1970s, many of us American composers were influenced by the music and life of Estonian composer, Arvo Pärt. I was very interested in Part, particularly because he was a Christian. He was part of the 'Holy Trinity' of composers: Pärt, John Tavener, and Henryk Gorecki. Pärt was monk-like in his life and musical compositions. Early on, he never toured America because he was under the Communist bloc, but we got wind of his music through other connections. I also met Aaron

Copland. After Copland conducted a concert in upstate New York, we chatted some. I have great admiration for his compositions and orchestration."

What about your compositional teachers?

"Samuel Adler was my teacher in Texas. Adler was born in Germany, but his family came to the US when he was young. Adler's father was a cantor in a synagogue on the East Coast, where Adler's sister taught Samuel the piano. Adler got advanced degrees from Harvard. He has published hundreds of compositions, many of which helped define my personal voice in music. But let me say, he was a tough instructor at the University of North Texas. Sadly, the climate at the time was anti-Jewish, so some resisted Adler coming to the college. But others persisted. I, for one, was glad he came. Of all my composition teachers, he was direct in his opinions and insights into music, some would say mean. One time I remember him taking one of the compositions a fellow student wrote. After playing it through, he looked at the student and said, 'This is [expletive], why don't you take this home and rewrite it.'

"But, my respect for Adler was great. While in the army, Adler organized a symphony orchestra that toured various locations. After his tenure in Texas, he left for Eastman School of Music in New York, then the Juilliard School of Music, where he became a noted composition teacher. I think he's still composing today; he's only a few years older than me, late eighties, I think.

"And of course, there's Roy Harris. But much has been written about him."

I asked Warner when he was introduced to avant-garde music.

"I sort of found avant-garde music myself. I was fascinated by the sounds and the way the composers notated the music. It was like art. But none of my composition teachers were promoting avant-garde music, per se; some were rejecting it all together. But in the 1960s, I began to listen to a handful of composers: Krzysztof Penderecki, John Cage, Terry Riley, and the like. A composer named Merrill Ellis familiarized me to the use of synthesizers in art music. Ellis was an experimental music composer and researcher. He was one of my instructors at North Texas, pushing my understanding of music in new directions. He was the first person to introduce to me the Moog synthesizer. Shortly after, I began to write electronic music into my compositions.

"George Crumb had a strong influence over me in some of my most significant works especially my *Mass for Abraham Lincoln* (for prepared piano, two performers, and tape background). He was a totally unique composer. I became fascinated by his stark, mysterious compositions including *Black Angels, Electric (amplified) String Quartet*, and *Echoes For Time And The River* for orchestra and other works.

"There are many other composers that I found intriguing, Olivier Messiaen, being one. From Messiaen I learned more about the musical sonorities coming from Europe, incorporating them within my own compositions. Messiaen was a Catholic mystic, so many of his works relied on Christian themes, albeit with a mystical twist."

A treasure chest of information, I thought to myself.

I followed up with a question about *Mass For Abraham Lincoln*. "Why did you choose to write a piece about Abraham Lincoln?"

Warner smiled. "Lincoln has always been my favorite president. As an eight-year-old boy I played Lincoln in a school play, reciting the Emancipation Proclamation in full costume, including the stovepipe hat.

"Beyond that, I've been drawn to the courage of the man. America was in a bad place during the Civil War; we were a divided nation. It took valor and great nerve to stand for what was right, in this case the end of slavery. Furthermore, I wanted to focus on the end of his life in my composition. In a sense, his murder was the beginning of new life for so many people. Lincoln represented what is great about America. Because of my interest in Abraham Lincoln and his impact on the United States, I chose him as my theme. I wanted to produce a piece that began with the assassination and the aftermath of his death—a dark moment in US history. I think I gave them more than what they bargained for."

"When did you write the work?" I asked.

"I started in 1974, ending in 1975. I received a grant to compose the work at The MacDowell Colony in New Hampshire. The Colony is one of the oldest artist colonies in the United States, allowing writers, playwrights, poets, and composers to carve out time to create. Each artist lives in a separate cabin in the countryside. I had a cabin on the 200-acre property just to myself. I had a piano and composition paper. It was a wonderful experience."

I pointed out that the piece is dark and very modern, verging on avant-garde. "What influenced your style of music?"

"It's funny you ask that, because at the MacDowell Colony I put screws, bolts, and other objects into the piano to get an ethereal sound that I was looking for. When you play on the keys you get a very interesting, quasi-percussion sounds. This type of manipulation of the piano is called a prepared piano. Additionally, I added recorded segments. The speeches of Abraham Lincoln are on a tape that plays behind the composers.

"Overall, I've been influenced by many steams of twentieth century modern music: twelve-tone, minimalism, electronic, and the like. Modern music in the US started with Charles Ives's unorthodox approach. European composers, including Arnold Schoenberg, abandoned traditional major-minor tonality and chose very dissonant melodies and harmonies.

"The *Requiem Mass of Abraham Lincoln* is aleatoric. Meaning that it does not have any designated key, there is no stable tonality. It feels spontaneous, dark, and dense. Though it is written out in musical notation, it feels improvised.

"It is a very heavy composition—we'd say dissonant. I wanted to capture the darkness that was cast over the US, and the confusion and dismay that Lincoln's death caused, in addition to the death manifest in the Civil War itself."

I notice the music score for *Requiem Mass of Abraham Lincoln* is very visual. It has a shape of a cross, triangle, and circle. "Why the shapes?"

"I'm a visual person. I like to have a visual presence with my music, both on stage and on the page of the score. One of the first composers to use visual notation was American composer, George Crumb. He symbolically laid out his music notation to represent a greater theme found within the music. This is sort of what e e cummings did with his poetry. I used visual notation with my *Requiem Mass*. I put in a cross—representing Lincoln's death and his faith, as well as other symbols to express the totality of the music. It's part of the art."

I notice in your notes on the score that it calls for the performers to dress in medieval robes as well as a cross-illuminated structure with lights. What's this about?

"As mentioned, I'm a visual person. The *Requiem Mass of Abraham Lincoln* is a staged piece. I've written several works like this. I'm affected by the visual components on stage. The combination of voice, movement, and action is fascinating to me. I really enjoy seeing musicians perform, both musically and through movement on the stage. For the *Requiem*, I had the two pianists do more than just play piano; they chanted the movements of the Mass as well as dressed the part—in robes.

"The lighted cross was an addition to drive home the Christian theme of the *Requiem*. The whole experience caused one lady in the audience to scream and walk out of the performance. Her outburst was totally unexpected. It was overwhelming for her. But the show went on," he concluded with a laugh.

How many movements are there in the piece? I ask.

"The *Requiem Mass of Abraham Lincoln* follows—to a certain degree—the traditional form of the Catholic Mass. In all, it has eight movements: an intro, *Kyrie, Tractus, Dies Irae, Lacrimosa, Sanctus-Benedictus, Agnus Dei*, and the *Requiescat*. These are all Latin terms. For my piece, I used subtitles to give them a little more connection to Lincoln's life. Take for instance the *Kyrie*. I called it "Freedom Versus Slavery." And the *Lacrimosa* I called "The Aftermath of War."

I notice that the time frame in which you were writing the *Requiem Mass of Abraham Lincoln*—mid 1970s—was at the end of a volatile time in US history—Kennedy was killed a few years earlier, then Martin Luther King Jr. was murdered, and political and social unrest were widespread. Were there any thoughts or connection of your piece, written about Lincoln's death almost a century earlier, to the modern problems facing the world when you wrote it in 1974?

Hutchison thought for a moment. "I hadn't thought of that, but I think this is very true."

Treasures abound in Hutchinson's life, I thought to myself.

The *Requiem Mass of Abraham Lincoln* isn't Hutchison's only mass. He also composed one in 1992. I ask him about it.

"The *Mass*," Hutchison stated, "is a composition that is roughly thirty-four minutes long and uses the Latin text of the Ordinary Mass: *Kyrie, Gloria, Credo, Sanctus,* and *Angus Dei*."

Why did you choose to write in a mass form—as opposed to other musical styles? I ask.

"I had often wanted to write music for a mass because it contains so many deep praises to God and stimulates the hearts of believers. Additionally, it has a musical heritage that spans centuries. So, I supposed you could say it was for heart and historical reasons."

How did the *Mass (1992)* come about? What inspired you in its composition, I continue?

"I was approached by my colleagues to compose a piece for them. The mass seemed like a natural fit. I was looking for something that was powerful and cherished. The mass is both grand and intimate, and at the time showcased our wonderful choir. And when I'm able to highlight biblical themes in a public setting, the mass became the obvious choice."

You wrote the *Mass (1992)* for a symphonic wind ensemble, which has between thirty and forty players. Why did you choose this orchestration over a more traditional format?

"When thinking about the composition, I felt that I needed to pave a new path forward with the piece. I decided upon the symphonic wind ensemble because it was very complementary to the university choir at NMSU, led by J. A. Alt—who incidentally conducted the piece during its world premiere. I enjoy the unique tonality of a wind ensemble, it offered strength, but also the texture I was looking for."

What do the five parts of the mass mean, and why are they important to the church service?

"The five parts of the Ordinary Mass are: the *Kyrie* which means, 'Lord have mercy; Christ have mercy.' Traditionally, the *Kyrie* was recited by the congregation as part of the worship service, providing congregational participation. The *Gloria* means, 'Glory to God in the highest.' The *Credo* means, 'I believe in one God.' The *Sanctus* means, 'Holy, Holy, Holy.' And finally, the *Agnus Dei* is translated as the 'Lamb of God.' These are important because

they lead people toward Christ, highlighting various attributes of God's nature. And as I pointed out already, there is a long, illustrious tradition of composers—both Roman Catholic and Protestant (of which I am one)—writing masses. I yearned to put my own stamp on the honored tradition."

As the composer of *Mass (1992)*, are there any standout moments for you in the piece?

"Compositions are like children; you love them all. But the standout sections for me are the *Gloria* and *Sanctus*. Not only do I love to celebrate God's glory, but also his holiness. Musically, there are some moving sections in the *Gloria* and *Sanctus* that make them personal and inspiring. I still listen to them with delight. I thank God that I was allowed to compose this particular piece of music."

During my many visits with Hutchinson, I sat with him listening to his splendid works, watching as he flipped through scores, following along with recorded piece. I thought to myself, *I'm sitting with a marvelous musical mind, one passionate about composition and God—a true artist.*

The routes on Hutchison's musical map are quite impressive. Upon repeat listening, score studies, and continual conversations with the composer, I've come to the conclusion that his music is embedded with same nature as the great composers of our time, fashioning a world of sound, ideas, and nuance that is uniquely American and modern.

One thing I have learned in my quest to understand the music—and the man—it is that his treasure chest is full of gems and precious metals, music of abiding worth. Quoting Jesus, Saint Ambrose said, "Where a man's heart is, there is his treasure also." Hutchison showed me that his treasures runs deep, to the conduit of Christ. Hutchinson's treasure is his trust in God, as expressed through his music. And this musical treasure is not to be hoarded but heralded.

With Hutchison, I'm finding my way to the X on his musical atlas—and I hope to continue to enjoy the treasures of Dr. Hutchison's music for years to come. We do well to bask in the light of composers like Warner Hutchison, listening for the subtle and profound ways Christ continues to speak though creativity in the world today.

William Stafford: Listening to the Leaves

Time, always almost ready
to happen, leans over our shoulder reading
the headlines for something not there.

These lines from William Stafford's poem "Reading the Big Weather" weigh on me. They remind me of the subtle power of the man's work, not only as a poet but as an instructor on the art of teaching and writing, and perhaps most importantly, his resilient stance as a Christian pacifist. They also force me to recall the time I missed out on meeting Stafford in person.

My first personal encounter with William Stafford came at the 1991 Annual Conference of the Church of the Brethren, held in Portland, Oregon. The theme that year was "Behold! The Wonder of God's Presence."

I drove up from California with my pastor, Jeff Neuman-Lee. Later, we connected with another friend, Isaak Dockter. Isaak and I camped just north of the city. Together, we drove into Portland daily to hear lectures on a variety of topics: peace, justice, Native American issues, and most importantly, how to follow Jesus.

Memories of my time listening to artists, storytellers, theologians, and musicians are vivid. However, in hindsight, it was at this conference that I had one of my great disappointments: not meeting William Stafford.

As an impressionable college student, I looked over the plethora of lectures and saw one called "Poetry Reading: William Stafford." This sounded great, but other sessions appealed as well. I finally decided upon a folk group concert instead (I was into music). Imagine that! I chose a now-forgotten folk group over William Stafford.

I sat at the concert and listened, unimpressed—mainly because I knew I should be at the Stafford reading. Something nagged at me, a still, small insistence that he was important—"*a weather of things that happen too faint for the headlines, but tremendous . . .*" Finally, I jumped up and ran over to the room where Stafford was reading.

The room was packed, so I decided to sit outside, listening to the final few poems and commentary. To this day, I don't remember which poems he

finished his reading with. And even more disappointing, I didn't look into the room to see Mr. Stafford reading his work.

Had I looked around the corner, I would have seen the poet that, over the next twenty-eight years of my life, would bring me pleasure and thought, someone I would turn to over and over again.

Born William Edgar Stafford on January 17, 1914, Stafford spent most of his life in the academic world, both as a student (receiving a BA, MA, and PhD) and teacher (teaching the longest at Lewis and Clark College in Oregon). As poetry consultant to the United States Congress (a position now called Poet Laureate), Stafford's own work was late to the publishing world. It wasn't until his mid-forties that his poems took root in American literary circles, and not until 1963—at the age of forty-eight—did *Traveling Through the Dark* take home the prestigious National Book Award for poetry.

To make up for my mistake of not getting his book *Scripture of Leaves* at the Brethren conference, I called Brethren Press a couple years later to see if they had it. To my great surprise, they had a copy—and even better, it was one of the last signed editions. It now sits prominently on my shelf.

I now collect William Stafford books. Since that first great purchase, I have found many treasures. My favorite is a first edition signed copy of *Traveling Through the Dark* (a collector's dream).

Stafford went on to write dozens of books, following a daily ritual of writing early in the morning. He kept a regular journal for fifty years, composing over 20,000 poems, 3,000 or so which have been published. Likewise, he travelled across the country teaching people the art of finding their voice by putting thoughts on paper. As a poet and teacher, he is remembered.

Yet to many, it was his personal life that mattered most. As a conscientious objector, working for the Church of the Brethren during World War II, Stafford stood at the forefront of people yearning for reconciliation and peace in the midst of a world ravenous for conflict and war.

As a member of an unusual class of Christian American poets dedicated to peace (William Everson, aka Brother Antoninus, being another) that came out of the World War II conscientious objector camps, Stafford first discussed his Christian peace stance in the book *Down in My Heart* (1948). It stands as his only prose treatise on living beyond the American psyche of war.

Through all my collecting and book searching, I have found Stafford, through his poetry, to be a gentle reminder that there is another way of living. And as Christians, we do, indeed, look for another world instead: the coming of God's kingdom, the establishment of his world, a dream that is a yet unseen reality. *"This world we are riding keeps trying to tell us something . . ."*

So, until that day of God's consummated kingdom, we abide, live, and work for building the kingdom on earth as it is in heaven. And somehow William Stafford knew this. In his poem, "Reading The Big Weather" (found in *Scripture of Leaves*), he summarized the tension of living for the Kingdom and waiting for the Kingdom:

Reading The Big Weather[64]

Mornings we see our breath. Weeds
sturdy for winter are waiting down
by the tracks. Birds, high and silent,
pass almost invisible over town.

Time, always almost ready
to happen, leans over our shoulders reading
the headlines for something not there. "Republicans
Control Congress"—the year spins on unheeding.

The moon drops back toward the sun, a sickle
gone faint in the dawn: there is a weather
of things that happen too faint for headlines,
but tremendous, like willows touching the river.
This earth we are riding keeps trying to tell us
something with its continuous scripture of leaves.

Frederick Hammersley: Transcendent Art

Somewhere along the way, I became an admirer of the artwork of Frederick Hammersley.

64. "Reading the Big Weather" taken from *A Scripture of Leaves*, by William Stafford, copyright © 1989, 1999 Brethren Press, Elgin, Illinois. Used with permission.

Maybe my fascination began in high school in San Jose, where I was introduced to the artist by the California Arts Council in an Artist-In-Residence program. I had two art teachers—Glen Rogers Perrotto and Betty Bates. They introduced me to Hard-edge painting, a distinctly California-based art, and hence Frederick Hammersley, one of the architects of the style.

Or maybe my interest in Hammersley began in college, at California State University, Stanislaus, where I studied art history. I learned more about Hard-edge painting, whose vanguard was the California Classicists, as they were called. Here I discovered that the movement began in Southern California through the similar styles of five artists: John McLaughlin (1898–1976), Lorser Feitelson (1898–1978), Feitelson's wife Helen Lundeberg (1908–1999), Karl Benjamin (1925–2012), and Frederick Hammersley (1919–2009).

Los Angeles Times art critic Jules Langsner coined the term Hard-edge. Langsner noticed artists from California implemented a broad use of color, strong edges, and non-objective renderings of geometrical shape and movement. A subspecies of abstraction was born. Langsner wrote about the movement, including Hammersley in his writings.

Who is Hammersley? A short word will do.

Born in Salt Lake City, Hammersley became one of the leading abstract, Hard-edge artists. After school in California and France, service in the military during World War II, and teaching, Hammersley relocated to New Mexico in 1968, first as an instructor at the University of New Mexico and then as an independent, full-time artist. He died in Albuquerque at the age of ninety. Since his death, Hammersley has fast become one of most-studied west coast artists due to his work in various fields—realism, abstract, computer, and printing—and his meticulous, almost scientific handwritten notes.

To get a better sense of the man, I made an appointment with the Frederick Hammersley Foundation to tour Hammersley's Albuquerque home-studio. And though it was the artist's work I longed to see, it was the house that captivated me.

Administrative Director Nancy Zastudil greeted me at the door. She showed me around the house and offered insight into Hammersley's life. I'll forego a detailed description of my tour, but here are ten things that caught my attention:

1. The humble three-bedroom home, bought for $18,000 in 1968, acted as both Hammersley's living quarters and studio.

2. Hammersley worked in a small room (perhaps what was originally the dining room off the kitchen) adjacent to a north window. One of the paintings he was working on when he died was on the easel, brushes and paints largely kept as he left them.

3. One room serves as art storage, keeping both the artist's and some of his father's art. Hammersley's father was an amateur painter; his self-portrait leaned against a wall in one storage area.

4. Hammersley's kitchen was painted with clouds, something Zastudil told me he painted himself.

5. The bathroom was wallpapered with a black-and-white checkerboard pattern—again, a Hammersley original.

6. There were several of Hammersley's paintings, photographs, and prints on the walls. The lithograph prints were much smaller than I had imagined (3x3 inches). To learn the lithographs were completed in 1949/1950 was a revelation. With a Pop sensibility, they were a decade ahead of the Pop phenomena that would come out of New York in the 1960s.

7. The books on the shelf were of interest, ranging from classics to the Bible.

8. Some of the family photos on a wall outside what used to be his bedroom showed Hammersley with an elephant, telling me his family might have traveled overseas.

9. The front entryway was red tiled, with simple furniture and a wooden bamboo chair in the corner, a walking cane hanging from the back. The same hand that painted great modern masterpieces is the same hand that used a walking cane later in life. Sadly, Hammersley died due to complications from a fall he took at ninety.

10. Many of the oil paints used by Hammersley were the same brand used by fellow New Mexico artist Georgia O'Keeffe. As I studied Hammersley's painting boxes, several unique items caught my attention: a golf ball, a pocketknife, matches, and a comb, among the normal tools of the profession.

To say the least, wandering an artist's home is a fascinating treat. But my interest in Hammersley goes beyond where he lived. As one who studies the intersection of philosophical transcendentals (unity, truth, beauty, and goodness) within education and culture, I have found Hammersley's art

a fine representation of the four transcendentals. It gives us insight into what he believed.

A quick word on the transcendentals.

The transcendentals are a sub-category in philosophy that corresponds to existence; they deal with ontology, the study of being. Though unified in theology, modernism has dissected the transcendentals into science (truth), beauty (aesthetics), and religion (goodness). But this is a simplification; historically, they were conjoined properties of being.

All cultures have dealt with the transcendentals on one level or another. In the West, Plato, Pythagoras, Socrates, and Aristotle all had something to say about the transcendentals. During the first century, the Apostle Paul interwove the transcendentals into a broader fabric, best seen in his letter to the Philippians, at 4:8. In the Middle Ages, thinkers such as Plotinus, Pseudo-Dionysius, and Augustine weighed in. But it was Thomas Aquinas, and later Immanuel Kant, who helped shape a modern understanding of them as both an objective reality and a subjective experience.

When the transcendentals are used as a framework to study Hammersley's work, the four areas act as an outline toward a broader understanding of his art. As a concise overview, here are some thoughts.

Truth. According to one theory, truth is that which corresponds to reality. At times, numbers and geometry represent the purest form of reality, coming closest to describing physical truth with the least variation (though not perfect, as logician Kurt Gödel demonstrated). As I mentioned, Hammersley was a painstaking note-taker and artist, writing down every aspect of his process. As such, his work could be seen as scientific (something noted by the Getty Research Institute[65]).

Additionally, he was the master of the line: pure, even, and precise. When you add his use of computer-generated numbers, geometrical and organic shapes, meticulous painting, and precise use of color, truth undergirds his artwork. Or said another way, the truth of his lines, color, and forms correspond to reality; they are an aspect of being. Hammersley's work is true.

65. Getty Research Institute, "Frederick Hammersley Archive."

Beauty. It was Augustine who said, "The eyes delight in beautiful shapes of different sorts and bright and attractive colors."[66] And Aquinas stated, "A thing is called beautiful when the mere apprehension of it gives us pleasure."[67] With these three basic understandings of beauty—shape, color, and pleasure—Hammersley's work clearly is beautiful, providing the senses pleasure with fantastic forms and color.

Furthermore, Aquinas believed that beauty held certain properties. These properties were *proportion, integrity,* and *clarity.* Other interpreters have translated the words as wholeness, harmony, and splendor. And yet another variation describes them as form, radiance, and order. Whatever the translation, Hammersley's work is consumed with proportion, integrity, and clarity, offering insight into form and color with splendid radiance. As such, his work is beautiful.

Beauty was a quality Hammersley took to heart. A lecturer I once heard noted that Hammersley often cried when he saw or experienced something beautiful.[68]

Goodness. Maybe a little more difficult to describe within the artwork of Hammersley, goodness is still definitely present. According to Aquinas, "goodness adds to being a certain reality."[69] Goodness is connected to beauty, as it is to truth—a reality of its existence. So, if an object is true and beautiful, if follows that it has properties of goodness as well.

Liberato Santro-Brienza said, "Goodness is the proper object of the will."[70] If goodness is an "object of the will," Hammersley's art can be seen as good, a representation of his will and creative thought, the object and outcome of goodness consummated in form. And concerning form, Luigi Pareyeson states, form is "perfect in the harmony and unity conferred upon it by its laws of coherence, complete in the mutual proportions between the whole and its parts."[71] If this is the case, Hammersley's work is coherent, proportioned, and harmonious; therefore, it is good.

66. Mann, *Augustine's Confession*, 59.

67. Knapp, *Chaucerian Aesthetics*, 22.

68. The Wonder Cabinet Conference at the University of New Mexico.

69. Aquinas, *An Introduction to the Metaphysics of St. Thomas Aquinas*, 22.

70. Bredin and Brienza-Santoro, *Philosophies of Art and Beauty*, 62.

71. As quoted in Eco, *The Aesthetics of Thomas Aquinas*, 68.

And if all else fails—and in opposition to the others—we can add John Chrysostom's thought, "Thus, we say that each vessel, animal, and plant is good, not its formation or from its color, but from the service it renders."[72] If it is the *service rendered* in an object that makes it good, then Hammersley's artwork fits the bill; it serves the senses with deep pleasure. In all cases of goodness, Hammersley's art achieves its affect.

Unity. The final transcendental infers a holistic, unified approach, a singular vision and object of the will, seeking coherence and undivided care. What can be inferred from Hammersley's work is that there appears to be a unified, creative approach to his art and life, seeking unity of aesthetic practice, even within the range of outcomes, stylistically speaking (abstract, realism, etc.).

Hammersley sought a cohesive visual experience intermixed with his linguistic nuances (puns in the naming of artwork, and his use of extensive notes). Even with divergent outcomes (in his various styles), Hammersley's work (with a nod to Hans Urs von Balthasar) is "symphonic," finding a multiplicity of expressions within a unified structure of art. Much like the various instruments, melodies, harmonic and rhythmic aspects in music find an expression—through the composer—in a symphony. Hammersley's work is unified in a symphonic way.

Take for instance his painting *Sacred and Pro Fame*, 1978, held at the Albuquerque Museum of Art. In *Sacred and Pro Fame* one finds a large painting with three primary colors: red, black and white. Upon first glance, the painting appears to be an optical illusion of sorts, the red and white geometric patterns playing against each other. But after continual observation, one finds the image to be a striped cross, and hence the teasing name—*sacred*. It's this interplay between color, geometry, and words that make Hammersley a fascinating artist, integrating the transcendentals in a marvelous way, leading to deeper questions. It's the symphonic interplay between line, color, and words that elicits thought.

Much more could be said about Hammersley's relation to the transcendentals, but neither time nor space suffice. Instead I leave you with a thought, as generated by journalist and author Robert Krulwich.[73] Krulwich notes that good science writing (or any writing for that matter) invokes three things: noticing, painting, and sharing. With noticing, the person needs to pause and look at an object, taking note of its unique facets and being. In painting,

72. Schaff, *Nicene and Post-Nicene Fathers*, vol. 9, 422.

73. Shared at a lecture Krulwich delivered at the *Wonder Cabinet* conference sponsored by the University of New Mexico, hosted by Lawrence Weschler.

notice will lead to discussion and description. And with sharing, discussion will lead to feelings and deeper thought.

All of these traits find a place in Hammersley's work. His art requires that you pause and notice the details, observing its color, precision, and form. Next, you must paint with words, describing what you see, eliciting a conversation. Finally, you must allow your feelings to find a place in the form of aesthetic awe as presented in the art, something that goes from the head to the heart. And when you do these three things, wonder will whisper its name.

Frederick Frahm: An Offering of Seashells

Around AD 400, so the story goes, St. Augustine was contemplating the Trinity. Having some difficulty wrapping his mind around the biblical doctrine, he went for a walk by the ocean. There he met a young boy who was using a seashell to scoop water from the ocean into a hole he had dug in the sand. When Augustine asked what he was doing, the lad replied, "It is no more impossible than what you are trying to do—comprehend the immensity of the mystery of the Holy Trinity with your small intelligence."[74]

Whether the story is rooted in reality, historians are unsure. But what the story does provide is a parable of discovery of deep transcendence, encountering truth, beauty, and goodness in unexpected places. The seashell becomes a metaphor for the mystery of life, the inability to fully comprehend the paradox of existence with the divine.

I recently had a seashell experience.

While attending an organ concert at a local Lutheran church, I heard the music of composer Frederick Frahm. The piece was entitled *Fantasy for Organ*. I was taken by the work, which combined modern tonalities with biblical themes.[75] To make matters more intriguing, the composer participated in the performance, narrating the text, the poem "Mysteries" by Susan Palo Cherwien.

I decided to investigate the work of Mr. Frahm. To my delight, he's well published. A little more digging revealed that Mr. Frahm is a graduate of Pacific Lutheran University, where he earned degrees in Church Music and Organ Performance. According to his website, "A significant portion

74. See de Voragine, "Of St. Augustin, Doctor and Bishop," *The Golden Legend.*
75. See Nixon, "Alcee and the King of the Instruments."

of his extensive catalog of music for liturgy is in print and is represented worldwide by more than a dozen publishers. A full collection of sketches, manuscripts, recordings and correspondence (1982–2011) are archived in the Mortvedt Library at Pacific Lutheran University in Tacoma, WA."[76]

Yet it wasn't his background as much as his music that caused me to pause and reflect. I perused his website and SoundCloud account,[77] finding music of quality, composed with consideration to a variety of modern music sensibilities.

I decided to reach out to Frahm to learn more about his upbringing and compositions. We met right before the Fourth of July at a locally owned café. We talked for over an hour, as he graciously answered my many questions.

I asked Frederick (as he gave me permission to call him), "Your website states you grew up in Hemet, California. Were you a musical child? Were there any influences (family, friends, teachers) that helped shape your yearning to become a musician and composer?"

"I grew up in a family which had deep appreciation for a variety of musical arts, but none considered it a vocation. I attempted piano as a boy and hated it. I had to practice next door, and I didn't think very highly of my teacher. Things changed when my dad died at age forty-six. From there music became my solace, and I was blessed to study with a remarkable teacher who knew just how to challenge me in the best way. I listened to the Time Life Classical album collection until the records became raw. You mix my fascination with music with my Lutheran upbringing—where music was woven into our life—and you'll see that pursuing music was a natural path for me to take."

I nodded, intrigued. Frahm was calm, providing his answers with clear insight in a conversational manner. Tell me about your inspiration. From where does the muse of creativity arise, I continue.

"My inspiration arises largely from my Lutheran upbringing. In a sense, the church shaped me. However, I don't make a distinction between the sacred and secular in my music. To me, all music is divinely rooted. I see music in symmetrical shapes, much like architecture. There is a collection of patterns that help form my approach to composition. Someone once told me that my music is Cubist in form, built in sections. I like this comparison. My

76. See https://frederickfrahm.com/.
77. See https://soundcloud.com/fmfrahm.

approach and inspiration in music is found in contrasts and symmetry. Take my piece, *Fantasy for Organ*. It was a breakaway piece for me. I built it in sections, like adding bricks to a wall. Previously, I had composed by weaving lines of music like a tapestry, but I came to find that to be imprecise. I wanted to articulate a very clear structure, using silence as a mortar."

There are several living composers that write both liturgical music and music for the concert hall; Arvo Pärt comes to mind. Do you have any modern influences, composers that help shape and define your musical sensibilities and tastes?

"I'd have to begin with Bach. Like me, Bach didn't see a divide between the secular and sacred. Bach is still the standard in both organ music and composition. Western music stands on his shoulders. Other composers that have inspired me are Daniel Pinkham (1923–2006) and Philip Glass (b. 1937). Pinkham was an organist in Boston and a fine composer. He wrote a wide range of music, from liturgical to art songs to symphonies. Pinkham's music showed me how to conserve material and to bring harmonic color to music with his use of polytonality.

"Philip Glass is a modern composer. In his day, he was considered radical, combining elements of minimalism with avant-garde sensibilities. Like me, he saw music as architecture. Recently I performed a Philip Glass piece next to one of my compositions during church. A man approached me after the service, fascinated by the structure of both compositions. Though the two pieces are different, there is an inner quality that helps bring them together. Maybe Glass's influence on me helped show a similarity."

You've written a wide range of music—symphonies, chamber, organ, chorales, handbell, opera, and the like. Do you have a favorite style to compose in? Is there one form that inspires you over another?

"Not really. I enjoy all styles. My trouble is giving the style a name. I think much of what I do transcends categorization. I really don't worry about fitting into a particular genre. Take for example a new piece recently completed, *John the Baptist*. I call it a Church Opera. It won't comfortably fit into the liturgical—church service—framework. It took me about three weeks to score—just under 1,000 measures! And as I'm wrapping it up, I'm wondering just what I've created. Additionally, I've composed around one hundred solo songs. And the past ten years I've worked on several chamber compositions. So, I enjoy all styles of art music."

How do you begin your composition process? Do you use a computer?

"I begin with pen and paper. I write the short score by hand—usually enough bars of music to get the general shape of the score into some more tangible form. I then move to the computer to continue and complete the work. I use the music-engraving program Finale. It's from this that I create a performance edition. I'll send a computer-generated score to the publishers, which is the industry standard."

Since your music is hard to categorize, how do you view yourself as a composer?

"I simply see myself as an artist working in the church. As mentioned, I don't make a distinction between the secular and sacred. I'm a composer who likes to expand the boundaries. The church was where I, as an artist, chose to compose; it was what was before me. As an example, several years back I was involved in a tough period in my life. The church I served was going through some problems. I was caught in the middle. From this experience came my song cycle, *Space of Night*. The text is based on the American author, Stephen Crane. Crane grew up in a very restrictive religious home. The text I used of Crane's helped me work through this dark night in my life. I was composing with a broken heart. The end result is a piece that transcends categorization; it was where my art, faith, and work conjoined. In composing, I strive for symmetry and dialogue between different component—faith, art, life—and detail in the formation of a musical architecture."

You have a strong sense of the text in your music, using both biblical and secular works. Can you talk a little about this?

"I'm drawn to text, prose, and poems. I enjoy the interplay between text and music. The lyrical nature of the spoken word fits nicely with my music sensibilities, building on the architectural structure in my music."

I'm particularly struck by your work for organ and strings, *Augustine and the Seashell*. What's the story behind this piece?

"I was visiting Italy in 2013; Susan, my wife, and I were on a trip celebrating our twenty-fifth anniversary. Our hosts took us on a road trip through Tuscany. We saw Lucca, Volterra, and ended up in San Gimigniano. It was here that I entered the Chiesa di Sant'Agostino (Church of St. Augustine). As I looked around the church in the afternoon light, I began hearing music in

my head. I wrote the first fifteen bars of the piece at that moment. I thought to myself, *This is the type of music that should be performed here.* As I studied the piece, I found that it is broken up in threes and fives, holy numbers. We gave the premiere performance of it at St. Luke on Ash Wednesday, 2015."

You perform upon, and compose for, one of the great instruments: the pipe organ. Why did you choose this instrument to play?

"My undergraduate work was in church music. My graduate work was in performance—with the organ as my instrument. By the time I reached college I knew organ was my choice. It was a natural fit based upon my background. The organ is so magnificent; it has great depth and breadth. There is a majesty to the instrument, covering many sounds, textures, and timbres."

Has your music been recorded?

"Yes. A British organist named Robin Walker recorded an album called *Works for Organ.* There are several pieces on the CD, included *Three New Mexico Sketches*, a composition inspired by some places found in New Mexico. Another album, *Septem Verba (Seven Words)*, for organ and violin, was recorded by David Felberg and Robin Walker. *Septem Verba* was recorded here in Albuquerque at St. Luke's."

As Frederick and I continued to talk in the café, his love of music, passionate faith, and quest for the beautiful and sublime became more apparent. Though Frederick was very approachable and down to earth, the transcendence he yearns to reach though his music is a noble quest, combining melancholy and exuberance, austerity and density, consonance and dissonance.

And like Augustine before him, Frederick seeks to dialogue about that which is plain and that which is opaque, where mystery and reason kiss and find new life in marvelous compositions.

Seashells abound.

Georgia O'Keeffe: The Desert Dweller

Georgia O'Keeffe (1887–1986) is perhaps one of America's finest painters, a modernist tour de force. Born in Wisconsin, the second of seven children, O'Keeffe left her midwestern upbringing to embark on artistic pursuits

unlike any female artist before her. O'Keeffe studied art in both Illinois and New York, held down a job in Chicago as a graphic artist, attended Columbia University, was a teacher's assistant in South Carolina, and taught art at a school near Amarillo, Texas.

All this travel and work occurred before her big breakthrough in 1916, when modernist photographer and Gallery 291 owner Alfred Stieglitz took notice of her work, shown to him by Georgia's friend Anita Pollitzer. O'Keeffe fell in love. After her marriage to Stieglitz, Georgia split her time between New York and New Mexico. It was New Mexico, however, that captured O'Keeffe's interest and attention.

Between the late 1920s and the late 1940s, O'Keeffe made several visits to New Mexico. But it wasn't until after Stieglitz's death in 1946 that Georgia moved permanently to the Land of Enchantment, settling in Abiquiu and Ghost Ranch in the northern part of the state, keeping a home in both locations.

O'Keeffe went on to become one of America's greatest artists, paving the way for a uniquely American style and viewpoint. The rest, if you will, is history. Her work continues to inspire, selling for millions of dollars. Even former President Barak Obama included her in his children's book *Of Thee I Sing: A Letter to My Daughter*. She's an American icon.

So, when three writers gathered in Santa Fe for an event to share stories about Georgia O'Keeffe, the only appropriate response was to attend. The writers were Pulitzer-winning writer and poet N. Scott Momaday, writer Margaret Wood, and poet Carol Merrill. The three assembled at the New Mexico History Museum to swap tales of their time with the famed artist.

Before I provide a summary of the discussion and home in on her religious beliefs, let me pause to briefly introduce the presenters at the event.

As mentioned in a previous section, N. Scott Momaday is the only Native American writer to win the Pulitzer Prize for literature. He was bestowed America's highest literary honor in 1969 for his book *House Made of Dawn*.

The second author is Margaret Wood. At twenty-four, Wood left her home in Lincoln, Nebraska, to work for O'Keeffe as caretaker. After her time with O'Keeffe, Wood went on to become a speech-language pathologist and penned a couple of books, *Remembering Miss O'Keeffe* and *A Painter's Kitchen*, a book about the food Georgia loved.

The third author is Carol Merrill. Like Wood, Merrill worked for O'Keeffe, but as a librarian and secretary. Merrill also worked with poet Allen Ginsberg. Over their time together, Merrill reflected on O'Keeffe through poetry and prose. Merrill wrote two books about her time with O'Keeffe. Her prose work is *Weekends with O'Keeffe*, and her poetry book is *O'Keeffe: Days in a Life*.

After an introduction by the host, Palace Press director Tom Leech, the three authors discussed their life with O'Keeffe and read excerpts from their particular books.

Merrill began. Her story started in 1973 when she wrote a letter to O'Keeffe. A one-hour meeting was set up between the two, which led to a seven-year working relationship. Merrill was tasked to work at O'Keeffe's homes in Ghost Ranch and Abiquiu, cataloging O'Keeffe's libraries and providing some secretarial duties. Merrill worked mostly on weekends between 1973–1979, taking detailed notes of the experience. She read from her poetry and prose books, her deep love of and reverence for O'Keeffe clearly articulated.

Following Merrill was Margaret Wood. Like Merrill, Wood shared how she was connected with Georgia O'Keeffe—through a recommendation of a friend. She was with O'Keeffe between 1977 and 1982. Wood talked about having to learn to cook for O'Keeffe, who was very particular, and mentioned interesting tasks she was asked to do, such as write down dreams and daily experiences. One of the greatest memories Wood had of O'Keeffe was the way she spoke, deliberately and thoughtfully.

N. Scott Momaday discussed his first meeting with Georgia O'Keeffe. In 1972, Momaday was on leave from teaching at the University of California Berkeley. O'Keeffe, in her eighties at the time, invited him to visit her at her home. Momaday told the story of how O'Keeffe asked him what he wanted to drink. Georgia retreated to get the drinks. And after a long time away (which began to make Momaday nervous), Georgia returned with the drinks. Momaday wondered why it took her so long. Ms. O'Keeffe replied that she had to take off the door at the hinges because her housekeeper had locked the pantry. The two went on to meet several other times, with Momaday making several connections to her life and thought. Momaday recited a poem he wrote based on his interaction with O'Keeffe, "Forms of Earth at Abiquiu."[78]

78. Momaday, *Against the Far Morning*, 25.

After their individual recitations, they shared recollections of O'Keeffe, taking questions from Tom Leech and the audience.

I was able to question the panel about Ms. O'Keeffe's religious belief. Carol Merrill provided the answer: "This is a good question. If she ever decided to be a religious girl, she'd choose to be Catholic because she liked the ceremony, the incense, the music, and the windows." Merrill continued with a story about the time poet Allen Ginsberg came to visit Georgia. As Ginsberg sat in the south porch of her Ghost Ranch home, Ginsberg showed her how he meditated in the Tibetan Buddhist way. He encouraged her to try. She didn't follow his lead. He asked, "What is it you believe?"

As Merrill described it, Georgia "gestured with an open hand up and arm outstretched in a semi-circle, saying, 'It's hard to say.'"

Later, I looked a little deeper into the matter of O'Keeffe's beliefs.

According to O'Keeffe biographer Roxanna Robinson, Georgia envisioned God as female.[79] This comment sounds as though Georgia may have found meaning outside her orthodox upbringing, which was Episcopal.
Yet other writers point out that O'Keeffe periodically went to services at the Christ in the Desert Monastery (mostly Easter and Christmas), twenty miles northwest of her home at Ghost Ranch.

Merrill gives greater insight in her memoir *Weekends with O'Keeffe*, writing, "At 3:00 a.m., we will go to Christ in the Desert Monastery for Easter services."[80] She then writes about the memorable service with Georgia, saying that O'Keeffe sat in the service "with hands folded in her lap."

On another occasion, Georgia told Merrill to have Merrill's parents, who were visiting the monks, "say hello to the fathers for her." It's safe to say Georgia had at least a friendly acquaintance with the monks at Christ in the Desert Monastery.

Others point out that Georgia would attend the church down the road from her house in Abiquiu, named St. Thomas. And on occasion, she attended

79. Robinson, *Georgia O'Keeffe*, 23.
80. Merrill, *Weekends with O'Keeffe*, 65.

events at the famous church of Chimayo, located thirty miles southeast of Abiquiu.[81]

Even famed Trappist monk Thomas Merton paid Georgia a visit at her Ghost Ranch home. After a conversation with Merton, Merrill noted, "She was impressed with his attitude toward the church."[82] Thomas Merton wrote about his travels to Christ in the Desert Monastery, discussing his time wandering O'Keeffe country in his book, *Woods, Shore, Desert*.

All this association with churches may mean little. Georgia may have attended the churches for religious duty only, or maybe curiosity, or may have actually attended to worship. Why not all three?

To me, O'Keeffe focused on the beauty of God. This is best seen in her tongue-and-cheek comment concerning her favorite mesa across the road from her home in Ghost Ranch. O'Keeffe said, "God told me if I painted it enough, I could have it." The beauty of God was her Beatrice.[83]

O'Keeffe didn't leave a statement of belief. Nor was she, to my knowledge, a member of any particular church, other than the Episcopal church of her upbringing.

"It's hard to say" may be her motto for her worldview when asked, but her life's work, painting, seems to suggest something more: a quest for beauty, truth, and goodness.

According to theology professor John Poling, who spent a summer with O'Keeffe, the famed artist was interested in common things. In *Painting with O'Keeffe*, Poling writes, "O'Keeffe, by emphasizing the common things, granted status to what most would have considered banal and trite. The common was used by her to remind us of what we had become; people so hungry for the extraordinary that we fail to see that we are surrounded by it."[84]

If one were to add up the sum total of the various characteristics of O'Keeffe's life, they imply a quest for transcendence, something where wonder meets

81. Wood, *Remembering Miss O'Keeffe*, 35.
82. Wood, *Remembering Miss O'Keeffe*, 169.
83. Dante's muse in his book *Divine Comedy*.
84. Poling, *Painting with O'Keeffe*, 127.

the ordinary, where heaven greets the earth. Or put another way, where humanity gathers with God.

And in Christian vernacular, this is precisely the message of Jesus Christ: the union of the human with the divine. Known as the hypostatic union, it is the combination of two natures in a single person. In relationship to the Trinity, Christ's interaction within the Godhead is known as the perichoresis, the mutual exchange of love among threefold Persons: Father, Son, and Holy Spirit.

Maybe, just maybe, O'Keefe's art is a signpost, helping people understand the concept of union: the moment heaven and earth met in a marvelous embrace in the person of Christ.

What I do know is that the insight shared by N. Scott Momaday, C. S. Merrill, and Margaret Wood helped shed light on the extraordinary life of one of American's greatest female artists, aiding me in understanding the woman who painted in pursuit of transcendence, be it beauty, truth, goodness, or self-expression. For in the end, it was something deeper in life that O'Keeffe sought, not just happiness. As Margaret Wood reminded us with something O'Keeffe said to her: "I think it's so foolish for people to want to be happy. Happy is so momentary; you're happy for an instant and then you start thinking again. Interest is the most important thing in life; happiness is temporary, but interest is continuous."[85]

And *interest* in O'Keeffe's life and work continues, moving us beyond happiness to something more sublime—joy.

85. The quote was shared during the lecture.

Part 2

A Culture to Itself[1]

Paul will drift away as he
stands with hair remnants
around. It's amazing to see:
scissors, comb, and razor.
His eyes shut and he leans
forward just enough for the
head of a voice to act as a
pillar for REM. His quiet life
and tie somehow intertwine.

Jay can cut two to Paul's one.
He will converse in a language
all his own. He speaks of private
investigators and the dead with
new hair. I've seen him almost
butcher a man; more blood on
the razor than a surgery table.
Escalon, where dairy was his
childhood, sleeps well with him.

Together they are a business of
being, a history all their own.
Many will come and provide
appendages to their pages of story.
For $3.50 a bargain of life
is dished in an historical array.

1. *The Penwood Review*, 22.

Pictures hang as sand on the
wall. No names, just faces with
hours of words. Together we sit.

I wonder if Mr. McHenry ever
pondered the life that would
happen on a street named after him;
in a barbershop where teacher
and hobo, minister and taxi-driver
converge to smell the same talc
powder and touch the moment
where something but silence
exists for the day.

Places

The definition of place is modest: a particular position or point in space. Place is a place that occupies space. The place we occupy in space is seven-tenths covered with water, a sphere slightly flattened at the poles and almost 25,000 miles in diameter. Even with all the water and uninhabitable land, we still have almost 16 billion acres on which we can live.[2] From cities to towns, to deserts, mountains, and oceans, people populate place with purpose and—in the inhospitable areas—dedicated persistence.

The spaces people inhabit can define them. Think of New Yorkers or denizens of Hong Kong, London, Munich, Modesto, California—where the poem above takes place in a barbershop—or St. Petersburg, all cities with atmosphere, an imprint, and a culture.

The Bible, too, is full of places: cities, deserts, towns, and various geographical regions. Even the new heaven will have a place—Jerusalem.

Furthermore, Jesus ministered in a variety of places: near lakes, by gardens, on plains, and atop mountains. Locations abound in the world of Jesus.

Concerning a theology of place, John Inge writes, "Place is very much more significant than is generally recognized . . . [T]hat place is a very important

2. Williams, "10 Interesting Facts About Earth."

category in the Old Testament and the narrative supports a three-way relationship between God, people, and place in which all three are essential."[3]

Furthermore, Inge suggests that "the incarnation affirms the importance of the particular, and therefore of place, in God's dealing with humanity. Seen in an incarnational perspective, places are the seat of relations or the place of meeting between God and the world."[4]

Those are lofty thoughts, but they bring us back to a ground-level truth: Place is important to God, a meeting ground where he acts.

For the following series of articles, I traveled to various places to discover something interesting about the space, finding the intersection of Christ and culture.

Marfa, Texas: The Last Supper with Andy Warhol

I drove to Texas to see Jesus. Not the real Jesus—he's everywhere (though I know some Texans who would argue that he is more present in Texas). No, I drove to Texas to see the Jesus Andy Warhol (1928–1987) painted as part of his *Last Supper* series, the artwork Warhol spent the last year of his life painting before his untimely death post-gallbladder surgery in 1987.[5]

Why Marfa? It's a good question. High art and the West Texas Chihuahua desert don't seem to mix. But chances are, you don't know Marfa.

Marfa has become a haven for artists and creative types, made famous by the minimalist sculptor Donald Judd (1928–1994) and the mysterious Marfa Lights (yes, they're real; I watched them). Over the past thirty-plus years—since the arrival of Judd—Marfa has become the premier art center on the outskirts of the Big Bend region of Texas (Big Bend is the national monument on the border of Mexico). Judd moved to the region in 1979, purchasing 340 acres of a former army base.[6] In 1984, the Chinati Foundation opened on the site, highlighting the modernist work of Judd and

3. Inge, *A Christian Theology of Place*, x.
4. Inge, *A Christian Theology of Place*, x.
5. Hoffmann and Thierolf, *Andy Warhol*, 7.
6. Sanders, "Why Donald Judd Brought Art to Marfa, Texas."

various other, similar artists. Marfa is now what NPR calls "An Unlikely Art Oasis In A Desert Town."[7]

I'd always wanted to go to Marfa but hadn't carved out the time. But after learning that three of Warhol's *Last Supper* paintings are in a semi-permanent exhibit housed in the town, the Chihuahua desert called to me. Taking my son Cailan with me on the journey, we drove the six-hour trip south to mysterious Marfa.

After passing the famous *Prada Marfa* sculpture in neighboring town Valentine on Highway 90, I knew Marfa was going to be something special. For those not familiar with *Prada Marfa*, it's an installation sculpture made to look like a Prada storefront. Created by artists Elmgreen and Dragset, the work is designated as a "pop architectural land art project."[8] Its jarring juxtaposition with the desert suggested that we prepare to expect the unexpected.

We arrived in Marfa on a Monday, checking into the Hotel Paisano (made famous by James Dean, Elizabeth Taylor, and Rock Hudson, who stayed at the hotel during the filming of *Giant*, Dean's final movie before his death). Beyond the star power of a past generation, the unexpected presented itself once again. In a small museum off the hotel lobby, I learned while watching a documentary on the making of *Giant* that the last scene of the movie between Taylor and Hudson was filmed after learning Dean had died in an auto accident. It gives the scene new meaning, thinking of the two actors' internal struggle to deal with the sudden loss of their costar. Indeed, the entire time we were at the Paisano, room 223—the room Dean lived while at the hotel—was constantly booked by European and Japanese tourists.

But I didn't drive to Marfa to learn Dean lore; I came to peer at Jesus. To do so, the next day Cailan and I walked down the street to the Brite Building. The only clue that the Warhol artwork was in the building was a sign in the window with four words: "Andy Warhol" and "*Last Supper*" underneath. The windows were covered in white with signs stating no photography or video.

To help me understand how three works of Warhol art arrived in Marfa, I turned to Gretchen Lee Coles, director of the Ayn Foundation in Marfa, and

7. Ulaby, "Marfa, Texas."
8. Jodidio, *Architecture Now!*, 202.

an artist in her own right.[9] Ms. Coles met us that morning and let us into the
building. Right away, I could tell the space—and Gretchen—was engaging.

As you walk into the Brite Building, you're confronted with three large
paintings in a three-walled room. To the left is a mammoth black and white
work encompassing the entire Last Supper scene (based on a replica of Da-
Vinci's depiction). Directly in front is a large color image of Jesus next to three
apostles. To the right is the same image of Jesus, this time next to a shirtless
man with the words "Be a Somebody with a Body." That's it: three paintings,
cream-colored walls, a grid-like ceiling, and a small table at the front of the
room with some literature on it. I don't know if the room can be likened to the
Rothko Chapel in Houston, but it did have a sanctuary-type feeling.

Sitting at a small desk—the only furniture in the room—I asked Ms. Coles
about the Ayn Foundation, the sponsor of the work. She let me know that
Ayn's founder, Heiner Fredrich, created the space so people would interact
with the artwork, not just stop by for a quick photo. It seems that Fredrich
wanted a space for contemplation and reflection. Coles didn't give much in-
formation about Friedrich other than he's a collector, dealer, and co-founder
of the Dia Foundation, which incidentally helped Donald Judd purchase
the land that became the Chinati Foundation in 1979. Still living, Fredrich's
family does most of the oversight of the Ayn Foundation in Marfa.

I asked Coles how long the Warhol paintings had been in Marfa. Her an-
swer was simple and direct: "Since 2005 when the space opened." And how
long would they be on display in Marfa? "The artwork is on a long-term,
semi-permanent loan," she responded with a smile (Coles was a pure delight
during our whole time together).

I then turned my attention to Warhol's works, asking when they were paint-
ed. "All Warhol's paintings were completed in 1986, a year before his death,"
Coles said. "In all, Warhol painted around one hundred works based on the
Last Supper theme."

She filled in some of the blanks: "Warhol was commissioned by Alexandre
Lolas in 1984 to paint a series of works based on *The Last Supper* to be
placed at the Palazzo Stelline, a building located next to the Santa Maria
delle Grazie where Leonardo's *Last Supper* is housed. Instead of using Leon-
ardo's famous painting of *The Last Supper* as a base, Warhol chose a cheap

9. See Coles' website at http://gretchenleecoles.com/.

replica he found in a book. The opening of the *Last Supper* exhibit took place in Milan, January 1987. Andy died one month later in February."

Coles didn't get into how or when Fredrich acquired the three *Last Supper* paintings represented in Marfa.

Many of the *Last Supper* works I'm familiar with are silkscreens, but the three works in the Marfa exhibit are hand painted. I ask Coles about this. "True. All three of the works represented in Marfa are hand painted. Warhol used a projector to trace the images on to the canvas. He used acrylic and large, unstretched canvas." I noted the size of the paintings. "Yes. Imagine how difficult it was to ship these to Italy," Coles mused.

Coles then drew my attention to the book on the *Last Supper* paintings. As I flipped through the book, Coles pointed out a few interesting facts. One is that Warhol used an advertisement image taken from a magazine to contrast with some of the images of Jesus. The "Be a Somebody with a Body" image juxtaposed next to Jesus offers either a symbolic rendering (Jesus is God in a body?) or something more tongue in cheek. Another interesting fact is that Andy Warhol was influenced by the iconography of the church he regularly attended. Coles recommended a documentary by Ric Burns on Warhol's influences, including his Byzantine-Catholic upbringing.[10] She noted that the documentary shows a series of repeated icons above the altar of Warhol's childhood church; the influence of iconography upon Warhol is clearly evident.

For some people, the images of Jesus and the influence of iconography may seem out of place for a man known more for his quirky lifestyle and love of celebrity. But the truth is that Warhol had a deep, if misunderstood, faith. He grew up with—and continued to practice—the Byzantine Catholic faith.

Many scholars see a parallel between the iconography of Warhol's religion to those of his adult, Pop-art paintings: bold colors, flat, non-perspective renderings, and repeated images, all adjudicated with iconic stature.

What's fascinating is that Warhol's published artwork is bookmarked by Christian images: One of Warhol's first published paintings, *Golden Hand With Creche 1957*, shows a hand holding a manger scene, and his last paintings were of Jesus and the Last Supper, from crib to cross.

10. See *Andy Warhol,* by Ric Burns.

According to John Richardson in the preface of *The Religious Art of Andy Warhol*, "Although Andy was perceived—with some justice—as a passive observer who never imposed his beliefs on other people, he could on occasion be an effective proselytizer. To my certain knowledge, he was responsible for at least one conversion."[11]

Furthermore, Richardson notes, in addition to Warhol's regular church attendance throughout his life, "he took considerable pride in financing a nephew's studies for the priesthood . . . and he regularly helped out at a shelter serving meals to the homeless and the hungry."[12]

And the author of *The Religious Art of Andy Warhol*, Jane Daggett Dillengerger, suggests that Warhol's attraction to celebrity relates to his Catholic faith—the importance of the image. And, as another author has noted, "The *Last Supper* series—rather than marking a new revelation of faith—actually elucidates the spiritual sensibility of his entire body of work."[13]

Fascinating. It appears that Andy Warhol—at the bare minimum—was a believer in God.

Warhol's belief plays out in how he depicted Jesus. His treatment of Jesus in the works at Marfa seems to indicate reverence that goes beyond mere fascination. In all three paintings, Jesus is given the central place, with the bread and wine given a noted centrality as well (this would make sense for a Catholic who believed in the centrality of the Eucharist).

In one painting, Jesus is the only fully colored figure, reaching his hands down to the elements of a plate, cup, and bread. In the largest of the works— a sprawling full-framed black and white representation—Jesus is the central figure, reflecting Warhol's use of DaVinci replica, but still notable. In the *Be a Somebody with a Body* painting, a hand—presumably Peter's or John's—reaches out toward the face of Jesus. It's an interesting question to pose: In choosing this close-up of the image, was Warhol reaching toward Jesus? We may never know.

But what is known is that there's much speculation concerning Warhol's fixation on Jesus during his final year of life. In Peter Kattenberg's book *Andy*

11. Dillenberger, *The Religious Art of Andy Warhol*, 13.
12. Dillenberger, *The Religious Art of Andy Warhol*, 13.
13. *Andy Warhol: Peer Assessment 2.*

Warhol, Priest, he writes about Warhol's dialogue between the secular and sacred, noting that the *Last Supper* series is "essentially a 'Yours Faithfully'" expression, an exclamation point on the entire corpus of Warhol's work. It's as if Kattenberg is saying that all of Warhol's iconic work was leading to the moment when he would paint the real icon of God—Jesus. Put in biblical language, all the work leading up to the *Last Supper* served the role of John the Baptist, just pointing the way to the main figure.

But ideas like these are speculative. To my knowledge, Warhol left no written statements on the interpretation of his work. He left that up to critics, scholars, philosophers, and theologians. But that's part of the allure of Warhol; his mystique is enhanced with each new interpretation.

Concerning a philosopher's take on Warhol, a few years ago I read a book by the philosopher Arthur Danto entitled *Andy Warhol (Icons of America)*. Danto gives a philosophical construct on the greatness of Warhol's art, helping unpack Warhol's brilliance as an artist and cultural critic, but Danto also connects Warhol to theology. Danto argues that "what makes him an American icon is that his subject matter is always something that the ordinary American understands. Everything, or nearly everything he made art out of, came straight out of the daily lives of very ordinary Americans . . . The tastes and values of ordinary persons all at once were inseparable from advanced art."[14] And if there is something most Americans understand, something "ordinary" in life—at least in Warhol's day, it's the religious foundations of the American culture: the freedom of religion, and more specifically, a Judeo-Christian worldview.

And later, Danto connects the significance of Warhol's work to Jesus. Danto writes, "Warhol was not the first to raise, in its most radical form, the question of art. He redefined the form of the question. The new form did not ask, What is art? It asked this: What is the difference between two things, exactly alike, one of which is art and one of which is not. In its own way it is like a religious question. Jesus is at once man and god. We know what it is like to be a man. It is to bleed and suffer, as Jesus did . . . So what is the difference between a man that is and the man that is not a god? How would one tell the difference between them? That Jesus was human is the natural message of Christ's circumcision. It is the first sign of real blood being drawn. That he is God is the intended message . . ."[15] In the Last

14. Danto, *Andy Warhol*, viv.
15. Danto, *Andy Warhol*, 23.

Supper series, Warhol accomplishes both things Danto suggests, showing Jesus as both human and divine.

In the end, it seems fitting that Warhol—either for religious or celebrity reasons—focused on Jesus in the latter season of his life; Jesus is *la plus grande célébrité*.

I drove to Texas to see Jesus, but I found something equally as intriguing: people dedicated to creativity and contemplation, presenting a small picture of the creator-creature process of which Jesus is the *beau monde*, the paradigm. I drove to Texas to see Jesus, but in a way, Jesus—the creative Christ—found me.

Chicago, Illinois: Why Art Matters

Journalist H. L. Mencken described Chicago as "American in every chitling and sparerib. It is alive from snout to tail."[16] Somewhere within the "snout and tail," Chicago is full of magnificent visual art. From the Institute of Art to the Contemporary Museum of Art to sculptures spread throughout the city, Chicago is a hub for art lovers. Chicago is also the residence to the Poetry Foundation, the former home of noted architect Frank Lloyd Wright, the childhood home of writer Ernest Hemingway, magnificent architecture, wonderful jazz clubs, and a thriving theater scene. Art abounds in the Windy City.

On a trip to Chicago, my family and I took in some of the art found in this great metropolis. Our first stop was at the Art Institute to see the exhibit *Picasso and Chicago*. The exhibit is the largest collection of Picasso's works gathered in the US in one exhibit in over thirty years. More than 250 paintings, sculptures, drawings, and watercolors graced the walls of this stately building. We arrived at the museum when it opened and left a half hour before it closed and didn't begin to see the entire collection the museum had to offer.

We also checked out the Museum of Contemporary Art, viewing the exhibition entitled *Destroy the Picture: Painting in the Void*, featuring the fascinating art of British artist John Latham (1921–2006) and others. Also, at the MCA were musical manuscripts by noted American composer John Cage (1912–1992). I was even able to pick up a signed book by bassist Peter Hook of Joy Division (one of my favorite bands as a teenager).

16. Lindberg, "I Adore Chicago."

Additionally, we were able to see the Frank Lloyd Wright House, the Ernest Hemingway museum and childhood home, the Poetry Foundation headquarters, the Smith Museum of Stained-Glass Windows, the Sadao Watanabe exhibit at Wheaton College, the C. S. Lewis and J. R. R. Tolkien collection at the Marion E. Wade Center, and listen to jazz at Al's Jazz Club. In short, we soaked in the art of Chicago.

So why all this talk about art? In a couple of words: Art matters. And it matters on two different levels: theologically and anthropomorphically, or divinely and humanly.

Let's tackle the theological elements of art first.

It's been said many times over that God is the Great Artist, the Master Creator. And it's true.

But what exactly does this mean? Is God a beret-wearing, easel-carrying, kindly gentleman painting all he can see? Of course not. But it does mean that inherent in God's person and character is the essence of creativity, the very basis of imaginative and inspired acts—including formulation of being and spatiality. All artistic endeavors are manifest in God's nature. I'm reaching here, but much like God is love, God can be seen as that which produces art: the quintessence of revelation. God by his nature is ultimate creativity. God and art are intertwined because God is equal to his nature.

The Lord stated to Moses in Exodus, "I am that I am." Here we find God identifying himself as the center—the source—of all being, including beauty, inventiveness, goodness, etc. And part of God's nature is to create. Therefore, God arouses and motivates creativity in the world, what I'll call Theo-art, Eternal Art, and God-Art. He is not only the Great Artist, but also the object of our desire, the initiator of the process; and by his very nature, he defines for us beauty and creativity.

In the first chapter of Genesis—where we first learn about God's nature—we discover that He creates. Specifically, it reads: "In the beginning God created the heavens and earth." As any Hebrew lexicon will tell you, the word for "create" is *bara*. *Bara* means "to shape, fashion, form, or create."[17]

17. See *Strong's Concordance*, "bara."

A few verses down, in verse 7, we see the word "made." The Hebrew word for "made" is *asah*, meaning "to do" or "to make."[18]

With both words we find God actively creating—in the case of Genesis 1, making all that is known in our universe. So, from God's creative self stems all creative activity. In a way, the two components, the creative and the act of creativity, are co-substantial, of one being.

Having said all that, I want to make it clear that God is not the same as his creation: Art/creation is not God. Rather, art/creation stems from God and reflects God, marked by his fingerprints, or brushstrokes, if you will. Just as all love isn't God, all creation or art isn't God. But both love and art find their meaning and essence in God.

I could go on and on about all of this. I won't. I hope the answer as to why art matters theologically is because art is directly related to God's nature, character, and actions in the universe. God the artist and the art-essence of God are one and the same.

Now to the second reason why art matters: anthropomorphically, or humanly. Art matters to people because it relates to us as creative beings, documenting our existence on Earth, allowing us to make philosophical and aesthetic claims, and fulfilling an function to form components from our world in creative acts (of which, I believe, stems from the *imago Dei*, the image of God woven into our DNA).

In his book, *The Answers Are Inside the Mountains*, poet William Stafford said, "Art will, if pursued for itself and not for adventitious reasons or by spurious ways, bring into sustained realization the self."[19] Or put another way, art helps us understand what it means to be human.

Later in the same book, Stafford states, "Art is the heaven of experience."[20] If you were to combine these two statements, you could come up with a basic, working understanding of art operating in humanity: Art—through our shared experience as humans—can help humans realize our self, our place as individuals within the world and the divine. So, if art matters theologically and anthropomorphically, is there such thing as Christian art?

18. *Strong's Concordance*, "make."
19. Stafford, *The Answers Are Inside the Mountains*, 3.
20. Stafford, *The Answers Are Inside the Mountains*, 43.

Yes, and no.

Noted theologian R. C. Sproul put it like this: "What makes art Christian art? Is it simply Christian artists painting biblical subjects like [Rembrandt's] Jeremiah? Or, by attaching a halo, does that suddenly make something Christian art? Must the artist's subject be religious to be Christian? I don't think so. There is a certain sense in which art is its own justification. If art is good art, if it is true art, if it is beautiful art, then it is bearing witness to the Author of the good, the true, and the beautiful."[21]

So, yes, there is Christian art when art is done with truthfulness, beauty, goodness, and the like: art that reflects the attributes of the Creator.

And, no. There isn't Christian art in that art can't be filled with the Holy Spirit like a human can. Art can be inspired by the Holy Spirit working through a person creating the art, but art can't be saved—in a spiritual sense, just as a desk can't be saved. For what makes someone Christian—biblically speaking—is the indwelling of God within that person; inanimate objects fall outside this understanding.

But both art and a desk are products of an eternal network of God's image working within his creation, producing, fashioning, forming, and shaping the objects with the stamp of his nature—but not inhabiting a nonhuman object in a real sense.

To this extent, art is neutral, much like a desk or a car is neutral. However, how art is used has moral implications. The subject—and understanding— of art can be Christian or non-Christian in orientation, but this discussion deserves separate treatment, so I'll leave it at that.

If there is not "Christian" art per se, is there a divine aspect to art? I think the above discussion makes the case that there is, which leads back to Stafford: "Art has its sacramental aspect. The source of art's central effect is one with religion's and those of other soul endeavors: the discovery of the essential self and the cultivation of its felt, positive impulses."[22]

I like that: "a sacramental aspect." A sacrament is something that is done with a significant, spiritual meaning, giving due honor to the object, be it

21. Sproul, *Lifeviews*, 178–79.
22. Stafford, *The Answers Are Inside the Mountains*, 3.

God or otherwise. In this case, art is a sacrament—not in the traditional Christian definition (baptism or communion)—but in the understanding of giving to God what he has ultimately inspired and brought forth, offering art as a sacrament, a gift to bring God honor.

A way to think through the sacramental aspect of art takes us back to Chicago. Sitting in Millennium Park, just north of the Art Institute, is a very popular sculpture entitled *Cloud Gate,* made by British artist Anish Kapoor. *Cloud Gate* (dedicated on May 15, 2006) is affectionately known as "The Bean."

Cloud Gate is a large metallic sculpture that reflects the cityscape and people who walk up to it. It is shaped in a bean-like form, covered in stainless steel. It's common to see hundreds of people surrounding "The Bean," snapping photos of the sculpture—but while taking pictures of *Cloud Gate*, they are also capturing the city and themselves in the reflection of the statue. *Cloud Gate* allows the viewer and the surrounding area to be a part of the art. In this case, the nature of *Cloud Gate* extends beyond itself.

Cloud Gate is much like the sacramental aspects of art. Though the people or the cityscape of Chicago reflected in *Cloud Gate* are not *Cloud Gate* themselves (part of the metallic makeup of the sculpture), they are in a way part of the art, reflected on *Cloud Gate* itself. They are intertwined, co-substantial, and woven into the larger narrative of what *Cloud Gate* represents. When people approach *Cloud Gate*, they give of themselves by being included in the art.

Cloud Gate is also a helpful analogy highlighting God's influence within the artistic process. All art is a reflection of God's creative nature; God is the originator of art. And because of his creative nature, God allows the reflection of his nature to proceed from himself, akin to the reflections from *Cloud Gate*. This reflection effects and influences those that stand within his presence (all humanity). In turn, people are found inhabited and influenced by God's nature through common grace, becoming partakers in God's divine artistic language. And this divine-human interaction has sacramental components—the offering of the art through a creative process, reflecting the nature of God on Earth.

And because of this sacramental/divine/human interaction, art matters.

Canterbury, England: Looking for C. S. Lewis

Lewis is a lion; loud, powerful, and worthy of study. Like many people writing about the fiftieth anniversary of C. S. Lewis's death, I could attest to his influence on my life through his writings, Christian witness, imagination, and life as teacher. It's true he's been an inspiration and role model for me in these areas.

But I won't write this type of article. Instead, I'd like to discuss a quest: my pursuit to find a first edition C. S. Lewis book. I didn't have a particular Lewis book in mind—any would do. But what's important is that the book is a bona fide first edition, a volume that—as a collector—would sit squarely on my *important* shelf.

What's the big deal in finding a first edition Lewis? you may ask. *Why don't you just go to Amazon or Abe Books and order one?* you say. That's fine and all, but it would have been an easy quest, a journey not worth taking. I need a little adventure in my expedition. Plus, I'm cheap. I want to see what I can find after tossing out the high prices of the various online stores that specialize in first editions. Furthermore, my quest began before I was familiar with Amazon or Abe Books, even before I had regular access to the Internet. I wanted my book quest to be a gift of fate, a meeting of the hunter and the hunted, a match made in heaven.

Why a first edition? Won't any edition do? Like any collector, having a first edition of an author you respect is a great treasure. Since my childhood, when my mother read Lewis to my brother, sister, and me, the Irish Don has loomed large in my imagination. And after becoming a serious Christian in high school, then entering the teaching profession upon college graduation, I saw Lewis as a role model of life and thought, a man of legendary status. Having a first edition C. S. Lewis would be a catch beyond description.

I started collecting books as a teenager. At first, I sought out volumes that meant a lot to my emerging mind, works like *Of Mice and Men*, *The Old Man and the Sea*, and *The Catcher in the Rye*. Then came the poetry and art books. And then the theology books during college. I spent several years combing through bookstores, thrift shops, and garage sales to see if the books I enjoyed surfaced. Sometimes I was lucky, other times famine set in, leaving me hungry for more. In the midst of these collecting binges, I'd pick up a Lewis here and there.

I remember the first time I found a complete set of *The Chronicles of Narnia* for cheap. I was looking through a thrift store in central California that gifted its proceeds to the homeless. Though not first editions, the books came in a nice casing. I also remember buying Lewis works at a bookstore in a favorite haunt, Recycle Bookstore in San Jose, California. There I found several great works of Lewis, even a couple of early editions; but none of them were first editions.

For years, the first edition eluded me. I only found cheap paperbacks, reissued hardbacks, and even some out-of-print editions, but no first editions.

My quest was part of the allure of my book journey, a combination of luck and a fine-tuned eye, a little art and a little science. I was always wondering what would arise at the library book sale. What would the bottom shelf at the secondhand store produce? What of the untapped used bookstore in a small town? Or the unchecked stack of books lying on the floor at a garage sale? For years, nothing did.

That all changed in 2005.

After several years of teaching and administration in both Christian and public schools, I changed professional gears. I decided to attend seminary. I chose a seminary that at the time held a relationship with Canterbury Christ Church University in Canterbury, England. I picked this school for this US-UK relationship. I was thinking that one day I'd like to teach an exchange program in England, or at least have the option to do so. I enrolled in the dual program in 2002. Some of my classes were with professors based in the States, while the other courses were taught through modules with professors based in England. The great thing about this program was that upon graduation I would travel to England for the graduation ceremony at Canterbury Christ Church University and Canterbury Cathedral.

Upon completion of my studies in 2005, my wife Melanie and I joined my parents on a journey across the Atlantic. After the normal tourist stops (which I'd already seen on previous trips), we descended upon Canterbury in the county of Kent for a few days before the graduation. I fell in love with the city. The combination of amazing Christian and cultural history was staggering—from Christian authors and thinkers—Augustine of Canterbury, Anselm of Canterbury, and martyr Thomas Becket—to the breathtaking Canterbury Cathedral, the city is rich in heritage and influence.

It was while browsing the streets of old Canterbury that I found the store: a UNICEF shop that partnered with Canterbury Cathedral, helping raise money for children affected by war. The bookshelves were in the back. I began to browse. After thumbing for a few minutes, I spotted it: a small, blue-covered dust jacket with the words *Beyond Personality* on it. Under the heading were the words, "By C. S. Lewis, Author of The Screwtape Letters." I opened it up to the colophon. It read, "First Printed in 1944." Could it be? The inscription pointed to a 1944 date. It was signed from a lady named Dorothy in December 1944. Yes, it was a first edition!

I couldn't believe my eyes. I looked around to see if anyone was staring at me, obvious in my joy. No one was. I thought: *Don't they realize what I'm holding? Can't they see that I've found the grail?* I knew what I was holding. Not only would the contents of this book find its way into the classic, *Mere Christianity*, in 1952 (US edition), the historical importance of the book was based on influential lectures Lewis delivered on BBC Radio between 1942 and 1944. *Beyond Personality* was the last of the lectures, given in 1944—near the end of World War II—the very year of the publication I held. Lewis was invited to give the lectures by Reverend James Welch, the BBC Director of Religious Broadcasting, who had read Lewis and invited him to deliver the messages. The first two lectures were called *The Case for Christianity* (1942) and *Christian Behavior* (1943).

To put it another way: this book is both culturally and theologically important. First, it was an important cultural marker during World War II, a reminder of the moral imperative to encourage and enlighten England's citizens with the Christian faith, a moral compass in the midst of sacrifice, pain, and strife. Second, the book is important in that it helps shed light on Lewis's view of the Christian faith, offering a penetrating look at God's work in history and within humanity.

Knowing this, I put the book under my arm; surely, no one would grab it from there, I thought. I casually walked up to the counter to pay for it. It was five English pounds. For a minute, I felt like I was stealing it, the cost much lower than I expected. But then I remembered where I was: in England. I'm sure many first edition Lewis works were lying around in shops, in homes and churches. I just happened to stumble upon one. It was my day. My quest was nearly complete. I paid the money, the cashier putting the book in a bag, saying something like, "So you like Lewis? He's popular in America, isn't he?" I don't even remember what I said back, the thought of owning the book too much on my mind.

As I walked out of the store, I strolled up to Melanie. She was browsing shops close by. I pulled out the book from the bag. I held it up, showing her my new find, like a father showing off his newborn. She smiled. My journey was complete.

True, I walked the graduation in robe and cap at Canterbury Christ Church University, with evening vespers being held afterwards at Canterbury Cathedral. True, I chatted with one of my theological heroes and professors, John Warwick Montgomery, himself a Lewis fan. Dr. Montgomery gave the commencement address, challenging us to live, think, and act Christianly in all we do.

And true, I was able to see some of England's finest Christian historical sites, bathing in the beauty and majesty of the land and people. But just as memorable as all these marvelous occurrences were, the little book that I now owned matched them in worth, a short volume with the simple name, C. S. Lewis, attached to it.

My pursuit of Lewis's book, like Lewis's own life, ended in England, separated by forty-two years. But Lewis's life, work, and influence still stand as a testament to God's grace and creative unction in the midst of a world craving for significance. And Lewis, through his works, gives us a glimpse into the imagination infused in the world by the Creator, of whom Lewis spent much of his life pursing with his heart, mind, soul, and strength. Like the characters in Chaucer's *Canterbury Tales*, traveling a journey towards a sacred place, we fellow pilgrims do well to follow in Lewis's footsteps. Good thing Lewis left us, in his books, bread crumbs to help us along the way.

In the end, reading helps us appreciate the amazement and awe of living. As William Nicholson wrote in the screenplay for the movie *Shadowlands* (based on the life of Lewis and Joy Davidson), "We read to know that we're not alone." Finding a Lewis first edition led me to the same conclusion; we are not alone, and books help remind us of this fact.

Ocean Grove, New Jersey: The Word in the World

The year 1869 birthed two uniquely American phenomena: American football and Christian summer camp meetings. What's interesting is that both of these activities came only a few short years after a period of national unrest: The Civil War, the assassination of Abraham Lincoln, and the end

of slavery. It was beauty arising from the ashes—or at least the rekindling of the desire for relaxation, rejuvenation, and even fun.

In November of that year, the first game of American football was played in New Brunswick, New Jersey. Rutgers University defeated Princeton University (then the College of New Jersey), 6–4. Football became a uniquely American sport and went on to become one of our great pastimes, garnering passion, prestige, and people (fans).

In the same year, something else was brewing thirty miles south of New Brunswick. A new community, Ocean Grove, was formed for the sole purpose of providing rest, worship, and respite for Christians, a place where people could adore God in the beauty of his creation. Ocean Grove was a city set apart for God's purposes. Founded by two Methodist pastors, William Osborn and Ellwood Stokes, the community was developed into a place for summer retreats and camp meetings, all for the sole purpose of evangelistic outreach and personal renewal. It was the beginning of what is termed "summer camp meetings," built on the foundation of the "camp meetings" concept founded by Methodist clergymen in 1807 in England and 1816 in America.

According *The New York Times*, Ocean Grove was the "queen of religious resorts,"[23] hosting rows of Victorian homes, beachfront property, and a quiet main street with shops, cafés, and restaurants. Ocean Grove was lovingly referred to as "God's Square Mile."

The parallel between the founding of Ocean Grove and origination of football is striking. Both elicited passion: one for a game, the other for God. Both had big gatherings of people: one in stadiums throughout the country, the other in what was called the Great Auditorium—a 6,000-seat building built in 1884. And both football and Ocean Grove developed a history that stands to this day. Yet there is a difference. Instead of the prestige of financial gain and fame found in football, eternal rewards are the goal of Ocean Grove: redeemed lives. For Ocean Grove, all prestige belongs to Christ.

I had the honor of taking in the passion, people, and history of Ocean Grove with Pastor Skip Heitzig of Calvary Church in Albuquerque. Heitzig was asked to speak at a summer retreat and I accompanied him. Heitzig spoke on "The Beauty of the Body of Christ," with text taken from 1 Corinthians

23. Page, "Summerfare' Offers Choir Festival."

12. In his four major points, Heitzig reminded the gathering that God loves variety, that God emphases unity, that the church is to maximize equality, and that the individual is to minimize self-sufficiency. And in a way, the points were a nice outline for the visit.

Later, Skip and I walked along the Atlantic coast, seeing both beauty and a beating.

The coast of New Jersey was devastated after Hurricane Sandy in 2012. Ocean Grove, because of its "religious" status, did not receive federal funding for improvement. This is where the body of Christ stepped in. Calvary Chapel Relief served over 6,000 meals to the affected families, a relief center was opened, 200 homes were assisted in Union Beach, and eighty homes were helped in the Barrier Islands. Additionally, thousands of dollars were donated to help the communities. In all, 1,060 volunteers from churches from Seattle to Maine and California to Florida participated in the relief efforts. Calvary Chapel Relief did all within its means to maximize equality, helping all that they could with the love of Christ.

Great things happen in God's Square Mile, as its past and present history attest. But the larger region is a metaphor for two differing worldviews: the sacred and secular.

The sacred perspective is represented by Ocean Grove. As I walked up the boardwalk, I was struck by the tranquility found in the city. Ocean Grove is a town that has a sense of peace and devoutness. It's a picture of God's rest: family gatherings on the beach, worship sung at the gazebo throughout the day, Bible teachings in chapels, services held in the Great Auditorium.

Yet, just half a mile up the road, Asbury Park was full of more material pursuits, representing a secular perspective.

Asbury Park is best known as the city where rock star Bruce Springsteen got his musical start. The performance spot where he cut his teeth, the Tired Pony, still stands to this day. I toured the facility and bought a shirt. Yet it wasn't the presence of the Boss that made the city an interesting study on the secular (he, too, has many songs filled with biblical imagery); but rather, the conduct and action of the folks on the beach made the city stand in stark contrast to Ocean Grove.

Two cultures, two worlds within a few miles of each other. How is a Christian to balance the two? After all, I admired Ocean Grove's peaceful piety, but I bought the shirt from the bar. My curiosity led me to consider two words: Christ and culture.

Christ

Jesus has been a point of contention for millennia. From a biblical point of view, Christ is both human and divine—the God-man who was born, lived, taught, died, and rose again. The Bible teaches that Jesus has two natures—something theologians call the hypostatic union. This technical phrase designates the union of Christ's humanity with Christ's divinity. The Nicene Creed used phrases such as "eternally begotten, and not made" and "became man" to help define the two natures.

The various terms were specific in that they expressed precise designations for Christ as functionally subordinate to the Father (his humanity), but not ontologically subordinate (that is, in his being, Jesus is the same essence as God, divine). Furthermore, Jesus even claimed to be divine. Both with Jesus' claims and the biblical record, a clear picture of Christ's two natures becomes well-defined.

If it sounds like I'm trying to bury a difficult truth in complicated terms, I'm not. Jesus Christ is a uniquely complex figure, and the words used to talk about him mean something.

Words matter.

I came to the realization that words matter sitting in a college English class in Fremont, California. We were reading and discussing T. S. Eliot's poem, "Journey of the Magi." For some reason, I had an epiphany while contemplating the forty-three–line poem. It wasn't necessarily the exclusive excellence of the poem that prompted the feeling. Something just clicked.

For the first time, words gained dimension and weight. I saw them as incarnations of thought, ideas representing the seen and the unseen. The word *car*, for example, represents an actual object, but the word *car* is also the vehicle for abstraction—freedom, responsibility, power, and so on. For the first time, I could see that words have important meaning. I became an

aficionado of written language, of these symbols that we agree have power and meaning.

The "Journey of the Magi" acted as a final destination for my own journey with language, a metaphor for the wonder of words.

One of the most powerful uses of words is an analogy, a comparison of two somewhat similar things to clarify the significance of one or both. Circling back to Christ, an analogy may be helpful when thinking about his divine-human nature. I especially admire the one presented by Augustine of Hippo.

For Augustine, words are "signs" rooted in reality, what he called "things." He categorized signs into "natural" and "conventional." Natural signs don't necessarily "lead to a greater knowledge of something else." A commonly used illustration for "natural" signs is how smoke indicates a fire.

A conventional sign is connected to ideas and meaning. For Augustine, conventional signs are those things "which living beings mutually exchange for the purpose of showing, as well as they can, the feelings of their minds, or their perceptions, or their thoughts."[24] Augustine saw conventional signs as having two levels: a literal sense and a figurative sense. It's like the word *car* I mentioned earlier—a word that is both an object and an idea. So, you have a three-part concept that describes the meaning: word/idea/mind.

Augustine used this concept to think about a particularly challenging subject, the threefold nature of the God of the Bible. In *On the Trinity*, his thought went something like this: If, indeed, Jesus is the Word of God, then there must be speech (the Spirit) and a speaker (the Father). This word-speech-speaker analogy correlates easily, then, to a conventional sign: the word (Jesus), ideas (Spirit), and mind (Father) illustration.

It may take a few moments to let this sink in. But Augustine's point is that the mind/idea/word concept is a unique way to think about the interrelationship within the Godhead: Father, Son, and Holy Spirit, co-equal and consubstantial. And though all analogies fall short at some point, some illustrations help bring clarity for an intellectually stirring truth. I think this is one of the stronger illustrations of the Trinity, particularly as it relates to the biblical phrase, "And the Word became flesh and dwelt among us" (John 1:14).

24. Augustine, *On The Trinity*.

Here's my point with this short tangent: in Christ, there are two natures, a divine and human. Or put within a cultural context: a sacred and secular conjoining, the Word and world.

Why is this important?

To see Christ in culture is to see the God-man in the fabric of his creation, a mystery of the Maker immersed in what he made. Jesus is God incarnate, and creation is God's thought made visible. In Jesus, the two came together—the Word and world. Jesus Christ is the greatest example of the meeting of the divine with the daily—a conjoining of eternal and earthly characteristics.

Jesus intersects the earthly and everlasting uniquely, acting as an example of how we, as finite people, can find heavenly truths through human endeavors. On some level, we are looking for places where God has left his imprint on individuals and institutions. Because Christ walked on the earth and created the earth, his footprints can be found, figuratively speaking. And because Christ is God—the Creator and Sustainer of all things—the prints he leaves can be probed. Like words, they have meaning.

Put simply: Creation—culture included—can help make God's word and work in the world—visible. Ocean Grove stands for Christ, and so represents the sacred aspect of my broader point.

But we can't rest here. It's on to the second definition we need to briefly unpack, culture.

Culture

Culture has a long and fascinating relationship with the church. Early protagonists, such as Tertullian (ca. AD 155–240), asked, "What has Jerusalem to do with Athens?,"[25] implying a cultural divide between philosophy and theology. Later, Augustine of Hippo (354–430) bridged the divide by proposing a two-city contact with culture: The City of God and the City of Man. Augustine's approach contained echoes of Jesus—"Render therefore to Caesar the things that are Caesar's, and to God the things that are God's"[26]—and Paul—"Do not be conformed to this world, but be transformed by the

25. Tertullian, "Prescription against Heretics," 3:249.
26. Matthew 22:21.

renewing of your mind, that you may prove what is that good and accept-
able and perfect will of God".[27]

During the Middle Ages, men such as Alcuin of York (735–804), Anselm of
Canterbury (1033–1109), and Thomas Aquinas (1225–1274) continued the
two-city approach to Christ and culture, integrating facets found in both
culture (reason, education, the arts, etc.) and faith (theology, biblical stud-
ies, morals, etc.).

From the early church to the Middle Ages, Christian thinkers espoused all
knowledge as divine illumination (a reference to Augustine), an intersec-
tion of the heavenly within the human.

In the Reformation period, men such as Martin Luther and Thomas Hooker
continued integrating—and encouraging—Christ and culture, through ed-
ucation, the arts, music, and other cultural endeavors. As products of com-
mon grace (grace given to all), culture was to be cultivated for God's glory.

But it wasn't until the Modern Era that the relationship between Christ and
culture was expounded upon by H. Richard Niebuhr (1894–1962). In his
classic work, *Christ and Culture*, Niebuhr framed a five-point interaction
with culture:[28]

- Christ against culture
- Christ of culture
- Christ above culture
- Christ and culture in paradox
- Christ transforming culture

I won't unpack these points. I'd encourage you to read the book. But since
the release of Neibuhr's work, a healthy discussion has continued, debating
the pros and cons of the various frameworks. People such as C. S. Lewis (*The
Abolition of Man*), Francis Schaeffer (*How Should We Then Live*), and others
have all weighed in on the dilemma of Christ and culture. The bottom line:
As culture creatures and creators, we can find Christ in our midst as one
who created the world, and one who came to the world.

27. Romans 12:2.
28. See Niebuhr, *Christ and Culture*.

The major takeaway is that Christians live in two worlds—the secular and sacred—and we use one (sacred) to influence the other (secular) and learn how one (secular) has traces of the other (sacred). We are people with two feet in differing lands.

It's interesting how two cities paint the reality of both Christ and culture. And though the New Jersey region is known for American football and summer camp meetings, God is the real star of both. So, whether you are throwing a football, singing a Bruce Springsteen song, or worshiping in a church service, remember this: The Author, Finisher, and Sustainer of the world and Word, the Creator, entered culture as a creature, so creatures can honor the Creator, Christ our Lord.

Las Vegas, Nevada: James Turrell's Quest for Light

What happens in Vegas, stays in Vegas. So goes the popular tourism ad. But not for me. Many people liken Las Vegas to Sodom—the city of sin—discussed in the book of Genesis. Sodom was where Lot's wife morphed into pillar of salt when she turned to watch the metropolis burn. On the surface, the comparisons between the two cities seem fair. Yet on a recent stop in Las Vegas, I found that there is light in the darkness, solace in midst of sin. And the light is art.

During my visit to Las Vegas my eyes were not set on the sordid parts of the city, but upon art settled in places of silent positioning. And rather than tuning in to the temptation, I turned to the artist, James Turrell, whose work is permanently displayed—of all places—in two locations in a mall adjacent to the hotel Aria and above a Louis Vuitton store.

For those not familiar with Mr. Turrell (b. 1943), a short word is needed. Turrell is a contemporary visual artist, receiving countless awards throughout his storied artistic career. As a Quaker, Turrell has spent his life pursing light (the main medium he uses in most of his artwork). According to *Quaker Artist*, "Turrell has produced over 120 one-man shows and taken part in over 115 group exhibitions on virtually every continent. He's been awarded numerous honors, including the Legion of Honor, a MacArthur Foundation Fellowship, and a Guggenheim Fellowship. Several books, like *Long Green* and many articles, as in *Time*, have been written about him. He appeared as the final artist in the BBC documentary *American Visions*."[29]

29. Fellowship of Quaker Artists, "Quaker Artists."

Continuing, the article states, "Turrell attends the Flagstaff (AZ) Meeting. He designed the Houston Meetinghouse . . . Turrell was raised a Conservative Friend in California . . . It's remarkable that an artist of his caliber should emerge from this background."[30]

Of particular note, Turrell has been working on his massive Roden Crater monument outside of Flagstaff, Arizona since 1974. Roden may be his magnum opus: a land-art piece in a dormant cinder cone volcano so large in scope that it rivals any major monument found throughout the world.[31] One could summarize Turrell's work as a means to draw people to the light (in Quaker terminology, light is synonymous with Christ)—in sense, perception, impression, and experience. Turrell's work can be seen as an immense light icon, something harkening back to the work of abstract iconographers such as Kazimir Malevich, leading to the movement of Minimalism.

As an artistic form, icons are an early Christian painting practice established during the second to fourth centuries. Icons are not meant to be realistic imagery—as in perfect representations of a biblical story or event—but are meant to be physical representations that reveal metaphysical truth, a type of reverse and spiritual perspective. Andrew Spira reminds us in his book *The Avant-Garde Icon*, "The definitive characteristic of icons goes beyond artistic or sociological significance; it lies with their metaphysical identity."[32]

Like an icon, Turrell's cumulative work has both physical (the light and medium) and metaphysical qualities (understanding, implication, and meaning). Yet unlike historic icons (where an image is painted), Turrell's work seeks the essence of the object through light, its minimal influence (light, line, color)—much like Russian painter Kazimir Malevich did with his *Black Square* painting.

It's as Michael Govan states in an essay in a book about Turrell, "The Quaker concept of 'inner light,' which is shared in a collect silent-prayer meeting, is echoed in the experience . . . in the collective silence, duration, and receptivity they induce. Quaker practice can be seen as the Minimalist of Christianity, a reduction in form in search of a deeper, more honest effect."[33]

30. Fellowship of Quaker Artists, "Quaker Artists."
31. See http://rodencrater.com/.
32. Spira, *The Avant-Garde Icon*, 8.
33. Govan and Kim, *James Turrell*, 15.

As I was viewing Turrell's work, my mind kept wandering to the book *Slow Art: The Experience of Looking, Sacred Images to James Turrell*. Author Arden Reed takes us on a journey of art that requires time to appreciate and assimilate, all the while discussing the spiritual and emotional connotations that slow art breeds. For Reed, slow art is a "dynamic relationship that transpires between objects and observers."[34] Slow art is akin to sacred art, something analogous to the Christian iconographers' attempt to initiate contemplation and deep thought. The culmination of Reed's book climaxes with Turrell's work, particularly Roden Crater.

Reed likens Turrell to a biblical character, stating, "Like some Old Testament prophet, whom he resembles, Turrell leads you on a journey from low to high, and from darkness into light. Literally."[35]

Furthermore, Turrell's art requires what Reed suggested, a "dynamic relationship that transpires between objects and observers."[36] This is what icon artists sought for their work as well: that the icon would act as a window to the heavens for the observer. And if anything, Turrell's Roden Crater opens up a window to the heavens, combining immensity with immediacy.

Let's just stop here and ponder this for a moment: A Quaker artist contributing beauty to the City of Sin? Yep. It's true. The darkness may be deep, but light will help penetrate the night.

To help locate the work of Turrell, my friend, Las Vegas resident and artist Jeff Lefever, gave me and my son a grand tour of artistic hot spots on the strip (and, surprisingly, there are many). Our first destination was Turrell's *Shards of Color*.

As I walked into the mall where the Turrell is exhibited, I stopped at a distance to view four geometrically shaped motifs. To someone unfamiliar with Turrell, the artwork would appear as holes cut into the mall wall exuding color (which, literally, it is). But a small plaque at the base of the exhibit tells otherwise. The plaque reminds us that the holes are light-art with a name: *Shards of Color*.

34. Reed, *Slow Art*, 20.
35. Reed, *Slow Art*, 234.
36. Reed, *Slow Art*, 10.

Upon arrival, *Shards of Color* emanated blue light. But as I stood and watched for a few moments, the colors gradually changed, becoming pink, reddish, and purple. Their shifting hues helped transform the mall into a place of wonder.

We then took an elevator up to the third floor to interact with the art. MGM Hotels (which owns the mall) was kind enough to encourage people to walk behind the artwork into small portal rooms to watch the color transform. On the way up, the elevator held another of Turrell's works, a light window changing colors. We ended up taking the elevator a couple of times to see the art in action, changing colors.

When we arrived in the small portals, we stood silently, taking in the shifting color of light. I studied the shape of the windows, following the curvature of the light source with my hand. Jeff and I talked about the complexity of Turrell's work while my son, Cailan, snapped photographs. Jeff pointed out how the changing light created a color matrix with lighting from the mall. A refined renovation of light hung on walls, subtle, but present and stunning.

Who'd have ever thought that in the midst of a mall dedicated to capitalism—and what many deem an incorrigible lifestyle in an incurable city— that beauty abounds?

Not too far from *Shards of Color* is the immersion installation work entitled *AKHOB*, an Egyptian word meaning *pure* or *living water*. Installed on the fourth floor of the Louis Vuitton City Center store in 2013, the art is a masterful reflection on serenity in the midst of a metropolitan center, offering an enlightening experience in a metropolis saturated with mega-lights.

AKHOB contains three chambers: an opening black staircase leading to an oval passageway, and two larger rooms painted in white and drenched in color—emitted from LED lights—that change hues over a period of time. According to *AKHOB* hosts, Turrell called these chambers *ganzfeld* rooms, taken from the German meaning "entire field." The German psychologist Wolfgang Metzger was the first to use rooms of total immersion to test a human's interaction with his or her surroundings. Turrell has perfected the experience into a cohesive work of transcendent art. Our hosts let us know that *AKHOB* is the only installation of its kind in the United States, winning an award of merit at the Nevada Design Awards in 2013. With rounded corners and blurred edges within the chambers, *AKHOB* provides an ethereal, eternal feeling, as if entering heaven.

It's an experience that requires presence.

After receiving a short presentation, we were escorted to the first room where we took off our shoes and put on white slippers (so we don't damage to floor, we're told). We then ascend the staircase into the light. As we stand for the next fifteen minutes, the colors change from bright pinks to greens to tranquil yellows and blues. I ask the hosts how tall the room is and am told, "Forty-one feet high." And the eternity room (as I called it)—located in the last open chamber—has a ten-foot drop (they had a trip alarm to ensure people don't get too close and fall over). The entire experience conveys silence and stillness; literally engulfed in light, we are partakers in an illuminating experience. My only regret is that exhibit rules don't allow us to stay longer.

Upon exiting the immersion experience, LeFever was quick to point out that he needs to return to spend time in prayer. Such is *AKHOB* and Turrell's artwork: majestic and ethereal, calling one to deeper thought and wonder. Later, I asked LeFever, who is a former instructor at the Laguna College of Art and Design, his thoughts.

"I consider *AKHOB* to be the best artwork found in Las Vegas. It is rare to see an art so pure as to be transcendent, crossing all religions, genders, nationalities, cultures, and languages. Furthermore, *AKHOB* goes beyond activism, agendas, and propaganda. Turrell is one of the artists whose work achieves a philosophical quality and enters the realm of pure intellectual and sensual beauty. He touches on the spiritual beyond religious description while coming as close to nature as art gets. A masterful synthesis using light as the medium."

Yet the infused spirituality evoked in Turrell's work is not without criticism. According to Arden Reed, Turrell's "spiritual side leaves [him] vulnerable to the charge of metaphysical dabbling." And other critics "attack Turrell for being 'spectacular,'"[37] a term meaning that he is elaborate and showy.

Criticism aside, the whole experience reminded me of what Jesus told his disciples in Matthew 5:14: "You are the light of the world." Light penetrates the darkness—just like the beauty of Turrell's art did in the mall. *Shards of Color* and *AKHOB* were more than changing colors in a building; they became metaphors of meaning, symbols of how Christians are to reflect and

37. Reed, *Slow Art*, 243.

be light. And even in places that lure people with temptation like Las Vegas, Christians must remind ourselves that we are agents of love and light.

As God's masterpiece, Christians are God's artwork. We are little poems of light shining in the darkness, reflecting he who is the Light. As James Turrell reminds us, we are to "treasure light," letting God's light working in us to be the revelation.

Stanford, California and Albuquerque, New Mexico: Why Attend a Poetry Reading?

In May of 2000, I drove a handful of high school students to Stanford University to attend *Finnegan's Awake*, a festival of Irish writers. It was touted as the largest gathering of Irish writers and poets on the West Coast—a perfect fit for the creative writing class I taught in Modesto, California.

My students were awestruck as they walked onto the Stanford campus, giddy at the architecture and atmosphere, and the fact that they were at a college event. *Giddy* amped up to *ecstatic* when Stanford student Chelsea Clinton, daughter of then-President Bill Clinton, entered the auditorium. One of my students, Lanna, ran up to Chelsea, asking for an autograph. Ms. Clinton was kind enough to sign, "To Lanna, Chelsea Clinton, May 4, 2000." She waved and smiled at the rest of my students, who stood slack-jawed at the transaction.

But Chelsea wasn't the reason I was there. I was there for the poets.

A field trip is always a great way for a teacher to sneak in some secret pleasures, and poetry was one of mine. I sold the event to my school administration as "a cultural and creative writing festival, an unprecedented privilege for the kids," or something like that. Secretly, though, I planned this field trip for myself. I wanted to meet a couple of the poets: Paul Muldoon (b. 1951) and Michael Longley (b. 1939), to be exact.

I sat in rapt attention as Longley read his poem, "Ceasefire." When he finished his last stanza I wanted to stand and holler in sheer delight. The poem is a masterpiece, particularly as a commentary on the political strife in Northern Ireland, where Longley is from. I looked over at my students, saying, "This is brilliant," but they were too busy looking over at Chelsea Clinton.

After the reading, I walked over to the book table. There, standing by the wall, was Paul Muldoon (who later went on to receive the Pulitzer Prize for Poetry for his book, *Moy Sand and Gravel*). His disheveled hair and large glasses gave him the look of an aging rock star. He was at the conference to participate as panelist and reader. His collection *Hay* had been published a year earlier. *London Times* editor Michael Hoffman called *Hay* "his boldest and most engaging poems yet."

I purposely bought a book of Muldoon's *Why Brownlee Left* as Muldoon stood nearby. I looked over; he smiled, in a smirky kind of way.

The broader question that I hope to impart in this article, however, is: why even attend a poetry reading?

The question brings up another poetry reading I attended by recently deceased poet Tony Hoagland. My participation began with a question from my friend, Stephen Christian, of the rock band Anberlin.

"Whatcha doing tonight, Brian?" Christian asks, settling into the chair across from me.

Stephen asks me because I'm the guy that seeks out cultural events around town to take in, consuming them like a fine dinner.

"You probably don't want to know," I retort, partially kidding. "No, really, I do," Stephen responds.

"I'm going to a poetry reading," I say confidently. Stephen rolls his eyes, looks over at another person in the room and points his thumb-down at me.

Now don't get me wrong: Stephen is a cultured guy—he is the leader of a successful rock band, touring the world, with an MBA and variety of cultural interests. And to his credit, we've attended a couple of art gallery events. So, he's no slouch. But the thought of sitting through a night of poetry readings just didn't resonate with him, especially not with his small children in tow.

"I'll pass," he says.

I can't tell you how many times I've heard, "I'll pass."

But listening to a fine poet read his or her work is an exhilarating experience, something I have a hard time passing on. It's like drinking water after a strenuous run. Or sitting through a mathematics lecture and actually understanding what the person is speaking about. Poetry is one part art and two parts life. It speaks of our humanity, our fears, hopes, and desires, and holds them out to the world, saying, "Look! This is existence—and you're a part of it!"

I've attended many poetry readings at various independent bookstores. And each time I walk through the doors, I get a sense of pleasure. Will the reading be good? Will people actually come out? What book will I buy?

This time was no different.

As I browse through the half-dozen poetry books on the display table, I look over and see Tony Hoagland standing, getting ready to read. He is, after all, the reason I'm at the bookshop. I buy his book *Donkey Gospel* at the counter and walk over to say hi.

"Thanks for coming," I say. "You live in Texas, don't you?"

"Part of the time," Hoagland responds. "And I live part of the time in Santa Fe. My wife works in the city. I go back to Texas when I need to teach at the university."

We chat about the difference between being a "local" poet or a poet from "out of town." After some jesting, Tony smiles at me, "You're so provincial." I laugh. I'd have gone in for another round of teasing, but his time for talking was upon us.

For those not familiar with Tony Hoagland, a little information is needed. Hoagland was an award-winning poet and teacher at the University of Houston. He was the author of several books of poetry, chapbooks, and essays. His poems pack great energy, wit, and tantalizing insight into the human condition. The American Academy of Arts and Letters described Hoagland's imagination as "intimate as well as wild." He died in October 2018. After his death, Norton published his book *The Art of Voice: Poetic Principle and Practice*.

I've admired Hoagland's work for years, since I first read it in *Poetry Magazine*. But this was the first time I was able to hear him read.

After a short introduction, Hoagland got up in front of the crowd—maybe thirty of us, all chairs taken—and gave us an introduction of his format. He said he preferred to read from paper, rather than books. He further told us that we could take one of the sheets of paper the poems were written on after his reading, nabbing a piece of the experience.

Did I hear him right? We could pinch copies of his poems, on the paper he just read them from? *A nice gesture*, I thought.

To give you a blow-by-blow of the reading would be unmeritorious. Tony is a fine poet, too good to treat like a football match. True, as the saying goes, he made us laugh, and he made us cry—but he also gave us penetrating insight into existential moments of thought. He held a mirror up to humanity and said, "Here you are." He made us feel, understand, and think.

As I listened to the forty-five-minute reading, I couldn't help but think which poem I'd nab. Would it be his political poems? The humorous and witty poems? The thoughtful, love poems? Then he began a poem entitled "Bible Study."

I was intrigued. Not only did the title of the poem draw me in, but the thought of what he'd do with the poem—the territory of words—would be a fascinating journey.

As Hoagland read, I was enthralled. And frankly, the poem was not what I expected, but I was drawn in, eating every morsel.

Hoagland continued in his high tenor voice, his red vest and baseball cap acting as his prop. After the reading, I knew then and there that I needed to take "Bible Study."

When Hoagland was signing books, I went up to the table to flip through the papers. A lady joined me, looking for her favorite poem. Then I realized: Hoagland didn't read "Bible Study" from a piece of paper; he read it from a book, one of the few.

"What poem are you looking for," Hoagland asked?

"Bible Study," I replied.

"I don't think it's in here, but you can get it online—the Poetry Foundation, I think," he said as he continued to sign books.

Good, I thought. *I need that poem.*

In the poem Hoagland has God speak to humanity, telling them to "survive," and "carry perfume among the perishing,"[38] a subdued reference to 2 Corinthians 2:15. With this line, Hoagland presents a reason as to why attend a poetry reading: survival and fragrance.

The next time I'm asked why I attend poetry readings; I'll remind them that I'm carrying "my perfume among the perishing." And I hope the fragrance is refreshing enough for people to do the same.

Clovis, New Mexico: I Sat on Buddy Holly's Couch

Two rock and roll movies made a distinct impression on me as a child.

The first was a TV movie entitled *Birth of the Beatles*. If I remember correctly it came out in 1979. The other movie, *The Buddy Holly Story*, premiered a year earlier. I was enamored of both films. As a preteen, I wanted to be a rock and roller because of these movies.

As cool and amazing as the Beatles were, they seemed larger than life to a kid growing up in New Mexico. These four Liverpool pop stars were from a far-off country and had throngs of people chasing after them. They were handsome and talented—an almost fairy tale group.

Buddy Holly, on the other hand, was altogether different.

Buddy was rooted in my part of the world: the southwestern United States. He was a real guy who played at roller skating rinks and fairgrounds.

True, Buddy looked funny to me (remember: this was the fashion-blind 1970s), but somehow this odd-looking fellow in the horn-rimmed glasses was hipper than most—he succeeded in creating a look entirely his own.

38. See "Bible Study" at the Poetry Foundation website: https://www.poetryfoundation.org/poetrymagazine/poems/57981/bible-study.

And when it came to Buddy's music, I couldn't believe that one kid could create so many hits in such a short time. When you think about it, Buddy wrote several rock and roll masterpieces in only a year and a half—all before his tragic death on February 3, 1959, following a performance at the Surf Ballroom in Clear Lake, Iowa.

He, Richie Valens, J. P. "The Big Bopper" Richardson, and the pilot, were killed in the early morning hours in terrible weather in route to Moorhead, Minnesota, when their plane crashed soon after taking off from nearby Mason City.

Of his three albums, *The Chirping Crickets* (November 1957), *Buddy Holly* (March 1957), and *That'll be the Day* (April 1958), Buddy had ten Top 40 hits. Pretty amazing.

Buddy was also unique because he wrote his own songs. In a day when most pop singers used material from song factories, this kid from Lubbock, Texas penned or co-wrote (with engineer Norm Petty) songs we still sing today.

And his songwriting ability hasn't gone unnoticed. Bob Dylan remarked on Holly's influence in his Noble prize lecture and the 1998 Grammy Award acceptance speech for *Time Out of Mind*, when Dylan said: "And I just want to say that when I was sixteen or seventeen years old, I went to see Buddy Holly play at Duluth National Guard Armory and I was three feet away from him . . . and he looked at me. And I just have some sort of feeling that he was—I don't know how or why—but I know he was with us all the time we were making this record in some kind of way."[39]

Likewise, Paul McCartney credits Holly for inspiring his songwriting pursuits. McCartney went on to host the documentary *The Real Story of Buddy Holly*. And today, McCartney owns the Buddy Holly song catalogue.

I didn't know most of this in 1978. I just knew Buddy was a fascinating guy.

But there was something this New Mexico kid did know about Buddy Holly: He recorded many of his early hits in New Mexico—in Clovis, to be exact.

Sadly, I never had the chance to head out to the Norm Petty Studios on the eastern edge of New Mexico before my family moved to California in 1983. If we had, maybe I would have met Mr. Petty. He died of cancer in 1984.

39. See Italie, "Bob Dylan turns his Nobel lecture with praise for Buddy Holly."

But upon a trip to Clovis, I made an appointment to see the Norm Petty Studios with Ken Broad, the man in charge of the studios. As I waited outside of the studio with my kids in tow, I pondered the different people who have recorded at this location on 7th Street: Buddy Holly, Roy Orbison, Waylon Jennings, and later, at a different site, LeAnn Rimes.

As Ken Broad got out of his truck, he had two folks from Australia with him, fans that had spent three years of their lives going to various Buddy Holly sites throughout the United States. It turned out that one was the former drummer for one of Bon Scott's (AC/DC) first bands.

Together, we walked through rock and roll history.

We saw where Roy Orbison stood while singing "Ooby Dooby." We heard the original tracks for Buddy Holly's song "Heartbeat" played on an Ampec quarter-inch tape machine. I was able to play the piano, B3 organ, and Celesta that Petty used on all of the Buddy Holly tunes. Likewise, I played a Stratocaster through the amp Buddy Holly used in all his Petty Studio recordings.

As a musician, I was in la-la land.

But where it got real for me was the back room where Norm Petty's guests stayed while they recorded. Ken Broad (who did an amazing job telling us stories, giving us details of recording techniques and unveiling hidden treasures throughout the studio) told us that Norm Petty liked his guests to feel comfortable, and felt that one couldn't "rush creativity." So, Mr. Petty elected to allow as much time as the recording artist needed to make great records.

In the back apartment, I saw the bed where Buddy Holly slept, the kitchen table where he ate, and the famous couch where the Crickets took an early photo. I sat on each one.

So why all this talk about Buddy Holly?

As I was sitting at Foxy's, the restaurant Buddy Holly frequented in Clovis, I asked myself, "What was Buddy Holly's spiritual life like?"

Sadly, there is very little documented in this area, other than testimony from Fundamental Baptists who felt Buddy had slipped from the faith.

According to material culled by David Cloud, "Buddy's older brother, Larry, who is still a member and a trustee at Tabernacle Baptist, believes Buddy was saved but backslidden—and the Lord took him home because of his stubborn rebellion."[40]

Furthermore, "The late Pastor Ben Johnson, who baptized Buddy, testified to E. L. Bynum, the current pastor of Tabernacle, that not long before he died, Buddy told him that he intended to get out of the rock and roll business after he made enough to get out of debt."[41]

In a short article written for *Phantom Tollbooth* (a website dedicated to music with Christian themes), Terry Roland notes, "Buddy Holly was still sending 10% of his income to his Baptist church in Lubbock, Texas. Holly didn't womanize or do drugs; instead, he got married to a woman his own age. For Buddy Holly, the Christian ethic and worldview were a given, without question. It was such a part of his life; he never thought to doubt the faith of his fathers as neatly woven into his career."[42]

All this to say is that it is difficult to determine how much of Buddy Holly's faith influenced his music. In all, Buddy seemed like any twenty-something: He was interested in girls, love, and having fun.

Yet I need to pause after remarking on Holly's pursuits. Is the search for love and fun antithetical to the Christian faith? Hasn't Christ promised joy? Has not the Apostle Paul esteemed the value of marital love? Is not the Christian faith a blast?

The answer to each of these questions is: Yes. Christ promised joy. Paul waxed eloquent about love. And the Christian faith—contrary to many ideas—is fun!

True, Buddy didn't write hymns, not that we know of. Nor do we have any public record of his testimony of faith. Rather, we have songs written by a creative youth discussing themes relevant to young people.

This being so, it's important to note that creativity is a gift from God. God is the Creator, after all. He alone gives us the ability to create. So, whether

40. Cloud, "The Religious Affiliation of Rack and Roll Star Buddy Holly."
41. Cloud, "The Religious Affiliation of Rack and Roll Star Buddy Holly."
42. Roland, "In Memory of Buddy Holly: The Day the Music Still Lives."

Buddy knew it or not, his Fender Telecaster had a way, albeit uncommon, to proclaim God's goodness and love by allowing the world to sing.

As Buddy writes, in the classic song "Everyday," that "love's a little stronger," we are reminded that our core responsibility as Christians is to love. Love is the grand theme of the Christian life—and Buddy prompts us to sing it with gusto every day.

Sometimes we may do well to sing along with Buddy Holly.

Hanford, California: Bulls and the Holy Spirit

On a beautiful Saturday evening, in a small California town, surrounded by cornfields, dairy ranches, and a half-lit moon, one of the most unusual, yet fascinating Azorean/Portuguese traditions took place: Festa Espirto Santo—The Celebration of the Holy Spirit.

According to F. M. Dias, one of the elder statesmen at the Hanford, California Festa, Queen Elizabeth of Portugal (1291–1336) began the celebration. Elizabeth was a pious woman, making prayer and fasting an intricate part of her day. She married the poet Diniz, King of Portugal. Together they had two children. And though Diniz wasn't always faithful, Queen Elizabeth remained with him, pointing him to Christ.

Whether or not there is a direct, historical link between the bull run and Elizabeth, I'm not sure. Yet, traditionally, the event was a festival for the elderly and poor, allowing royalty and the community to provide for those less fortunate, giving entertainment and sustenance.

Overall, there are two guests highlighted at the festival: The Holy Spirit and the bulls.

The emphasis on the Holy Spirit—once again—has a connection to Elizabeth. Tradition holds that she wandered the Portuguese cities with a crown and dove, raising donations for the poor. Later, the feast was celebrated during the season of Pentecost, a time to commemorate the formation of the church with the coming of the Holy Spirit. And because the Holy Spirit is given freely to all those who believe in Christ—a sign of abundance—everything at the festival is free: food, entertainment, drinks, and the like.

At the festival I freely ate sopas (meat, cabbage, and Portuguese bread), linguisa (Portuguese sausage), and Portuguese ribs. Chef Luis Pereira explained that the pork was marinated in veititos. What was freely given, I freely took.

The other guests at the bullfight are the bulls. Some have suggested that the bulls represented evil; other people say they were just a symbol of prosperity. Either way, the bulls are the heart of the entertainment in an event called the Tourda-a-Corda (Bull on a Rope).

Now when I say bullfight, I do not mean spears, blood, and a lone matador. Rather, it is a street fight, with professional street fighters—called toureiros—controlling the bulls, usually with umbrellas or cloth. In addition to the toureiros, four to six men—called forcados, wearing bolero hats and white shirts, harness the bull with ropes, keeping the animals from running beyond the fenced-in street. The street at this festival was lined with haystacks.

In Portugal, the tradition is called the pega, where the forcados are dressed in a traditional costume of velvet, with long knit hats as worn by the celebrated Ribatejo campinos (bull headers).

In California, the bulls are not hurt; and, unless people do not get out of the way, neither are the participants.

Most of the participants used umbrellas and makeshift capes to cause the bull to charge their way. Once the bull runs towards the fighter, the object is simply to get out of the way without being hit.

The many-layered, hay-lined streets—with American, Portuguese, and Azorean flags—were the place most of the people sat to watch the spectacle. Hundreds of people joined the event, mostly of Portuguese descent. To begin the festival, they sang three songs: the American national anthem, the Portuguese national anthem, and a song directed to the Holy Spirit, *Alva Pomba*. When I asked Eva Monteiro, the woman next to me who translated the evening for me (the whole festival was in Portuguese), what some of the words were, she said, "Holy Spirit, come like a river."

The first bull was huge. Once he was let out of the cage, I got an up-close look. This beast was the real deal! No cute little cow here. This bull was enormous and was charging at anything that moved. I, of course, stayed

out of its way, but got a sense of its power once it ran by me, breathing heavily and looking like it would love to get one of these crazy people silly enough to get in its way.

Through the course of the next six bulls, I was in the path of the bull twice. Of which, both times, I jumped out of its way. One of the rope-men joined me in hopping up on the straw bales, landing on my lap.

The Azorean father and son team, Magalhaes, (Francisco and Fabio) gave a wonderful display of bull-fighting techniques during the festival. I asked them what the object of the bullfight was. They told me that it was to play with the bull, keeping out of its reach until it wears out. Once the bull tires, a new bull is brought onto the street. Seven bulls in total were used.

The younger Magalhaes, Fabio, has scars to prove that one does not always get out of the way. To the left side of his eye, and all over his arms, are reminders that the bulls are by no means tame creatures.

Joining them in the bullfight display is local fighter, Joe Dias, other novice fighters, and the curious, including me. I asked Courtney Dias what she thought about her father being a bullfighter. She said, "It was fun." When asked if she bullfights, she replied, "yes," but "only with calves."

Another local bullfighter is Mike Bogas. He is part of a group of eight for-cados who travel to the larger fights, taking on the bulls without a rope. He assured me that I would be safe in the ring. He, for the most part, was my guide on the enclosed street. He explained to me that bulls see only in a triangle and focus in on movement, so if I stood still, I should be fine. Let me assure you, however, I ran once the beautiful behemoth looked my way!

Speaking with one of the rope holders, Dennis Rebelo, I asked him the aim of his job. He simply said, "to keep the bulls under control, so they do not get out of hand in the street, which, in turn, keeps the people safe." I was glad to hear this and asked him if he could especially keep the bulls on a tight rope around me. He laughed and said, "Maybe."

The event went on for two and a half hours. I am pleased to say that I, nor any of the bulls, were hurt. Overall, it was a fun, fascinating, and intriguing festival.

When the Tourada-a-Corda was over, the Portuguese band, Tulare, pounded out songs in a traditional style, while people talked of the night's events, danced, and enjoyed life under the warm, black, night sky.

So, what does the Holy Spirit have to do with bullfighting? To tell you the truth, I'm still not too sure. But what I can say is that there was a spirit of family, fun, and tradition that shaped the whole evening. Maybe, in the scope of things, the spirit of charity, possibly initiated by Queen Elizabeth, is still the guiding sentiment 800 years later, causing people from this small town in California to thank God for His provisions, while singing the hymn, "Alva Pomba: Hymn to The Holy Spirit":

> You come, oh! You come, between glory clouds.
> Between the angels and blessings of love,
> It enters the cantos of perpetual victory
> Who to the poor persons its arms extend,
> You come, oh! You come.
> You offer most beautiful offerings,
> You offer them on behalf of God;
> You will harvest one day a thousand there you arrest;
> When to enter in the kingdom of skies.
> You come, oh! You come!

Lincoln County, New Mexico: Billy the Kid

"A Youth with Nineteen Murders to His Account Now Across the Divide"[43] is the headline from a July 30, 1881 newspaper concerning Billy the Kid. I don't know if the information is correct. But the newspaper does hit upon the fact that Billy the Kid was well known in his lifetime as he is in his death. As for the American fascination with the Kid, I can only attribute it to Hollywood, press, and books.

But for some reason, America's favorite outlaw holds a particular fascination within his home state—New Mexico. I yearned to learn more. To do so, I chose Boxing Day. The day after Christmas, our family decided to do something different: We packed up some clothes and headed south, two and a half hours south, to be exact. Our destination? Lincoln, New Mexico, the

43. *The Republican*, headline.

former residence and workplace of one of the most popular—and some say notorious—outlaws in the Old West.

Why go to a place of murder, intrigue, and mystery the day after Christendom's day of love and hope?

The answer consists of two concrete reasons. One, we've always wanted to see the historic town, taking in a piece of the past in what is truly a beautiful area of New Mexico.

Two, and this may seem odd to some, I wanted to see why Christ came, the reason we celebrate Christmas, why God sent Jesus to seek and save the lost. And even more, to seek an answer: Is there a place for forgiveness in the midst of such chaos and evil?

Here's what I mean: The conflict that made Billy the Kid's name was called the Lincoln County War (1876–1878). Billy (real name William H. Bonney-McCarty) had just arrived from his childhood home in Silver City, New Mexico. He took a job with an Englishman named John Tunstall. As it turned out, Lincoln was entangled in a web of warring factions involving businessmen, insurance policies, politicians, and land rights.

On one side were Tunstall and Alexander McSween. Tunstall was a new transplant to Lincoln, setting up a business in 1876. McSween, a former preacher turned lawyer, was his friend and financial partner. In the other camp stood Irish business owner James Dolan and his business partner, Lawrence Murphy. Each side gathered ranchers, businessmen, and hired hands to fight the other group over business issues. The Tunstall-McSween faction was known as the Regulators. Billy the Kid was part of this group.

The Lincoln County War was marked by revenge killings and conflict involving a host of individuals, including Lew Wallace, then governor of the Territory of New Mexico and author of the Christian classic, *Ben Hur*. On December 15, 1880, Governor Wallace put a price on "The Kid" for $500. This led to Billy's arrest, conviction, and then escape from the Lincoln County courthouse, killing two deputies in the process.

When all was said and done, the Lincoln County War produced modest results, promoting suspicion and hatred in the region rather than peace and justice. The remaining Regulators, including Billy the Kid, continued as fugitives for a year.

In due course, Sheriff Pat Garrett and his posse tracked down and killed some of the Regulators, finding Billy in July 1881 in Fort Sumner, New Mexico. Billy the Kid was shot, killed, and buried at the fort on July 14.

According to the most reliable accounts, the Lincoln War left around twenty casualties. Other reports state that there were closer to thirty or forty murders, even up to sixty over the course of the two-year conflict.

We may never know how many people were killed. The fact is that the Lincoln County War was a picture of humanity at its worst: Murder, political infighting, deceit, revenge, mass drunkenness, greed, business dishonesty, and hatred ruled the day. It was a snapshot of wickedness of its day—akin to the various mass shootings of our day. Unbridled evil.

As I sat on the porch of the historic Wortley Hotel, looking at Lincoln's quaint blend of dilapidated buildings, renovated homes, museums, souvenir shops, and a few personal residences, I couldn't help but wonder if history bore that thought out. Specifically, were the homicide rates of the Wild West greater or less than they are today?

Here's what I found:

In 1878, the murder statistics are estimated at five per 100,000 residents.[44] And if the US had roughly 40,000,000 residents,[45] the homicide rate would fall somewhere around 2,000.

In 2015 the murders were listed at 15,696,[46] or roughly 4.5 per 100,000 people.[47]

As one can see, the homicide rates are roughly the same, falling somewhere between four to five per 100,000 people.

It appears that the number of violent acts leading to death is relatively the same. And the myth of a violent, wild west is just that—a myth.[48] Violence

44. Maltz, Roth, and Eckberg, "Homicide Rates in the Old West."
45. "U.S. Population, 1790–2000."
46. FBI: News, "Latest Crime Statistics Released."
47. Mises Institute, "FBI: US Homicide Rate at 51-year Low."
48. DiLorenzo, "The Culture of Violence in the American West."

isn't relegated to a specific area—or even an era; it encompasses any region and time where people reside.

Prior to 2015, there was a decrease in the murder rate in some cities,[49] but by 2015 many major cities saw an increase in homicide rates. In general, the United States has the highest murder rate in the developed world,[50] but still falls behind compared to other nations.

Most cultures deem murder a sin or something similar. This being said, the question is: Is there a solution to murder? Can it be stamped out or stopped? The short answer is yes and no.

First, yes. In Jesus, the Father was establishing a kingdom of righteousness, one providing justice and salvation. In order to be a part of this kingdom one must receive—and believe in— the gift of salvation provided by Christ. And then, one must become a kingdom builder as represented by a pursuit of Christ's truth, goodness, and justice.

So, yes, there is a solution—Jesus. And for those who follow Christ, a life of justice will ultimately prevail. Though murder is still with us today as it was when Jesus was born (people still are sinners by nature after all), the road to the final point in history when wrongs will be made right is one step closer.

Yet this leads to the next point, answering the *no* portion of the question. Even with more Christians in the world, murder will not cease (evil is still present), but maybe it will decrease as the kingdom is continually built, brick upon brick, life upon life. With newfound faith people may take items of harm and turn them into objects of healing. We can only hope. The Christian's job is to proclaim Christ and allow the Holy Spirit to convict and call the person to repentance.

But there's another thought just as intriguing: The Lord may use the horrendous incidences caused by humans—murder included—to paint a picture of his grace working through providence.

In 2010, a group of New Mexico citizens were pushing for political exoneration for Billy the Kid. Former New Mexico Governor Bill Richardson

49. FBI: News, "Crime Statistics for 2013 Released."

50. Presse-France, "U.S. Murder Rate Higher Than Nearly All Other Developed Countries: FBI Data."

declined the pardon.[51] Since then, others have taken the mantle to see that the outlaw—who some consider an honest person in the midst of political and corporate greed—get a fair hearing, with the ultimate result being a posthumous pardon. To date, Billy has not been politically forgiven.

I know true forgiveness doesn't come from a political pardon; it comes from Christ. Yet if Billy were pardoned at some point in the future, the picture would be poignant, an ember shining in the ashes. And as many can attest, the Lord can make beauty from ashes (Isaiah 61:3), a flicker of light in the midst of darkness.

Speaking of the light: as the sun began to peek over the mountains in Lincoln, I decided to take a morning jog down Lincoln's only paved street. With the silence about me, I began to reflect on the light of Christ. I pondered the way his life has changed lives throughout history, renewing individuals, cities, counties, regions, and even countries. Later in the day, my wife and I had tea at the Dolan House (the rival gang of Billy the Kid), drinking and eating a scone as the hostess explained the history and the renovation of the house. It was present calm in the midst of historical chaos. After tea, we walked by churches and saw Christian symbols on doors and bumper stickers. Light has come to an area of darkness.

And what's true of Lincoln is true for any community: Christ's light shines bright for all who will receive; forgiveness comes to those who bask in its renovating luminosity through a humble request.

And though murder is a reality that we live with around the world, let's not forget the slaying of the One that has led to the salvation of many. The revenge of a realm can be transformed by the renewal of the Redeemer. If it can happen in Lincoln, it can happen elsewhere.

So, again, it's worth asking: Why go to a place of evil the day after Christmas?

For one, Christmas represents the reason why God sent Jesus: to seek and save the lost. And by all accounts, the participants in the Lincoln County War fall within the arena of those needing redemption.

The incarnation is the point in history where God provided a new beginning, a new governing authority for the world, Jesus. Isaiah, writing hundreds of years before Christ's birth, states concerning the Messiah, "For to

51. Hopper, "Gov. Bill Richardson."

us a child is born, to us a son is given; and the government shall be upon his shoulder, and his name shall be called Wonderful Counselor, Mighty God, Everlasting Father, Prince of Peace. Of the increase of his government and of peace there will be no end, on the throne of David and over his kingdom, to establish it and to uphold it with justice and with righteousness from this time forth and forevermore. The zeal of the Lord of hosts will do this."[52]

In Jesus, the Father was establishing a kingdom of justice and righteousness, one providing peace and redemption.

To a certain extent, redemption—or at least renewal—has come to Lincoln, New Mexico. It is no longer a town marked by mass murder. As our family strolled the streets, we noticed they were lined with luminarias—the traditional Christmas decorations of New Mexico, representing the coming of Christ. People were festive, celebrating the birth of the Savior.

Likewise, some of the individuals who survived the war became Christians and respected members of the town. George W. Coe, Billy's right-hand man who lost a finger in battle, became a staunch Christian and prosperous landowner, starting the Golden Glow Ranch in Lincoln. He hung up his guns to serve the community and Christ.

And, as mentioned above, Lew Wallace penned one of Christendom's most popular novels, *Ben-Hur: A Tale of the Christ*, later made into an Academy Award-winning movie starring Charlton Heston. Many consider *Ben-Hur* to be "the most influential Christian book of the nineteenth century."[53] The main character of the novel, Ben-Hur, comes to recognize "that Christ stands for a different goal than revenge, and he becomes Christian, turning to supporting the new religion with money which he has inherited, inspired by love and the talk of keys to a greater kingdom than any on earth."[54]

Wallace completed the novel in the New Mexico Territory while he was serving as territorial governor. According to a popular online encyclopedia, Wallace wrote that he "composed the climactic scenes of the crucifixion in his room by lantern light, after returning from a dramatic encounter with Henry McCarty, better known as Billy the Kid."[55]

52. Isaiah 9:6–7.
53. Lifton, "Ben-Hur: The Book That Shook the World."
54. See https://simple.wikipedia.org/wiki/Ben-Hur_(1959_movie).
55. See https://simple.wikipedia.org/wiki/Ben-Hur_(1959_movie).

Think of this: The events of murder, greed, betrayal, and hatred spawned during the Lincoln County War influenced one of Christendom's great works of literature.

Just as Ben-Hur found forgiveness in Wallace's novel, and Coe found forgiveness in Christ for his actions in the war, others have found forgiveness in Christ.

Christ's light shines bright for all who will receive it. Forgiveness comes to those who bask in its renovating luminosity, not through a political pardon, but through a humble request, asking to stand in the illumination of His eternal, transforming love.

In England, Boxing Day is when servants or employees receive gifts (a Christmas box) from their boss. On this particular day after Christmas in Lincoln, New Mexico, I received my "Christmas box" from my "Supervisor," the Lord, as he reminded me that he is still seeking and saving the lost, bringing light into the midst of darkness. This place reminds me of grace.

The Southwest: In Search of Great Literature

In Cormac McCarthy's Pulitzer-winning novel *The Road*, a father and son leave on a journey in a post-apocalyptic world; the father trying to find well-being for his son, keeping him safe from hordes of cannibals with only one bullet in his gun. It's an amazing novel, worthy of the accolades bestowed upon it, and one every father should read.

In a moment of inspiration, I, too, decide to take a journey with my son. No, I'm not fighting evil people-eaters, nor do I have a one-bullet gun. But I am doing it for my well-being, as a type of literature voyage following Cormac McCarthy's footprints and spending time with my youngest child, Cailan.

To summarize the excursion: We take a driving tour around what I call the McCarthy Loop. Beginning in Santa Fe, we head down I-25 to El Paso, connecting with I-10, then I-35 to San Marcos, Texas. There's reason for all the stops, of course, all related to McCarthy.

But why choose to follow McCarthy around the Southwest?

As noted in a previous article, besides being one of the finest living writ-ers working in the English language, McCarthy is a writer of theological and philosophical weight, asking questions about evil, God, freedom, and suffering with amazing, if unsettling, insight. As one who studies theol-ogy, I am both fascinated and repelled by McCarthy's stark prose and vi-sion. McCarthy is a writer of profound nuances, mythical and real—all wrapped up in a biblical tone. But more so, great literature matters, and its pursuit a noble cause.

Picking up on the theological themes manifest in McCarthy, Matthew Potts in his book *Cormac McCarthy and the Signs of Sacrament* describes the interplay of Christian theology and McCarthy's novels. Potts' explores Mc-Carthy's work to find "movement of sacramental signs."[56]

I guess I'm looking for my own sacramental signs.

With fascinating ideas like these, we jump in our truck and begin our jour-ney in Santa Fe.

Why Santa Fe? Other than it being the city where Cormac McCarthy re-sides, Santa Fe houses the Santa Fe Institute—an organization that explores the intersection of science, literature, and a host of other disciplines under one roof; it's an organization that McCarthy cares deeply about.

Upon a visit to the Santa Fe Institute, I learned that Cormac had his hand in many of its decorative elements: the portrait of Isaac Newton hanging above the conference room fireplace (Cormac commissioned the artist) and the trimmings of another meeting room, resembling a pool hall. I was also shown the desk in the library where Cormac likes to read and write.

McCarthy arrived in Santa Fe after living a few years in El Paso, Texas. It was in El Paso that McCarthy wrote some of his first Western-inspired books—*Blood Meridian* (considered by Harold Bloom to be the greatest modern Western American novel) to the beginning of his Border Trilogy novels: *All the Pretty Horses*, *The Crossing*, and *Cities of the Plain*. Cormac moved to the Southwest after living in Tennessee, where he wrote his earlier Southern-inspired novels.

Knowing this, El Paso was our next destination.

56. See Potts, *Cormac McCarthy and the Signs of the Sacrament*, Introduction.

Cailan and I left Santa Fe and drove down I-25 past the land of outlaw Billy the Kid (Lincoln County), Apache chief and fighter Geronimo (Socorro and Sierra Counties), and a host of scientific marvels (The Very Large Array radio telescopes and the Space Station). There were road signs promoting the renovation of a 400-year old Catholic Church (McCarthy was raised Catholic). This region is very McCarthy-ish: science and theology meet the desolate west, with a tad of history and violence tossed in.

We arrived in El Paso shortly after lunch.

McCarthy lived on a street named Coffin Avenue (the number will remain anonymous for the sake of the current owners). It's tucked in a small community adjacent to barren hills. If you drive to the end of Coffin Ave it stops at a small cliff, giving one a view of the area below. The street runs in an odd, off-kilter trajectory. But it's a nice, if unassuming, neighborhood. The El Paso house has recently been immortalized in the book, *Cormac McCarthy's House: Reading McCarthy Without Walls,* by Peter Josyph. When Cailan and I arrive, it is a beautiful, sunny day, about 75 degrees. A couple is walking a dog, other folks are doing yard work. Basically, it's like any upper-middle class neighborhood in America. It just so happened that a particular home in the neighborhood once housed a great American author who penned some masterpieces within its walls.

I snapped a couple of photos, thinking, *So, this is where it happened.*

There's nothing more for us to do there, other than ponder the mystery of McCarthy's greatness in the midst of modern suburbia, so Cailan and I head back through town to I-10. You get a sense of the isolated area McCarthy wrote about in his Border Trilogy novels as you drive this portion of the freeway. Cactus interspersed with brush, treeless mountains in the distance. El Paso is a connector city to Juarez, Mexico. The area is a comparison of two cultures, of two languages, of two ways of life. These themes are prominent throughout the Border Trilogy, particularly *All The Pretty Horses* and *The Crossing,* and even in the non-trilogy novel *No Country For Old Men.*

After a stop in San Antonio (where the Briscoe Western Art Museum Book Club is studying *Blood Meridian*) to visit the Alamo, missions, and take in some art, we head north to San Marcos.

Why stop in San Marcos?

If there is a Jerusalem to this McCarthy pilgrimage, San Marcos is it. The Wittliff Collection houses the McCarthy papers and manuscripts—the holy grail of McCarthy's work. Housed in the Albert B. Lakek Library on the campus of the Texas State University, San Marco, the Wittliff collection has a host of esteemed Western writers—Sam Shepard, Larry McMurtry, even Willie Nelson memorabilia. Many consider the acquisition of McCarthy's papers as the great catch, helping put the collections on the map.

And if there is a keeper of the grail, it's Katharine Salzmann. She is a marvelous person, but more on her in a moment.

As you enter the Wittliff section of the building, cream-colored walls with wood trimming greet you. Two students sit at a desk.

Cailan and I peruse the Austin Music Poster art exhibit, viewing the host of folks that have played the Austin region. I was pleased to see a Tom Waits poster among the dozens of poster art. We then walked through the Willie Nelson exhibit on display. Great memorabilia.

It must be said that nowhere in my mind did I think I'd be able to see the McCarthy archives. I didn't make an appointment, nor did I think it was open to non-researchers (I was a reader/researcher at the Huntington Library in San Marino, California, so I know the drill).

Yet, after buying a book of letters between Sam Shepard and Johnny Dark published by Texas State University and the Wittliff Collections, called *2 Prospectors*, I asked the lady about the archives and the number of researches that come each year to study the McCarthy papers.

"Oh, you'd need to email Kate about this. She has all the information," she says, handing me a card.

"Thank you," I reply. *Pretty much as I figured.*

As I conclude my time in the exhibit space, I notice two ladies with a man and woman in a room with various author photographs hung on a wall, including two of McCarthy. They were talking about comic books, of all things. I look at the exhibit on J. Frank Dobie, a Western writer who spent some time in New Mexico, as they wrap up their discussion.

The folks in the room say their good-byes. One of the remaining ladies turned to me and asked me about the Shepard and Dark book I was holding. Somehow, I know her face. It was Kate Salzmann. I had seen the documentary *Shepard and Dark* about Sam Shepard's quest to collect his correspondence with Johnny Dark. Salzmann had a cameo as Sam Shepard was meeting with the Wittliff to discuss his papers and the letters. I told Salzmann I recognized her.

She invited me into the room.

The other lady with Salzmann was the former director of archives, now retired. They ask why we came. I tell her my story, the Cormac McCarthy loop. They seem fascinated by the journey. Then it happens. "Would you like to see some original McCarthy manuscripts?" Salzmann asks.

"You can do that?" I ask. It's a dumb question; she is the lead archivist.

"Of course."

"I'd be honored." I then tell her that my sister is an archivist in New York. We chat some.

"What manuscripts would you like to see?" Salzmann asks.

"If it's not too much of a problem, can I see *Blood Meridian* and *The Crossing*?"

As Salzmann walks through a door, the former director talks about some of the writers in the collection, telling a few stories about them. The importance of literature looms large in this place.

Salzmann walks in with a cart, two boxes and card catalogs. She takes one box off the cart, opens it up—and shows us *Blood Meridian*.

"Do I need gloves?"

"No, you know how to handle them."

And handle them I do. I flip through the first few pages, asking questions about editing, the typewriter, and manuscript condition. It's an amazing experience.[57]

57. There is a wonderful book about the editorial decisions made concerning

Next comes *The Crossing*. We repeat the process. I'm enthralled by the sequence of events. I turn pages, study comments, and sit in wonder.

As she's putting away the manuscripts, Kate tells me about the Wittliff Collections. Founded by writer William Wittliff in 1987, the collection's main focus is on Southwest writers, poets, and photographers of notable importance. Salzmann explains that Mr. Wittliff is the catalyst behind the collections, the main proponent and spokesperson for the esteemed collection.

Salzmann tells me about meeting Mr. McCarthy. He was kind, talking easily about movies, but speaking little about his books.

In my mind, Salzmann is a sage, a keeper of scrolls and information of deep importance—manuscripts of profound impact. Salzmann was kind, informative, and helpful. Even my son seemed to take in the process with care. Salzmann asked him a few questions about books. I rejoice in the questions.

There's a beauty in literature that elicits life. It's as F. Scott Fitzgerald wrote, "That is the beauty of all literature. You discover that your longings are universal longings, that you're not lonely and isolated from anyone. You belong."[58]

And belong in place housing great literature, we do.

In *The Road*, the father reminds his son that he must be the keeper of the fire, stating.

> You have to carry the fire.
> I don't know how to.
> Yes, you do.
> Is the fire real? The fire?
> Yes it is.
> Where is it? I don't know where it is.
> Yes you do. It's inside you. It always was there. I can see it.[59]

There's speculation as to what "the fire" in McCarthy's books represents (a theme touched upon in a few of his works). Some say life, others say God. Both are probably right.

McCarthy's work entitled *Cormac McCarthy's Literary Evolution: Editors, Agents, and Crafting of a Prolific American Author*, by Daniel Robert King. It's an insightful read for folks yearning to understand the editing process.

58. See Huang, "The Life and Works of F. Scott Fitzgerald."

59. McCarthy, *The Road*, 279.

I feel like reciting this section of *The Road*, but refrain. Instead we sit among the Wittliff Collections with big smiles on our faces, feeling the warmth of literature's flames. Literature must be kept alive, burning bright for future generations. I feel like I am doing my part.

I am pleased the road I took involved my son in a quest to understand more about great literature, finding that time spent with him is the greatest gift of all. And though I didn't have a one-bullet gun, I now have one word: *fire*.

Part 3

Blink[1]

See how the lilies of the field grow. Matthew 6:28b

I suppose I could
spend my whole
day looking at you

[though the river is
drying, and wars rumor,
with disease knocking
and pestilence abounding]

my little flower: orange-
red with yellow pistils
perched among purple lavender.

[I breathe and think of
lifting my eyes
to see this Earth passing].

But for a moment
there is nothing as
fair as God's fingerprint

pressed upon this

field of quiet

asking me not to blink.

1. *The Penwood Review*, 27.

Things

God is the creator of things; therefore, things matter, whether they're flowers, music, cars, cells, brains, art, amoebas—you name it. There is a whole host of definitions for the word *thing*, but broadly speaking, things are what can be found in creation and the world of humankind.

To get an idea of the sheer variety of things that exist, you only have to turn to the plant world, as I did in my poem above. Research suggests that the earth contains roughly 400,000 species of flowering plants.[2] That's lot of flowery things in the world.

The Bible isn't lacking in things, either: it mentions a host of things, from towers to trees. And God is the author and creator of it all. Because of that great truth, I turn now in this section to a selection of impressions about *things*—some lovely, some strange and fantastic—from art to typewriters.

Abstract Art: Christo at the River

Some time ago, celebrated artist Christo (born Christo Javacheff in Bulgaria in 1935) spoke at the Albuquerque Museum of Art on his then work in progress, *Over the River*. *Over the River* was a proposed land installment that was to cover a portion of the Arkansas River with transparent fabric between the towns of Salida and Cañon City in Colorado.

Christo—who worked in conjunction with his wife, Jeanne-Claude (1935– 2009), on most of his notable works—is recognized for his massive fabric-based art that drapes or surrounds monumental spaces, usually involving abstraction and conceptual ideals. Works such as *Wrapped Coast* (1969), an installation that shrouded 1.5 miles of coastline in Sydney, Australia, and *The Umbrellas*, which spread huge umbrellas over large sections of land in Japan and the US (1991), defined Christo and Jeanne-Claude as international celebrities and leading installation artists, garnering both admirers and critics around the globe. Following his wife's death in 2009, Christo has continued to push the limits of installation art, conjoining aesthetic curiosity with colossal space.

At the Albuquerque Museum of Art, Christo spoke for roughly an hour in his moderately thick Bulgarian accent, covering several past and current

2. Edwards, "Estimate of Flowering Plants."

works and giving an in-depth review on *Over the River*, using photographs and blueprints as his guide.

I sat in amazement as Christo described the amount of preparation, thought, and political maneuvering his works require. From structural analysis to large-scale engineering feats, these works are vast monuments to one person's imagination, prodigious undertakings of aesthetic wonder.

Case in point: *Over the River* consists of nearly six miles of fabric, twelve tons of steel, precisely engineered support structures, and crews to assemble, keep, and sustain the work over a six-week period. The work was first imagined in 1992 but has yet to see the light of day.[3] I asked Christo if his works get vandalized. Luckily, they don't; there's a general appreciation for works of this magnitude.

After listening to Christo, my mind drifted toward the role of abstract art in the world. Early in my Christian walk, I read Francis Schaeffer's classic and influential book *How Should We Then Live?* and was struck by his insightful look at history and the flow of culture, showing how worldviews are shaped by philosophy, literature, and artistic expression. His conclusions on how Christianity answered the questions posed by various worldviews made great sense to me.

That book led me to pick up others by Schaeffer, notably *Art and the Bible*. I appreciated many of Schaeffer's thoughts in this little book as I gained understanding and insight into the arts from a Christian perspective. To this day, I still welcome his four standards of understanding and appreciating art: technical excellence, validity, intellectual content (the worldview that comes through), and the integration of content and vehicle.

Yet there was one thing that troubled me: as one who worked in and greatly respected the field of abstract art, I was disappointed in Schaeffer's opinion about abstractionism. Schaeffer insinuated that abstract art fosters a worldview that distances itself from the Bible, stripping away the humanity of people. He also alluded that abstract art—both in visual and written form—lacked deep content. And, as he stated, "An art form or style that is no longer able to carry content cannot be used to give the Christian message."[4] As a

3. Christo put a hold on *Over the River*; see Worthington, "Christo pulls plug."
4. Schaeffer, *Art and the Bible*, 80.

young Christian, I interpreted this to mean that abstract art can't communicate a Christian worldview.

Elsewhere Schaeffer wrote, "Totally abstract art stands in an undefiled relationship with the viewer, for the viewer is completely alienated from the painter. There is a huge wall between them."[5] It appeared that Schaeffer didn't have much room in his understanding of art to include a Christian notion of abstractionism. The strong phrases "no content," "a huge wall," and "alienated" were meant to convey something specific: abstract art within a Christian worldview is amiss; the two don't mix.

I found myself disagreeing with Schaeffer's conclusion. Now, to be fair, because Schaeffer lived and wrote during the time abstract art was rising in prominence, I'm not sure his keen mind had time to adjust to the ideas surrounding the new genre. I think he hadn't yet come to terms with the fact that abstract art does contain content in both form and substance; it is ripe with meaning.

His statement that abstract art "alienates" the viewer from the painter may show a lack of understanding abstract art. And he failed to connect abstraction to God's created order: God is the author of abstraction. Just look closely at a flower or any natural object up close, and abstraction is there, present in shapes, lines, and colors.

Schaeffer was correct, however, that abstract art divides. It seems there are three reactions to it: people adore it, abhor it, or ignore it. Why? Abstract art screams significance, thought, and opinion; it stretches our understanding of art, form, structure, and meaning. It demands a reaction.

I believe that abstract art shouldn't isolate; rather, it should cause one to investigate, leading one to contemplate. Abstract art forces the human mind to pose questions, make judgments, and form conclusions. Great abstract art invites the viewer into the work with a greater awareness and perception of the technique and style the artist employed in its creation, opening a window to the artist's mind at work.

These ideas resonated with me during a trip to Denver, to visit the Denver Art Museum and the Clyfford Still Museum. At the Denver Art Museum, the *Modern Masters* exhibit highlighted artwork from Jackson Pollock

5. Schaeffer, *Art and the Bible*, 60.

(1912–1956), among other abstract artists. His painting *Convergence 1952* in particular caused me to stop and ponder. Part of my fascination was because I was reading the book *Tom and Jack* by Henry Adams. I learned from the book that Pollock's art actually includes faces, animals, and other unique figures and forms—albeit deep within the paintings. In other words, his artwork is not purely abstract. In one of his first noteworthy paintings, *Mural*, Pollock even used his name (written in large letters across the canvas) to balance the rest of the work. His work is not void of content.[6]

Pollock's *Convergence 1952* is monumental. It is bold. It draws you in, as if it's saying, *Here I am. Look at me.* The first thing I noticed was the drips of paint—the technique, if you will. Then the color, the flow of lines, and the layers. The painting didn't create a wall between Pollock and myself, nor did it alienate me from his thought. Rather, it caused me to stop and ask, *What is this about? How did Pollock paint this?*

Pollock gave the world a gift. It took a while for some to unwrap it, but as more and more people continue to peel away the packaging—not just of Pollock's artwork but also of other abstract painters'—these gifts will continue to delight the senses and the mind.

Then there was the Clyfford Still museum. Still (1904–1980) was another masterful abstract painter. As one of the first American abstract expressionist painters, his work is one of deep contemplation and mood. Though not as visually complex as Jackson Pollock's, his work moves with meaning and structure, bringing a sense of distance and deliberation to the canvas.

What is it about abstract art that causes such strong responses in people? Why do some dismiss it as "something my kindergartner can do"? The answers to these questions are far-reaching, but I'll use Schaeffer's four standards to summarize the importance of abstract art:

Technical excellence: Though some people dismiss abstract art as technically inferior to realism, there is actually a marvelous technicality inherent in its very form. It has its own language of method, style, and substance, seen through its use of color, balance, texture, line, and structure. Knowing and understanding that language can help the viewer appreciate the work with greater clarity. To show the depth of thought that goes into modern

6. See Adams, *Tom and Jack*.

painting, I recommend the reader to view Corey D'Augustine's video series entitled *In the Studio*. Here you'll learn how the abstract masters painted.[7]

Validity: Abstract art is valid in that it is a product of the human will, a legitimate expression of mood, feeling, and the human condition. Think of viewing an abstract painting like viewing the sky. Upon first glance, it may appear a boring blue. But as you look, you notice a splash of clouds, then a bird flying by, then variances in shades of blue. Just as someone looking at the sky may appreciate it with greater study, an abstract painting may at first seem basic and lackluster but upon further viewing will reveal its intricacies. Many abstract artists imbue meaning, structure, and technique into their work through color, shade, texture, balance, form, and style, just as the Creator imbued unique color, meaning, and structure into the sky.

Just because something seems simple doesn't mean that it lacks validity; validity is innate in the work itself. All art has being; it is. And to a certain extent, simplicity—its very existence—is a key factor in helping understand some of abstractions worth, power, and cogency.

Intellectual content/worldview: All humans have a worldview, a way of seeing reality. Abstract art is one way that people perceive what is around them (the world) and within them (their mental and spiritual life). Because of this, abstract art is heavy with intellectual content and has great things to say about life and culture. When we look at any artist's work, we may ask, what did they mean by creating it? What is the essence of their worldview? Does it correspond to reality, either internally (emotions, etc.) or externally (the nature of the world)? Does it have structure, form, and a sense of meaning? And does it express a Christian understanding of the world?

Integration of content and vehicle: By this, Schaeffer may have meant *how* the art communicates the worldview of the artist. Though there are direct ways an artist can communicate a message or meaning, many times artwork lacks a direct meaning. In many situations, it comes down to the interpretation of the individual viewer, which means many different interpretations can arise from a single work. For instance, someone might look at Michelangelo's Pieta statue (Mary holding the dead Christ in her lap) and see Christ dying for the world. Another will see a mother's love for her son. Yet another will see the death due to rebellion. Still others may simply view the statue as a slab of

7. See *In The Studio*. As an example, his assessment of Willem de Kooning is found here: https://www.youtube.com/watch?v=r7sJ_WNiSrs.

marble designed with purpose and order—art for art's sake. Whatever Michelangelo wanted to communicate, people will view the Pieta differently.

An artist may create a work of art with love for Christ, the church, and people, but that doesn't mean its content will be communicated as such; the meaning may be hampered by the worldview of the person viewing the art. Put another way, the intention of the artist may not necessarily translate to the viewer. Though I firmly believe there is an objective side to art (as expressed later), the subjective side fosters various interpretations and meanings.

I know Schaeffer understood this. Elsewhere, he stated that art can't be—or shouldn't be—relegated to simplistic interpretations. Though content and vehicle are important, especially when it comes to understanding the artist and their work, they aren't the only factors in determining the worth or appreciation of art. Something more profound happens in how the content is integrated within the vehicle, largely connected to modern sentiments like pain, crises, and transcendence.

To underscore this point, art critic Daniel Siedell has stressed a particular method for interpreting modern art: Martin Luther's theology of the cross (*tentatio* or *agonizing struggle*). In this interpretation, art emerges not necessarily from proportion (as in classical art) but from pain. For Siedell, "Modern art puts us back in touch with our pain and suffering, which is where art meets us, where God meets us. . . . And, east of Eden, it is only through this suffering and fear that we can experience beauty, goodness, and truth."[8] For Siedell, art and beauty are not necessarily handmaidens of systematic theology but of crises as revealed in culture.

In the end, all authentic art is a product of grace. Siedell wrote that "authentic art is nothing less than an aesthetic testimony to the promise of grace, and as such, it deserves our utmost respect and our efforts to preserve it against forces that would distract us, especially those forces that come in the name of decency and moral values."[9]

I like Siedell's thoughts: grace, pain, and a theology of the cross all play a part in the creation of modern art—including abstract art.

8. Siedell, *Who's Afraid of Modern Art?*, 9.
9. Siedell, *Who's Afraid of Modern Art?*, 25.

My point is that abstract art is as profound as realism, affording a vehicle for the contemplation and comprehension of creativity in human thought. Abstract art is also relevant, giving people a means to understand the divine-human interaction. And, in the end, abstract art is as valid as any artistic medium—a way to interact with God's creative self; to offer thanksgiving, ask questions, pose problems, and give praise; and to confront conflict and pain.

So, to artists like Christo, I say, keep creating. For in doing so, I believe you are imitating and representing the Creator, the one who fashioned the universe with creativity and precision—abstraction included.

Bicycles: Follow the Theologians

Albert Schweitzer did it. Karl Barth did it. C. S. Lewis did it. Jacques Ellul did it. And over the years, I've done it—not as a theologian, but simply as a lover of God. The one common feature between this illustrious group of Christian thinkers and myself is that we've all enjoyed the pleasure of riding a bicycle.

At one point, I made it a practice to ride to work one day a week, making the eleven-mile journey along the Rio Grande in Albuquerque. I still ride my bike to the store, the library, and any other place my heart desires. It's a freeing experience.

One year for National Bike to Work Day, I filled out a questionnaire about why I was riding my bike to work. I began by checking the "environmental" box. But I also checked "exercise" and a few other boxes. I wish there was a "fun" box—I would've checked it, too. Bike riding really provides a number of benefits to both people and the earth.

I think theologian, musician, and missionary doctor Albert Schweitzer (1875–1965) would agree. In his *Memoirs of Childhood and Youth*, Schweitzer wrote about his first impressions of the bicycle:

> While at the village school, I witnessed the introduction of the bicycle. We had heard several times about the carters getting angry with people who dashed about on high wheels frightening the horses. Then one morning, as we were playing in the school yard during the break, we learned that a "speed runner" had stopped at the inn on the other side of the street. We forgot school and everything else and ran over to gape at the "high

wheel" which had been left outside. Many grown-ups showed up as well and waited with us while the rider drank his pint of wine. At last, he came out. Everybody laughed at the grown man wearing short pants. He mounted his bicycle and, lo, was gone.[10]

Schweitzer also described what it was like to get his own bike: "In my second to last year of high school, I myself acquired a bicycle, which I had fervently desired for a long time. It had taken me a year and a half to earn the money for it by tutoring students who lagged behind in mathematics. It was a second-hand bicycle which cost 230 marks. At that time, however, it was still considered unseemly for the son of a pastor to ride a bicycle. Fortunately, my father disregarded these prejudices."[11]

Concluding, he wrote, "The well-known orientalist and theologian Eduard Reuss, in Strasbourg, did not want theology students to ride bicycles. When, as a student of theology, I moved into the St. Thomas Institute with my bicycle in 1893, the director, Erichson, remarked that he could permit this only because Professor Reuss was dead. Today's youth cannot imagine what the coming of the bicycle meant to us. It opened up undreamed-of opportunities for getting out into nature. I used it abundantly and with delight."[12]

I use the bike with the same *delight*. The bicycle connects you to nature, the land, and the world unlike any other mode of modern transportation.

The theologian Karl Barth (1886–1968) was also smitten with the bicycle. *Christian History* magazine relates that he "was one of the first pastors in his region to own a bicycle, which he used to pedal to ministerial meetings."[13] Imagine that: the author of the massive and influential *Church Dogmatics* rode a bike to meet with other pastors.

Professor, writer, and apologist C.S. Lewis (1898–1963) enjoyed bike riding as well—so much so that he wrote an essay called "Talking about Bicycles" in which he related bicycles to deeper theological truths. Lewis began his essay with a dialogue between two friends:

> "Talking about bicycles," said my friend, "I have been through the four ages. I can remember a time in early childhood when a bicycle meant nothing to me: it was just part of the huge

10. Schweitzer, *Memoirs of Childhood and Youth*, 23.
11. Schweitzer, *Memoirs of Childhood and Youth*, 23–24.
12. Schweitzer, *Memoirs of Childhood and Youth*, 24.
13. Galli, "Neo-Orthodoxy."

meaningless background of grown-up gadgets against which life went on. Then came a time when to have a bicycle, and to have learned to ride it, and to be at last spinning along on one's own, early in the morning, under trees, in and out of the shadows, was like entering Paradise. That apparently effortless and frictionless gliding—more like swimming than any other motion, but really most like the discovery of a fifth element—that seemed to have solved the secret of life. Now one would begin to be happy."[14]

Lewis went on to write, "Again and again the mere fact of riding brings back a delicious whiff of memory. I recover the feelings of the second age. What's more, I see how true they were—how philosophical, even. For it really is a remarkably pleasant motion. To be sure, it is not a recipe for happiness as I then thought. In that sense the second age was a mirage. But a mirage of something."[15]

For this man in Lewis' story, the bicycle—and the attitude with which he approached it—represented the seasons of his life, the pursuit of happiness, and a shadow of a deeper longing: a longing for God.

French theologian, lawyer, and sociologist Jacques Ellul (1912–1994) used the bike as means of transportation. In his case, an impromptu bicycle ride played a part in the time he first became convinced of God's existence.

As he wrote, "All of a sudden I knew myself to be in the presence of something so astounding, so overwhelming, that had entered me to the very core of my being. I jumped on a bicycle and fled. I thought to myself: 'You have been in the presence of God.' I started to run for my life from the One who had revealed himself to me. I realized that God had spoken, but I did not want him to have me. I did not want to be controlled by another."[16]

From delight and happiness to the revelation of God's existence, the bicycle has played an important role in the lives of Christian thinkers since its inception. And it plays an important role in mine today.

One October during the Albuquerque International Balloon Fiesta, I took an early morning ride along the Rio Grande to take in the sights.

14. Lewis, *Present Concerns*, 83.
15. Lewis, *Present Concerns*, 84.
16. Ellul, *On Politics, Technology, and Christianity*, 52.

The river was calm and peaceful. Cool, crisp air greeted me. As the sun rose, so did the balloons, silhouetted against the Sandia Mountains. I rode by cottonwood trees beginning to change colors—fading green, a touch of yellow, a sparkle of gold. Canada geese flew in formation overhead, singing to the morning sun. I saw an egret gracefully fly by and take refuge in a Russian olive tree. It was an experience like no other.

Bike riding has even more to offer than just enjoyment. But there are plenty of reasons why more people don't do it.

For example, economics has an influence on whether people ride bikes. According to the National Highway Traffic Safety Administration, "Access to a bicycle rises with household income. According to a government survey of nearly 10,000 Americans: just 29% of those with household incomes less than $15,000 had regular access to a bicycle, 47% with incomes $30,000-$49,000 had access, [and] 65% with incomes $75,000 or more had access."[17]

There's a lot more than income that matters as well. There are sociological factors that determine why people don't ride bikes: the independence a car provides, the size of cities, having children to care for, lack of bike-specific roads, the fear of accidents, and laziness.

As good as some of those reasons are, I suggest that we keep one eye on the future. It's great to read about how the theologians of yesteryear enjoyed riding bicycles. But for us today, we can't ignore the fact that bike riding is good not just for us, but also for the environment. And both of those things—people and planet—are worth the ride.

There are dozens of benefits to biking, including:

1. Better health, which cuts down on healthcare costs and increases the quality of life

2. Less pollution and emissions

3. Affordability: owning a bike can help alleviate poverty among lower income individuals all over the world[18]

4. Less traffic and noise pollution

5. More space for nature and the environment

17. See PeopleForBikes.org.
18. ECF, "The bicycle as a tool for social equity."

I would add that biking also brings you closer to God's creation, to enjoy and revel in the beauty of his masterful design—and to bring you into a deeper knowledge of and love for him.

So, it's time Christians get back on the bike: to think, pray, exercise, and help save gas—and maybe even the ozone layer. Look into joining a club, or just take it slow, like the Slow Bicycle Movement encourages.

And maybe in the process of riding a bike, you'll be drawn closer to Christ. As theologian N. T. Wright said in his commentary on Colossians 2:8, "Being a Christian is like riding a bicycle; unless you go forward, you'll fall off. . . . At every stage of Christian experience, what you most deeply need is not something other than the king himself. You always need more of him. He's what it's all about."[19]

So, let the experience of bike riding move you forward in your journey with Jesus. Like the theologians of yesteryear, give God the glory for every aspect of life and culture, then let the bicycle bring delight as only two wheels can.

Birds: Faith Takes Flight

As I child, I was convinced I could talk to birds. Once on a trip near the Presbyterian retreat center Ghost Ranch (the former summer home of artist Georgia O'Keeffe), we stopped by a small zoo they had on the property. There I walked through the aviary section, whispering to the birds. At nine years old, I was sure a particular red-tail hawk understood what I said; we communed in a language all our own. Since then, birds have become one of my favorite animals.

Several years ago, my Navajo friends gave me a Navajo name. After watching me run about on the Reservation, Grandma Marlene chose dahiiti'hii—the hummingbird—as my designation. She said she gave me the name because I "can't sit still and like to lead with [my] nose."

January 5 is an important day for bird lovers; it is earmarked the National Bird Day. Originally established by Charles Babcok in 1894, it was the first American holiday to recognize our flying friends. On this day bird lovers are to celebrate the occasion with bird watching events and participate in other bird-related activities.

19. Wright, *Paul For Everyone: The Prison Letters*, 164.

I was also pleased to learn that in 1918 the US Congress signed the Migratory Bird Treaty Act—MBTA, providing protection for birds migrating in the United States.[20] As one of the wonders of God's creation—and important participants in ecological preservation, birds should be valued and cared for; I'm glad the US government protects them.

Birds are an indicator of ecological well-being;[21] if we have healthy birds, chances are we'll have happy people. Or as the *Telegraph* reports, "Watching Garden Birds is Good For Your Mental Health."[22] My son Isaiah Nixon, who's an avid New Mexico birder and geographer, points out that the birds help us listen in life: "Birds teach us—in the haste of the day—to be still. With bird watching we become aware of the transcendent and more-than-human aspects of life speaking to us, waiting for us to listen."

I like that. We need to listen to the birds, and the Bible can help us.

Over 300 passages in the Bible reference birds. Most of these passages use the general name fowl or bird. Other passages name a specific type of bird— hawk, vulture, etc.—thereby giving a clue to the interpretation of the text.

For instance, eagles convey strength, power, and endurance, while vultures usually reference death (see Matthew 24:28). The dove—a favorite bird of the biblical writers—represents peace, God's favor, the nation of Israel, and the Holy Spirit. Jesus told his disciples to be "wise as serpents, but gentle as doves,"[23] implying gentleness and good will.

Birds abounded in Jesus' world; he referenced them in several parables and teachings. "Consider the birds," he reminded the disciples as he discussed how God cares for people. "Are not two sparrows sold for a penny?" Jesus asked his followers, stating that "Not one will be forgotten before God," implying the Lord will not forget his children.[24]

Jesus also compared birds to the kingdom of God: "The birds come and make nests."[25] And he referenced birds when discussing the fact that he had

20. See 16 U.S. Code § 703.
21. Hill, "Birds as Environmental Indicators."
22. Wilgress, "Watching Garden Birds."
23. Matthew 10:16.
24. Matthew 6:26–34.
25. Matthew 13:32.

no home: "The birds of the air have nests, but the Son of Man has nowhere to lay His head."[26] The Holy Spirit—in the form of a dove—also descended upon Jesus at his baptism. In short, Jesus was well aware of his feathery friends of flight.

The fact that Jesus was an admirer and observer of birds has led many Christians to be keen devotees of the amazing animals.

Reformer Martin Luther called birds "our schoolmasters."[27] The Christian poet and clergyman George Herbert used birds in some of his poems, arranging the poem "Easter Wings" in the shape of bird wings. C. S. Lewis used birds throughout his *Chronicles of Narnia* books, showing their variety and beauty, naming over a dozen in Aslan's kingdom. Welsh clergyman and poet R. S. Thomas was an avid birdwatcher, spending much of his vacations on birding escapades.

Christian author Debbie Blue wrote a book called *Consider the Birds*, using birds as a means to delve into human nature. And the Americana-goth band Wovenhand—which has many Christian overtones in its music—released an album also entitled *Consider the Birds*. As lead singer David Eugene Edwards stated, "I wanted to remind myself of the birds. I am often anxious. I need to fall on my faith more."[28]

And then there's Dove Award-winning Christian musician Fernando Ortega, who's spent considerable time photographing birds throughout New Mexico, posting his photographs on Twitter, and winning awards for his bird photography (2018 New Mexico State Fair). In a *World Magazine* interview, Ortega stated he has fourteen bird feeders in his yard, "not counting the hummingbird feeders."[29] I spent some time with Ortega at the New Mexico State Fair. Ortega walked me about the exhibit space; his enthusiasm for photography and birds was infectious as he named the birds and pointed out the intricacies of the photographs.

Finally, there's the best-known bird-watching Christian: John Stott. A lifelong enthusiast of birds, Stott called his admiration of birds "orni-theology." One of his best-loved books is *Birds Our Teachers*. In this work, Stott related

26. Luke 9:58.
27. Luther, "Do Not Be Anxious About Your Life."
28. Beta Music, "The Vault."
29. Schmidt, "Singing and Sojourning."

birds to subjects ranging from repentance, self-esteem, gratitude, work, freedom, joy, and love. When I had the honor of meeting John Stott, the book I chose for him to sign was this marvelous work.

In New Mexico we celebrate the sandhill cranes every fall with a festival dedicated to their arrival. In Socorro, they are a feature bird at the world famous birding spot, Bosque del Apache National Wildlife Refuge.

As I watched the sandhill cranes at the open space during the Sandhill Crane Festival in one year, I couldn't help but think of John Stott's book where he reminds us of Jesus' command to be bird watchers. Stott said, "It was Jesus Christ himself in the Sermon on the Mount who told us to be bird-watchers! 'Behold the fowls of the air.'"[30]

Stott continued, "The Greek verb employed here [behold] means to 'fix the eyes on or take a good look at.'"[31] For Stott, bird watching is simply taking Jesus at his word. Stott concluded, "So we have the highest possible authority for this activity . . . [T]he Bible tells us that birds have lessons to teach us."[32]

And teach us they do. Birds are more than just feathery fowl—they're instructors tethering us to God's grace and creativity, helping our faith take flight.

Birds—as representative of God's creation—should be of concern to us. Why? Here's two reasons.

One, as people of the Book, we should let the Bible lead in all areas—including our view of nature. As the Creator, the Lord called his creation "good."[33] Based on God's view of his work, Christians' opinion should reveal the Lord's: creation is good, a reflection of his being as expressed through created order. And since birds are part of his creation, we should value, care, and be concerned for them.

Two, the fact that God loves the world is one of the great tenets of the Christian worldview.[34] God's love for the world encompasses his entire creation, from molecules to man, from *Gardnerella* to galaxies; God's love is endless.

30. Stott, *Birds our Teachers*, 9.

31. Stott, *Birds our Teachers*, 9.

32. Stott, *Birds our Teachers*, 9.

33. See Genesis 1.

34. See John 3:16.

His love for humans includes the social fabric of our constitution, being a reflection of the divine community found in the Godhead.

In short, the whole universe is an immense community. As Christians participating in two broader communities—the city of humanity and the city of God, as Augustine would remind us—we find that we yearn for the success of both. As an example: when something is amiss within the city of God (the church), we must act biblically and decisively to find a solution. So, too, when something is amiss in the broader city of humanity (creation or culture): we must seek a solution for our society.

In short, God's creation and the people who inhabit it are intertwined; people and place are a vast community of participation. Knowing this, we do well to consider the birds, caring for them as our Heavenly Father does.

Jazz: A Language of Prayer

Growing up in the seventies and eighties, I was a product of the popular music and musical outlets of the time: rock, post-punk, genre-specific radio stations, LP records, and MTV. I was also blessed in that my parents, who were both singers, influenced me to delve into genres like opera, high church music, and light classical. All of these outlets helped shape my musical sensibilities.

But one stream of music that didn't enter my consciousness—at least on a serious level—was jazz. Sure, I knew about jazz, people like Louis Armstrong and the pioneers of pop jazz: Herb Alpert and Chuck Mangione. And of course, there were the old crooning stalwarts who infused elements of jazz in their music: Frank Sinatra, Bing Crosby, and the like. But the larger world of jazz remained a foreign language to me—until a fateful visit to the library.

In high school, I was one of those library rats who browsed the bookshelves and record bins every week to find interesting new sounds and literary voices I could relate to, making them my own.

One time I found an album that had an odd cover: what appeared to be a mannequin in front of a chalkboard with a city behind it. The artwork caught my attention, so I checked out the record. The album was *Misterioso*,

343

22243

the performer Thelonious Monk. I've been an admirer of the bearded man with sunglasses and a cool hat ever since.

Later, I studied jazz in college as part of my undergraduate emphasis in music history and became a fan of many composers and players—Monk, John Coltrane, Eric Dolphy, and Dave Brubeck being among my favorites. Ever since then, I've kept one ear tilted toward the world of jazz, finding new favorites and keeping the flame burning of those who have long since passed.

From a Christian standpoint, jazz is intriguing. It's an art form of not just beauty but also cerebral gymnastics, pointing to the intricate nature of God and his creative acts. And I'm not the only believer who's taken a keen interest in this genre of music. Many other Christians have written about the theology, influence, and ideology of jazz.[35] And several jazz composers, including Duke Ellington, Dave Brubeck, John Coltrane, Thelonious Monk, Eric Dolphy, and Wynton Marsalis, have integrated Christian themes in their music.

A number of theologians have also been fans of jazz. For instance, one of J. I. Packer's favorite pastimes is listening to jazz—especially the likes of Jelly Roll Morton.[36] I love that mental picture: the author of *Knowing God*—a practical handbook on the attributes of God—sitting around listening to one of the first great jazz composers.

Through the years, great theological minds have correlated jazz to deeper, biblical truths. Anabaptist theologian James McClendon summarized the shared characteristics of jazz and worship as participation, improvisation, cooperation, recognition, and inclusion. "These," he wrote, "are the requirements for Christian worship of the sort commended by Paul in 1 Corinthians 14."[37] For McClendon, jazz and worship share similar foundations.

In a lecture titled "The Spirit in Creative Expression," R. C. Sproul talked about seeing Thelonious Monk in concert:

> What I noticed immediately was that this man was dressed in
> blue jeans, a faded sweatshirt, he had a cigarette hanging out of

35. Robert Gelinas has given great thought to the topic. See his website, https://robertrgelinas.com/finding-the-groove. See also Jamie Howison's book on John Coltrane, *God's Mind in that Music*.

36. Smith, "Patriarch—Dr. J. I. Packer."

37. McClendon, Jr., *Witness*, 174.

his mouth, sunglasses on—this is now one o'clock in the morn-
ing—and a black wooly Russian Cossack hat. Thelonious Monk
came on the stage, and it was like he was spaced out. He didn't
know where he was. He walked over and straddled the piano
bench sideways and sort of casually leaned over, and started to
plink the keyboard, one note, with one finger. Plink, plink. He
was all over the place with this one finger making sounds that
sounded awful. Then he turned around, sort of, on the bench,
and added the left hand, and started to play what I called Ve-
nusian music: music from Venus. It was not of this world. The
music was dissonant. It sounded like nothing I'd ever heard be-
fore. . . . And then as the sounds that he made got further and
further and further out, it became apparent that there was some
kind of proportionality, some kind of harmonic relationship go-
ing on that was mathematically consistent, and that where most
jazz players were playing ninths and thirteenths, Monk was out
in thirty-firsts and forty-thirds. And somehow, he resolved it.
And out of the discord came a final harmony. And I thought: I
have been in the presence here of a genius.[38]

In Sproul's experience, jazz produced genius, even if it went beyond the
realm of current musical language and understanding. In this, jazz offers
a picture of common grace: God working in and through people with his
truth, beauty, and goodness, reflecting his creative self.

Dutch theologian and historian Hans Rookmaaker asked, "Why did we
[the church] reject . . . jazz years ago, without ever bothering to listen
and ask ourselves whether it might help rejuvenate Christian music?"[39]
How—and why—has the body of Christ largely neglected a form of music
that has such inherent signposts of beauty and craftsmanship? *Must the
church always remain stodgy?* Rookmaaker seemed to insinuate. These are
good questions to ponder.

Beyond the merits of the music itself, a great comparison can be made
between jazz and prayer, a call-and-response between the Creator and his
creation.

There are moments when prayer is a one-sided conversation: you talk to
God and let him know about your concerns, dreams, and desires. This can
be likened to a solo in a jazz number—a single instrument expressing itself.

38. Sproul, "The Spirit in Creative Expression."
39. Rookmaaker, *The Complete Works*, 2:379.

Then there are the moments when God talks back, leading you according to his will and speaking melody into your life. This can be likened to another, different solo break, a conjoining of solos.

Through this improvisational give-and-take combination of listening and speaking, you become in sync with the Lord. Like any good jazz performance, in prayer you'll see the blending of wills working through harmony, sequences, and rests as a means of bringing together the whole composition, different parts becoming one. And when you add in the prayers of the people—congregational prayer—you have the whole band playing in synchronization.

Author Bob Hostetler expounds on the similarity between jazz and prayer:

> I often "pray like jazz." For example, I regularly pray the Lord's Prayer. Sometimes, I pray it just as it appears in the Bible. Other times, however, I pray like jazz. I might begin, "Our Father in heaven, may Your name be kept holy, may It be honored in my family, in my church, in my community. May my conduct today be a credit to Your Holy Name. May everything I do and say reflect Your Holiness rather than my frailty." And so on.
>
> In my daily confession, I often begin with the familiar words, "Almighty God, my Father, I confess that I have sinned against You through my own fault, in thought, word, and deed." And then I usually have plenty of cause to do some free-styling by specifying things like, "In my thoughts, I have hated and cussed and lusted; with my words I have lied and deflected and exaggerated; in deed I have been lazy and careless and a lawbreaker." And so on.
>
> Or I might sing or say a hymn in my evening prayers, such as, "I Need Thee," and after the first few words ("I need Thee every hour, most gracious Lord; No tender voice like Thine can peace afford"), I might improvise, "I need Your healing touch, to comfort and renew, and give me back the joy that comes only from You." Or I may depart entirely from the meter and rhyme scheme and sing or speak whatever my heart longs to express in that moment.

Hostetler concludes, "Praying like jazz gives me the blessing of praying scripture and liturgy and other writers' prayers without limiting my expression or blunting my intimacy with God."[40]

40. Hostetler, "Pray Like Jazz."

That's improvisation.

Going back to McClendon's shared characteristics of jazz, we can see that in prayer, there is *participation*: two or more persons talking together. There's also *cooperation*: a convergence of communication. There's *recognition*: the person recognizes God, and God recognizes the person. And, of course, there is *inclusion*: all people can pray and are welcome to have a conversation with God.

Like prayer, jazz can sooth and settle, or it can call us out and challenge us. No wonder K. Shakelford said that jazz has a "spiritually anodynic or healing power."[41] It may be one of the closest counterparts we have to prayer. For in the end, as John Coltrane said, "Music is the spiritual expression of what I am—my faith, my knowledge, my being. . . . When you begin to see the possibilities of music, you desire to do something really good for people, to help humanity free itself from its hangups. . . . I want to speak to their souls."[42]

Jazz, like other creative expressions, offers a language of sophisticated splendor and complexity. It continues to be a source of varied and unending contemplation for me, from my early days as a library rat until now. Christians in particular would do well to take greater notice of the genre and its musician-theologians, those who play with the great skill, humanity, and inspiration given to them by the Master of music.

Journalism: Telling a True Story Well

"Fact over fiction" was my motto growing up. As I youngster, I didn't appreciate fiction. My reading habits revolved around magazines and books that communicated facts and information—science and history. It seemed to me that if I was going to read something, I should read about something real. Novels were needless.

My attitude changed when I began to seriously read novels in my junior year of high school. I have Steinbeck, Salinger, and Hemingway to thank for that.

But even as I grew to appreciate novelists, I gravitated toward their nonfiction work, such as Steinbeck's *Travels with Charley* and Hemingway's *Death*

41. Shakelford, "Jeremy Begbie."
42. Sullivan, *Encyclopedia of Great Popular Song Recordings,* vol. 1, 401.

in the Afternoon and *A Moveable Feast*. Even C. S. Lewis's memoir *Surprised by Joy* was more appealing to me than his science fiction trilogy.

I didn't know the term for it then, but I was a consumer of creative nonfiction. The common thread in creative nonfiction and its various subgenres is simply that the author aims to tell a true story well, using the same methods a novelist would: description, character development, and dialogue.

Creative nonfiction is a booming business, particularly in the United States, with highly paid writers telling true tales of courage, fear, travel, abuse, adventure—and anything else you can think of. Americans in particular eat up the genre.

Within the field of creative nonfiction is narrative journalism, which is perhaps not as glamorous but just as important. The task of a narrative journalist is similar to a creative nonfiction writer: to tell a true story well, with particular attention to accuracy and research. Most narrative journalism finds a home in magazines dedicated to the craft: *Esquire*, *New York Review of Books*, *Outside*, *New Yorker*, *Harper's*, *Rolling Stone*, and the like.

Unfortunately, journalism in general and the press have seen better days. With the demeaning accusations world leaders have brought against the press in particular, one would think they might be cowering under a rock. But they aren't. There's a simple reason why: fact. And fact—a realistic rendering of how things are—matters. Especially in America, the press is essential to our national consciousness.

On that note, Thomas Jefferson—our third president and the man who helped frame the Declaration of Independence—said the following:

- "The only security of all is in a free press. The force of public opinion cannot be resisted when permitted freely to be expressed. The agitation it produces must be submitted to. It is necessary, to keep the waters pure."[43]
- "[A despotic] government always [keeps] a kind of standing army of news writers who, without any regard to truth or to what should be like truth, [invent] and put into the papers whatever might serve the

43. Jefferson, *The Writings of Thomas Jefferson*, vols. 15–16, 491.

ministers. This suffices with the mass of the people who have no means of distinguishing the false from the true paragraphs of a newspaper."[44]

- "Our liberty . . . cannot be guarded but by the freedom of the press, nor that be limited without danger of losing it."[45]

Jefferson hits on the absolute importance of a free press. Which leads to the fact that journalists—those men and women who seek out and report facts—are important. Take Pulitzer Prize-winning journalist Ernie Pyle as an example.

Born in Indiana on August 3, 1900, Pyle got his start in journalism editing his college paper. He later moved to Washington, DC, and worked as a reporter for the *Washington Daily News*. In 1926, Pyle and his wife, Geraldine, left Washington and drove across the United States, eventually taking up residence in Albuquerque.

During World War II, Pyle became a war correspondent, writing about America's involvement in the war efforts in North Africa, Italy, and, later, Japan, where he was killed by enemy fire on April 18, 1945.

As America's beloved roving reporter during the 1930s and 1940s, traveling America reporting on stories of common people, Pyle not only informed the public of current events but, later, brought many people to tears with his stories of valor and humanity during World War II. Pyle is remembered for writing about the everyday person, whether in rural America or on the front lines of the battlefield. His compassion for the common man, written in simple prose, earned him the respect of millions of readers, with over 400 newspapers around the US carrying his stories.

John Steinbeck, another war correspondent and Pulitzer Prize-winning author, said of Pyle: "There is the war of maps and logistics, of campaigns, of ballistics, armies, divisions and regiments. . . . Then there is the war of the homesick, weary, funny, violent, common men who wash their socks in helmets, complain about the food . . . and lug themselves and their spirit through as dirty a business as the world has ever seen and do it with humor and dignity and courage—and that is Ernie Pyle's war."[46]

44. Jefferson, *The Writings of Thomas Jefferson*, vol. 1, 349.
45. Jefferson, *The Writings of Thomas Jefferson*, vols. 15–16, 73.
46. As quoted in Green, "Then There is the war of the common men."

Pyle died in the pursuit of fact. And the freedom to express facts through a free press is an essential ingredient for a free people.

This truth was underscored when I attended a celebration for Ernie Pyle Day (held on August 3, his birthday) at Pyle's former Albuquerque home, which is now the Ernie Pyle Library. Among other presenters, University of New Mexico journalism professor Michael Marcotte spoke about the current state of journalism in the United States.

Marcotte stated that it is not politicians' attacks on the press per se that are causing a decline in journalism, but a confluence of factors: technological changes (newsprint is going away, and social media and the Internet are taking over), changing economics (advertisers are putting money where the people are, namely, social media and the Internet), and public perception. To drive home his final point, Marcotte shared statistics from the Pew Research Center: 80 percent of Americans trust the military, but only 38 percent trust the press and 27 percent trust politicians.[47] When you add in the fact that the professional field is changing, with low-paying jobs and lack of work, it's easy to see that journalism is treading difficult days. But it is still indispensable.

Marcotte also addressed an interesting question: Why were journalists like Ernie Pyle so revered in their day? According to Marcotte, Pyle told good stories that connected to people. He showed empathy for the little guy and gave attention to details others might miss, highlighting the common humanity between the reader and the subject.

Marcotte gave four reasons why we can still appreciate Pyle today: what he did and what he died for, his talent for listening to people, the fact that he put himself in harm's way to communicate story, and his obligation to tell the truth. In short, Marcotte reminded us that Pyle stood for something greater than himself: fact and freedom.

Journalism—including the wider world of narrative journalism—is more than just reporting facts, however. It is a response to our common condition, our quest to know, to feel, and to respond to the truth, beauty, and goodness—and often the evil—in the world. If for no other reason than this, a free press is paramount to our privileged place on this little planet called Earth. We need to value it for what it is: a voice of our humanity. We should

47. Pew Research Center, "Public Trust in Government."

respect the press, even if we disagree with it, and resist any attempts to silence or censor it, for in doing so, we fail in our freedom.

Rather than criticize journalists, let's pray for them and celebrate their contributions—especially Christian journalists. I'd encourage you to acquaint yourself with the genre and pick up a book about or by a Christian journalist who has used their career to tell true stories well. Here are a few to consider, listed alphabetically by last name:

Buckley, William F.: Nearer, My God: An Autobiography of Faith. As an author, TV host, and journalist, Buckley was a man of faith and a force in the world of journalism, supporting a conservative ethic with broad civility toward all he interviewed and wrote about. Buckley is best remembered as a contributor to the public affairs television broadcast *Firing Line.*

Chesterton, G. K.: The Autobiography of G. K. Chesterton. This British journalist and author is one of history's great literary writers. Known as the "prince of paradox," Chesterton used his journalistic insight to write some of the Victorian era's most memorable books and articles, including the Father Brown mysteries, *Orthodoxy,* and *The Everlasting Man.*

Muggeridge, Malcolm: Chronicles of Wasted Time. Muggeridge was a British journalist and radio broadcaster who exposed the communist regime in the USSR, later becoming a regular guest on British television and film. His later works focused on the impact and importance of a Christian worldview.

Neuhaus, Richard John: Richard John Neuhaus: A Life in the Public Square, by Randy Boyagoda. Lutheran clergyman turned Roman Catholic, Neuhaus was the founder and editor of *First Things,* a journal dedicated to Christianity within the public square.

Olasky, Marvin: Unmerited Mercy: A Memoir. Born a Jew, Olasky went on to become the editor of one of the biggest Christian news magazines, *World.* His story, as he stated in his book, is one of "unmerited mercy."

Phillips, McCandlish: An American journalist who worked for the *New York Times,* Phillips was called one of the great journalists of his era by esteemed journalist Gay Talese. Phillips exposed the Jewish background of senior members of the KKK and the American Nazi Party, winning the Page One Award from the Newspaper Guild for his work. His noted work is *City Notebook* (1974), a series of narrative articles about New York City.

Strobel, Lee: *The Case for Christ.* This book follows journalist Strobel's personal investigation of the evidence for Jesus, which led him to become a Christian. The book was made into a movie in 2017.

Wooding, Dan: *Twenty-Six Lead Soldiers.* English journalist Dan Wooding is the founder of ASSIST News Service. At first writing for various British newspapers, Wooding later turned his attention to cover the Christian world, from the persecuted church to Mother Teresa, Billy Graham, and Brother Andrew.

Yancey, Philip: *I Was Just Wondering.* This book showcases a number of articles Yancey wrote for *Christianity Today*, giving us a peek into his various insights and interests as a writer.

Journalism: it's more than a profession, it's a pronouncement. We do well to preserve and protect its pursuits.

Mental Illness: Donald Woodman and Agnes Martin

Mental illness runs in my family. My grandfather was diagnosed with schizophrenia with delusions of grandeur. As a pastor, this was not a good combination for him. His mother, too, had bouts with mental illness. I loved my grandpa, but never fully understood his state of mind, knowing that it affected my mom and uncle severely. I've heard stories of weird behavior but overlooked the behavior because I was fond of him. So, when I came upon an article published by *Relevant Magazine* entitled "4 Misconceptions about Mental Illness and Faith"—two things my grandfather had—I took notice. Writer Andrea Jongbloed gives four quick characterizations some people have concerning mental illness:

1. People with mental health conditions are unsafe.
2. People with mental illness are unpredictable and difficult to relate to.
3. Most people with mental illness are on welfare or homeless.
4. People with mental illnesses would rather not talk about it.[48]

Jongbloed's article tackles a difficult subject, bringing out many important realities associated with mental illness, particularly as it relates to fear. It's

48. Jongbloed, "4 Misconceptions about Mental Illness and Faith."

a message the church needs to hear. Christians need to ask how we are to minister and convey God's truth and love to individuals with mental illness—in all its forms. Mental illness, like any illness, is a deep and daunting reality we must face head on—with charity, compassion, and, hopefully, a clear idea of the science behind the disease.

Generally, I agree with Jongbloed's points; there are too many misconceptions regarding the mentally ill. However, one question came to my mind during a recent lecture I attended that Jongbloed didn't address in her article (though she alluded to it). The question concerns people trying to help individuals with mental illness. What happens when a person attempting to help crosses the threshold of compassion and falls prey to depression themselves, turning from helping to hurting the person or themselves?

Noted photographer Donald Woodman—husband of internationally celebrated feminist artist Judy Chicago—presented the lecture I'm referring to. Woodman gave the presentation in support of his newest book, *Agnes and Me*. The "Agnes" in the title refers to acclaimed visual artist, Agnes Martin.

For those who do not know Agnes Martin's work and renown, a short word by her representative, Pace Gallery, highlights her importance:

> Agnes Martin (b. 1912, Macklin, Saskatchewan, Canada; d. 2004, Taos, New Mexico) imparted a legacy of abstraction that has inspired generations of artists. Using a limited palette and a geometric vocabulary, her works are inscribed with lines or grids that hover over subtle grounds of color. Martin's work is recognized as pure abstraction, in which space, metaphysics and internal emotional states are explored through painting, drawing and printmaking. Martin is the recipient of numerous awards including the Golden Lion at the Venice Biennale in 1997 and the National Medal of Arts in 1998. She has been the subject of one-artist exhibitions worldwide, including a five-part retrospective at Dia: Beacon, New York, in 2007, and, most recently, a 2015 retrospective at Tate Modern, London, which will travel to Kunstsammlung NRW, Düsseldorf; the Los Angeles County Museum of Art; and the Solomon R. Guggenheim Museum, New York.[49]

49. Pace Gallery, "Agnes Martin."

What is not discussed in this short biography is the fact that Martin was schizophrenic, hearing voices and acting at times in unbearable ways. And the way various articles, institutions, and people have dealt with Martin's mental illness ranges from "the voices told her what to paint" (which doesn't give the credit to Martin for her creativity), to a crazed genius, to an unwillingness to discuss her illness at all.[50]

But Woodman knows better. Over the seven-year period he was associated with Martin and her illness, Martin's uneven behavior and demands on Woodman led him to the point of an attempted suicide, seeking therapy to make sense of it all. The help he attempted to give turned to hurt. True, the signs of Martin's illness were everywhere at the beginning of their working relationship—from Martin's "voices" and self-imposed, inconsolable seclusion, to her erratic behavior. But Woodman thought her behavior was part of her personality, the mystic-artist so celebrated in the art world.

During the lecture, Woodman said Martin's unpredictable behavior became very pronounced toward the end of their working relationship: "One minute she'd say one thing like, 'I love you,' and the next moment she's saying, 'I hate you, go away.'" It was the erratic conduct and words that caused great consternation and confusion for Woodman. He didn't know she was mentally ill (he had hunches), but his suspicions were confirmed after picking Martin up from a mental institution in Colorado. Martin left Woodman's property one day and wasn't heard from for over a week. After a call from the hospital, Woodman drove five hours to pick her up. After the episode Martin opened up about her struggle with mental illness. But sadly, the friction continued, and after another episode (Martin ended up in an institution in Santa Fe), Woodman was gone; their working relationship was over.

If *Agnes and Me* accomplishes one thing, it highlights how one person came to terms with another person's mental illness. But the book is so much more than that, worthy of attention on multiple levels. And, yes, Martin and Woodman did reconcile before her death, largely because Martin got the help she needed.

So, we circle back to my question: How is a person to help someone that is hurting the helper (like Martin was with Woodman)? The answer came during Woodman's presentation: He pointed out that as he walked through a museum celebration of Martin's work in Europe, he was comparing the

50. Laing, "Agnes Martin."

high praise he was reading and hearing about with the reality of Martin's life. It was during this time that Woodman came up with a theory concerning Martin: "She developed a visual language to stop the voices that were constantly in her head; to bring quiet to that, so she could get to the things she painted. She didn't paint about sophisticated things. She was interested in beauty, joy, and innocence." One of the reasons Martin painted was to push away the pain of mental illness.

Woodman's realization provided me with an outline, a way to summarize how to help the helper, in three words: beauty, joy, and innocence. And though Woodman didn't give these three words as a point-by-point remedy for helping someone dealing with the mentally ill, I think they can be subtle guides to ensure that the helper (or mentally ill person) is not hurt to the point of no return.

Beauty: As made in the image of God, people represent one aspect of God's creative acts in the world, a type of bestowed beauty. People have purpose and meaning because of this image—God's imprint—upon our lives. When that print is scarred and the beauty defaced (as with all people, the mentally ill are subject to sin, the self, the world, etc.), we need to ask: What's the remedy for the repair? The clearest answer is a relationship with God in Christ.

But what if the person can't fully comprehend the theology due to their mental illness (such as a severe case of schizophrenia)? At this point, love must manifest; we are to love the unlovable, even if it is from a distance. If the helper of the mentally ill becomes harmed in a relationship, it doesn't mean he or she should stop loving the person. No. The helper needs to employ the language of love. And love requires that we help—maybe not personally, but through encouragement, recommendations, prayer, and assistance, helping the person find the services needed from proper professionals: psychologists, licensed Christian counselors, and doctors—people equipped to deal with the illness.

When we see beauty in someone, our reaction should not be to balk at their condition but to help them blossom into what God intends for them. Exercise love, finding God's beauty in the barrenness of mental illness by helping the person find hope.

Joy: If part of what it means to be human is to find purpose and meaning in life—something beyond just being happy (a state that is always in flux due to feelings)—then joy is something we must remember. Joy isn't something

that we possess (as C. S. Lewis would remind us, "It is never a possession"), but a longing for the kind of existence God intends for us, a deep, lasting character of life, something we press toward and continually seek.

The question is: how do we help a mentally ill person discover meaning in life—joy? For those with mild forms of mental illness, the answer is like any human being: it's first found in Christ, and then in the things that delight him, as worked out through the person's passions and pursuits. But the answer can get complicated the more serious the mental illness, requiring professional insight.

However, there is a simple side to the equation as well: What brings the person joy? As pointed out above, Agnes Martin found joy in painting. As Woodman observed, Martin was able to use her art to help with her mental illness, keeping the voices at bay. Other people have found joy in a host of things: serving others, creativity, and the pursuit of God. And again, if a helper finds himself or herself hurt beyond that which is helpful, then point the person with mental illness to another mentor or professional, someone that will help the person pursue joy, if possible.

Innocence: This third area is a little more difficult to express. I use the word *innocence* not in the theological sense—as a person's moral state of being (someone free from sin or guilt)—but in another meaning of the word: simplicity and harmlessness. In the first sense of the word a pastor or counselor would need to unpack how one is to view innocence. But in the second definition of the word—simplicity and harmlessness—are found key factors that act as a guide in the relationship.

First is simplicity. Is the relationship with the mentally ill person simple? Are you helping the person find God's beauty and joy in life? Are you imaginative in your insight, keeping the person focused on the things that are important to them and their world? Or is your relationship complicated, beyond the scope of your ability to comprehend their condition and care for the person? Do you find yourself confusing the person—and yourself? If it is complicated, then find a mentor to help you simplify the situation or direct the mentally ill person to a professional.

Second is harmlessness. As someone trying to help a mentally ill person, you must ensure you are not harming them or yourself—with bad advice, unproven theories, or unbiblical challenges (along the lines of "the Bible doesn't say anything about mental illness, therefore you are 'demon possessed,'" etc.).

If your relationship with a mentally ill person is harmful to them or you, find a new path to tread, turning the person over to a professional. In the end, you should seek innocence—a pure heart in helping them to heal. Sometimes people with mental illness just need a listening ear and hopeful heart. If you're that person, great; if not, don't let help turn to hurt.

Now let me be clear: I'm not a professional Christian counselor, nor do I claim that the advice given above is textbook clean. No. Rather as a minister with over twenty-five years of counseling experience, I have seen the harm given to both parties in treating mental illness. My point in this article is simple, going back to something Andrea Jongbloed (who struggles with mental illness herself) writes in the conclusion of her article:

"The common stigma against mental illness is exactly what led my pastor and the church leadership to have a negative view of my condition. In light of this, we the people of God have an invitation. In Mark 12:31 Jesus tells us to 'love your neighbor as yourself.' I believe welcoming someone with a mental illness into Church is a great place to exhibit this.

"Be open to learning about mental illness. Have potentially awkward conversations with newcomers who struggle with their mental health. You won't regret stepping outside your comfort zone. You will be blessed with stories of struggle, resilience and redemption. If you're lucky, maybe you'll even become part of someone's story of recovery and reconciliation with the Church."[51]

Toward this end, I say *amen*. Use the framework of beauty, joy, and innocence as an outline for resilience and redemption, understanding the boundaries when dealing with a mentally challenged individual. And like the portrait Donald Woodman painted in *Agnes and Me*, the story of working with someone with mental illness can either hurt or help. For Woodman, it hurt. For others, it can help. In the end, my prayer is that it will heal, bringing hope to everyone involved.

Mountains: John Nichols Encourages a Climb

Living in the southern portion of the Rocky Mountain range in New Mexico, I'm quite familiar with the beauty mountains manifest. They are mysterious and magnificent, providing a glorious frame of reference—both

51. Jongbloed, "4 Misconceptions about Mental Illness and Faith."

geographically and metaphorically—for those of us blessed enough to live in their shadows.

Albuquerque is surrounded by mountains. To the east of the city rises the Sandia and Manzano mountains. To the north are the Jemez and Pecos ranges; to the west, Mt. Taylor; and further south, the Sacramento chain.

Mountains, high desert, and big sky rule this part of the world.

It's of no surprise that award-winning New Mexico author John Nichols[52] (whose book, *The Milagro Beanfield War,* was made into a Hollywood movie by Robert Redford in 1988), has written a novel about a sixty-five-year-old man climbing a mountain.

Called *On Top of Spoon Mountain,* the book follows a character named Jonathan Kepler, who wants to climb a mountain range with his two grown children on his sixty-fifth birthday. The book is a metaphor about the fate of the earth and a touching portrait of an aging man and his children.

I caught up with Mr. Nichols, aged seventy-two at the time, in Albuquerque. He was in town speaking about writing *Spoon Mountain.* Before his lecture, I spent some time chatting with him. Unsurprisingly, our conversation turned toward mountains, particularly the mountains he dearly loves in his hometown of Taos, New Mexico, the Sangre de Cristo.

I asked about the condition of the mountains in the Taos area since the 1990s, when a local PBS station, KNME, did a documentary on Nichols's involvement in protecting the area.[53] He said, "A lot more people live where they filmed that documentary. I don't go out there as much." Nichols liked the mountains when they were less inhabited.

52. Born on July 23, 1940 in Berkeley, California. As the author of thirteen novels, eight nonfiction books, screenplays, and a host of other media-related endeavors, Nichols is a man with a story and a stand: the environment. At a later meeting, Nichols gave a backdrop to his upbringing in New York where his family moved after his birth. From his grandfather's influence as an ichthyologist, to his father's CIA-turned psychologist-turned-naturalist pursuits, to his prep school education where he was taught how to become a "lawyer, doctor, or work the stock market," but "I protested, wanting to become a writer, a rock guitarist, or a comic artist." In 1969 Nichols moved to New Mexico, "the closest thing to a third world country without being in one," he joked.

53. *Colores,* NM PBS.

Mountains mean a lot to Nichols. So much so, that he even inscribed his book to me with the words, "I hope that you can always climb all the real and all the metaphysical mountains as well!"

Since arriving in New Mexico, Nichols has roamed the meadows and ranges—from majestic mountains to mesas. Along the way he fished, hunted, and became an amateur botanist and naturalist. He returned again and again to nests, fields, water spots, and plateaus, learning the names of birds, flowers, plants, and anything that moved, including bighorn sheep, which he said was like "watching paint dry." Even after open heart surgery due to an infection, Nichols—with a walking stick in hand—continued his pursuit of nature's bounty, climbing the mountains of Taos County.

At a later presentation with Nichols, he told a poignant story regarding mountains. It was after 9/11. Because he wrote late into the evening the night before, he didn't wake up until 1 PM on September 11. When he did slouch out of sleep, he looked at his phone machine: it was packed with messages from people in New York. He listened in shock. But he was expecting a friend for a hiking trip on that day. When the friend arrived, they determined to continue with the hike. "Why spend a day watching TV?" Nichols said. He let nature do the healing. Together the two climbed the mountain, in stillness, in wonder. They looked as far as the eye could see— north, to the Colorado mountains; south towards Albuquerque's Sandia Mountains, and west towards the Jemez Mountains. In Nichols's smallness, mountains and nature spoke.

What is it about mountains that create such great emotion in people?

Scottish-born, California-based naturalist John Muir states, "Thousands of tired, nerve-shaken, over-civilized people are beginning to find out going to the mountains is going home; that wilderness is a necessity."[54]

For many like Muir and Nichols, mountains are a necessity.

Even biblical writers admire mountains, offering them as a metaphor for God's protection, "As the mountains are round about Jerusalem, so the Lord is round about his people from henceforth even forever" (Psalm 125:2).

Mountains and hills are mentioned over 500 times in the Bible. God often reveals himself on the mountains. Consequently, mountains carry deep symbolism. Mount Sinai is the place where Moses received the gift of the Law, the Ten Commandments. Thus, writes author Joe Paprocki, "Mount Sinai is a symbol of God's Covenant with Israel. Zion, to the south, is the location of the Jerusalem Temple."

Paprocki continues, "In the New Testament (Mark and Luke to be precise), Jesus appoints the Twelve on a mountain. In Matthew's Gospel, Jesus delivers the Beatitudes in his Sermon on the Mount, conjuring an image of Moses who received the Commandments on Mount Sinai. Matthew's mostly Jewish audience would immediately pick up on the comparison between Moses and Jesus. Matthew, in particular, has 6 significant mountain 'scenes' in his gospel: Jesus' temptation (4:8); the Sermon on the Mount (5:1); a number of healings (15:29); the Transfiguration (17:1); Jesus' final discourse (24:1); and the commissioning of the Apostles (28:16)."

Concluding, Paprocki writes, "Perhaps the most significant mountain scene in the Gospels, however, is the Transfiguration of Jesus. Jesus is accompanied by Moses and Elijah, who themselves encountered God on the mountaintop in the Old Testament. Now, they encounter God through Jesus and Jesus, in turn, is seen as the fulfillment of the Law (Moses) and the Prophets (Elijah)."[55]

To say the least, mountains are important in the Bible.

I've traveled through northern New Mexico's mountains, soaking in their beauty and pondering their power. And I agree with Muir, mountains have become a necessity for me. To a certain extent, mountains contain power in their ability to transform, offering a glimpse into the handiwork of God.

Furthermore, when I look at the mountains out my door, I feel like Donald Miller did when he wrote in his book *Through Painted Deserts*: "And if these mountains had eyes, they would wake to find two strangers in their fences, standing in admiration as a breathing red pours its tinge upon earth's shore. These mountains, which have seen untold sunrises, long to thunder praise but stand reverent, silent so that man's weak praise should be given God's attention."[56]

55. Paprocki, "What is the Significance of Mountains in the Bible?"
56. Miller, *Through Painted Deserts*, 253.

Miller may be right; maybe mountains are signposts of something greater, more awe-inspiring, the Maker of such marvelous creations. Maybe, just maybe, mountains are like dots on a map, that when connected with lines, draw out a picture of God's fingers at work on the Earth.

As I sat listening to John Nichols speak about his book concerning a character climbing a mountain, humorously stating that "It took only twelve years and a hundred drafts to write and it's not even *War and Peace*," my mind drifted toward the real things: mountains and the magnificent God that gave them form.

But the moral of Nichols' presentation was apparent: leave the concrete jungle every now and then and find a natural path, a place for restoration and reflection. In doing so, you'll be like the Muir, who said, "I bade adieu to mechanical inventions, determined to devote the rest of my life to the study of the inventions of God."[57]

Before I open Nichols' *On Top Of Spoon Mountain*, I think to myself, *I hope Kepler makes it to the top*. For that matter—and I say this both realistically and metaphysically—I hope we all make the climb up *the inventions of God*.

Church: Monument, Museum, and Memorial

Museums are special places. To a certain extent—at least in our secular world—they've replaced the church as the domicile of solace, reflection, and inspiration. And a great museum is this and more, giving the participant ample room to muse, consider, and ponder the meaning of art, history, ideas, and life, causing us to interface with society and culture in a unique way.

Now hear me out: I'm not saying that museums have replaced the church. They haven't. As one who actually looks forward to weekend services, I'm not about to say that the church is dead. It isn't. It's alive and well, just like the God it seeks to follow.

But the museum is a unique experience, one that affords a larger perspective on existence. Museums give people the microscopic view of civilization and a macroscopic understanding of our place within it, among large and small worldviews—it can all be found in a museum.

57. Muir and Branch, *John Muir's Last Journey*, xxix.

On a trip to Kansas City, I was able to take in the artistic view of civilization at two art museums: The Kemper Museum of Contemporary Art and the Nelson-Atkins Museum of Art.

It just so happened that the day before we visited the Kemper that its namesake, R. Crosby Kemper, died. The *Kansas City Star* reported on Mr. Kemper's support of both museums I visited: "Kemper appreciated nearly all the arts. His bank's art collection included works by Andrew and James Wyeth, Thomas Hart Benton, Roy Lichtenstein, Andy Warhol and Alexander Calder. He donated liberally to the Nelson-Atkins Museum of Art."[58]

I was appreciative of the legacy Kemper left as I walked the halls of both museums, a recipient of his foresight and investments. He showed that museums matter.

What is it about a museum that draws people like me? Maybe it's the "living tradition," as Daniel Siedell states in his book, *God in the Gallery*. Siedell writes, "Museum art, then, is a profoundly historical practice with a developed tradition, a living tradition of the dead rather than a dead tradition of the living."[59] Maybe I enjoy art because I like tradition, particularly a living tradition.

Or maybe it's the practice of honing my mind and sensibilities, something akin to a cultural and institutional intellect training. Again, Siedell comments: "Art is not only a cultural practice, it is also an institutional practice. Therefore, any discussion of art must take into account its institutional framework. . . . Modern art and its living tradition exists not only invisibly in the hearts and minds of its practitioners and participants but also embodied, meditated in and through its visible public institutions."[60]

Another museum-type experience I had was at Mount Rushmore. The majestic monument-museum is a place of wonder and beauty. In Rapid City, the main urban center at the feet of the Black Hills where Mt. Rushmore resides, my family and I walked the presidential sculpture tour—a memorial of sorts for of all the nation's leaders.

58. Davis, "R. Crosby Kemper Jr. dies in California."
59. Siedell, *God in the Gallery*, 23.
60. Siedell, *God in the Gallery*, 24.

For some reason, three things—a monument, a museum, and memorial—caused me to think about the universal church. I asked myself what is the state of the church today? What category does the church fall within? Is it a monument, a museum, or a memorial? I've heard many say that they don't see the church as a museum, but a membrane of living members. And to a certain extent I agree: We don't need dead donors (memorial), but alive do-ers (the church). However, when you look at the totality of the definitions, all three words can apply to the living church.

A *monument* is defined as a "statue, building, or other structure erected to commemorate a famous or notable person or event." In a way, the church—at least as a building—does commemorate a famous person—Jesus. The church—the people who worship in the physical—stands as testimony of a treasure: the life and teachings of Christ. Furthermore, the church celebrates an event: the death and resurrection of the Lord. Biblically speaking, people are "the church." The Apostle Paul reminds us of this: "Your body is a temple of the Holy Spirit" (1 Corinthians 6:19). But the building is where the people congregate to celebrate the risen Christ. Put another way, God's people—and the buildings in which they reside, however humble or grand—can be seen as monuments of God's goodness, his saving grace within a person and place. So, both the people and the building are a testimony of God's acts within the world, monuments of the Maker.

The definition of *museum* is "a building in which objects of historical, sci-entific, artistic, or cultural interest are stored and exhibited." Though not as easy a connection, there are parallels between a museum and a church. In a museum, one finds objects of historical and cultural interest—though I dare say we find objects of interest in some churches as well: Bibles, stained glass (at least in traditional churches), libraries (some with fine old books), architectural delights, artwork, and more. Church buildings are important edifying markers, giving insight into the people, beliefs, and culture of a particular community. And though it pains many to say their church is a museum, the larger understanding of the word—as conduits of cultural significance—shouldn't cause one to stumble but celebrate; a church is a building where we keep items of importance. And nothing is more impor-tant than the things of God.

Furthermore, churches can be—and should be—cultural points for the community. I think of the church I visited in Boston, the Old North Church, where Paul Revere saw the signal that caused him to proclaim, "The Brit-ish are coming"; or the San Francisco de Assisi Mission Church in Taos,

New Mexico, which has been an inspiration for artists and photographers over the years; or any local community church that houses the Boy Scouts, classes, or help groups. Churches serve the community and thereby act as cultural reminders of the importance of the church within society. And though some see churches as strictly museums, the people that attend the services, I hope, see the church as an Ebenezer stone (see 1 Samuel 7:12), whereby Samuel took a stone and set it up as a reminder that the "LORD has helped us." The church building does highlight cultural artifacts, but none more important than its message concerning the Lord, the gospel. To this extent, churches are museums, gatherers of grand things.

Finally, a *memorial* is defined as "something, especially a structure, established to remind people of a person or event." How a memorial relates to the church is obvious: The church is a living memorial to what God, in Christ, has done for the world. Communion is one means by which most churches remember—memorialize—the life, death, and resurrection of Christ. But churches can be memorials in other ways: weddings, baptisms, funerals, celebrations, and community builders. Church is community in code. I don't mean *code* as in some secret society, but that there is a special language—the language of God, a code, the Bible. And it's this code that guides the people, place, and provenance of the church. The church is a place to remember what God did and what God will continue to do through people submitted to him; through places—buildings—dedicated to him; and through provenance—the source of our life, worked out by power of the Holy Spirit. The church is a living memorial to the activity of God.

The great hymn "Immortal, Invisible, God Only Wise" states it well: "Immortal, invisible, God only wise, in light inaccessible hid from our eyes, most blessed, most glorious, the Ancient of Days, almighty, victorious, Thy great name we praise."

The hymn, written by Walter Smith, references the Apostle Paul's praise in 1 Timothy 1:17: "Now unto the King eternal, immortal, invisible, the only wise God . . ." As the church we declare the great and wonderful certainty of God's work in the world: Christ's past presence, his current presence through the work of the Holy Spirit, and his future coming.

And just as museums host vast collections of artworks—displayed in buildings throughout the world, the church is on display for the world to see. Like a piece of artwork is a witness to the prestige of the museum and collector, the church is to be a witness to the reality of God in our world.

Jesus, speaking to the disciples, spoke of the means of that witness: "But you will receive power when the Holy Spirit has come upon you, and you will be my witnesses in Jerusalem and in all Judea and Samaria, and to the end of the earth" (Acts 1:8).

And just as a museum has unique characteristics concerning its collection of art or objects of splendor—specialties or emphases—so too should the church. But rather than artwork, love is our characteristic. Jesus said, "By this all men will know that you are My disciples, if you have love for one another" (John 13:34–35). Instead of master artwork, love is the greatest display of our unique characteristic in the world.

And one final comparison between a museum and church: both specialize in artwork. For the museum, it's statues, paintings, assemblages, performance art, and the like. But for the church, it's people that God specializes in. The Apostle Paul writes that the church is God's artwork. Ephesians 2:10 states, "For we are God's masterpiece. He has created us anew in Christ Jesus, so we can do the good things he planned for us long ago."

The Greek word for "masterpiece" is *poema*, meaning "poem" or "piece of art." The church is God's creation—his artwork—to fulfill all the good things he has planned for the world.

I wonder if we've invested in the church like Kemper did in the museums in Kansas City, or South Dakota in Mount Rushmore? Have we put the time, energy, and finances into making the church the greatest "living museum" in our community? Let it be acknowledged that this "living museum" isn't just about beautiful works of art—which the church has inspired and created throughout the centuries—but about the people, God's poems and God's ultimate building: his kingdom, being built one life at a time into the greatest work of art the universe could imagine, the new heaven and earth.

Now that's a museum that I can't wait to see.

For in the end, you—the church—houses the most precious item known to humankind—God. So, make Christ the monument (a place to celebrate), the museum (the place to "come and see"), and the memorial (a place to remember) of your life.

Protest: Shia LeBeouf Shows Us How

The first thing that British artist Luke Turner told me concerning the mass of people gathered behind the El Rey Theater in downtown Albuquerque was that the demonstration was "not a protest."

When I asked him what it was, then, Turner replied, "It's an anti-division movement. We are for unity, a central voice of agreement." And actor Shia LeBeouf, who joined Turner, would agree, chanting from afar, "We are *anti* the normalization of division."

When pushed a little further, Turner said that three artists—LaBeouf, Nastja Rönkkö of Finland, and himself—began a "participatory performance" art piece called "He Will Not Divide Us." The "he" is Donald Trump. The work began in New York City and moved to Albuquerque. The performance piece is public in nature, inviting people to say the words "He Will Not Divide Us" into a camera mounted on a wall.

I approached the wall where the words "He Will Not Divide Us" hung above the camera. Drawing closer, I heard a Native American youth rapping into the live web cam. Shortly afterward, a man in a ball cap and ponytail rose from the crowd, hugging the rapper. It was LaBeouf. Over the course of thirty minutes, LaBeouf worked the crowd like a passionate preacher, chanting, hugging, listening, and stopping for pictures.

Later I learned that the performance piece was shut down in New York City after allegations of aggression. The work was moved to Albuquerque where LaBeouf and team received permission for the performance from the city.

Whether or not one agrees with the sentiment behind the performance, one thing was clear: people were exercising their rights as citizens to voice their personal concerns. And for this I was pleased. We live a democracy where freedom of speech is encouraged. We're the better for it.

And protest—be it with art or activism—is nothing new. It goes back to the earliest moments of human history. Even the Bible is full of protest, be it Moses protesting the treatment of the Hebrews or early Christians protesting the treatment of the new faith movement.

The bottom line is that protest goes hand in hand with being a human.

Yet underneath the idea of a protest lies something deeper, more philo-
sophical and moral. At its heart, protest carries the notion that something is
unjust, that the world is out of alignment, that truth is not being heard. And
because of this people react; they protest.

The definition of *protest* is "a statement or action expressing disapproval
of or objection to something." The prefix, *pro-*, is from the Latin, meaning
"bringing something publicly forth." And the suffix, *-test*, is taken from the
Latin for "a witness." To protest, then, is to be a public witness.

The protest movement of the past should not be allocated just to biblical
examples; social protest abounds as well. Here in America we are familiar
with protest movements such as the civil rights movement (led by Martin
Luther King, Jr.) and Vietnam protests (led by such divergent individuals as
Abbie Hoffman and Daniel Berrigan, SJ), among other more recent protest
movements such as Black Lives Matter.

In a way, protests prove that we are people with principles, moral creatures
created to for truth, beauty, and goodness—though not all protests claim or
uphold these tenets. Either way, protests demonstrate that there is a moral
order to the universe.

And though "He Will Not Divide Us" is not touted as a protest per-se, one
can easily see that what LaBeouf, Turner, and Rönkkö are trying to accom-
plish falls well within the accepted definition: It is a public witness. Because
of this, it is protest for people using performance art to make a point, a
positive one at that: a subtle reminder that power in a democracy still can
reside with the people.

The question I ask myself is how should Christians approach protest or po-
litical engagement? The question reminded me of a *Time* magazine article
that designated the person of the year in general terms, as "The Protestor."
Time stated that the "person" is someone who has had great impact—for
good or for ill—on the year.

According to the writer of the article, Jim Frederick, "Because of the success
of the protests this year, at least for the time being, governments and people
in power are going to have to pay very serious attention to public protesters
in a way, that for the past couple of decades, they had been irrelevant or

marginalized. I think that the concept of mass, mobilized protester is a very potent political force and will be now for several years at least."[61]

Paul gave voice to protest in the New Testament when he claimed, "Jesus is Lord." For in saying this Paul was clearly stating that Caesar and the Roman government were not!

Paul often got in trouble for representing Christ—but he took it in stride, since Jesus himself said for his followers to expect confrontation or persecution for being his. In the purest form, Jesus is the Great Protestor, the One who protested the ways of evil, eventually leading to the cross.

But Jesus' protest was not for the sake of protesting, nor for a finite cause. While there was an end to his protest, an intended goal, the long-term picture points to eternity: The cross led to the grave, which led to the resurrection, which will one day lead to a new Heaven and new Earth.

So, though we protest the injustice we see in the world—and agree or disagree with politicians who point one direction or the other—our highest aim should be toward the promise of God's established kingdom. It's his battle; it's his kingdom. Thereby we should wage a peaceful battle, according to his rules, his purposes, and his plan.

Noted theologian Vernard Eller knows a thing or two about the kingdom of God, having written books that deal with the topic. Eller's *The Promise: Ethics in the Kingdom of God* is one of my favorites. It made me think, react, and ask, particularly as a Christian, "Am I taking the words and life of Jesus seriously?" What strikes me about Eller's work is how contemporary it is, though published back in 1970. All the subjects he discusses are issues that we still face today, but with greater girth and weight to the problems.

Take, for instance, the topic of love. Eller finds this one of his core themes in *The Promise*. In the chapter, "I Can't Give You Anything But Love," he writes, "The ethics of promise moves the emphasis away from love's 'feeling' component to the nature of its 'activity.' . . . Agape love is activity, like God's which serves to bring men under his kingly rule and into his future."[62]

61. Frederick, "The Protester."
62. Eller, *The Promise*, 28.

In the same chapter, Eller concludes, "If the love you would practice is to be Christian agape, then it can be done not by your initiating love but only by your becoming a channel through which God's love can operate."[63]

Eller is saying that we must let God love others through us.

Elsewhere in the book, Eller uses Dostoevsky's novel *The Brothers Karamazov*, and D. H. Lawrence's commentary on Dostoevsky, to discuss human freedom, stating: "Until God has been made Lord, all possibilities of human freedom are illusory."[64]

Combining the themes of love and freedom, Eller writes, "What God does when he loves men is to bring them under his kingly rule and when a man comes under that kingly rule, he finds freedom. What a man does when he loves another man is to help him into the kingly rule of God where he can find his freedom."[65]

Love. Freedom. Kingly authority. All-important topics discussed in *The Promise*. And all things worthy to protest for.

Quoting J. R. R. Tolkien, Eller uses the phrase, *eucastastrophe* (overturning), to discuss Christ's advent, life, and resurrection as the protest cycle "that heralds and guarantees the ultimate eucatastrophe of the consummation of the kingdom of God."[66]

For Eller, Christ is the One who overturned all powers, initiating the true kingdom through his resurrection. And as Christians we are to live under the "kingly rule of Christ" in the modern world: "The means to the kingdom of God is to become obedient, radically obedient, to God's kingly rule in the present."[67]

In discussing a Christian's eschatological (end times) perspective, Eller uses the Robert Browning poem, "Pippa Passes." In the poem, Pippa (an orphan

63. Eller, *The Promise*, 29.
64. Eller, *The Promise*, 41.
65. Eller, *The Promise*, 47.
66. Eller, *The Promise*, 23.
67. Eller, *The Promise*, 26.

girl living in Italy) comes to realize that "because God is in his heaven, all is in the way of coming right with the world."[68]

In other words, God is making all things good (Romans 8:28) in accordance with his original purposes described in Genesis 1. And God is doing so through his Spirit working in his people based upon Christ's finished work on the cross and the reality of the resurrection. Because the Father accomplished all this through Christ, the Christian's task in this partnership is not to work *for* our salvation, but to work *out* our salvation (see Philippians 2:12). In short: We are to obey. The "working out" is our obedience—the task of following Christ—as described by Paul in the Philippians passage. And even obedience in the "small events" of life is fruitful.

If working for the kingdom involves protest, so be it. Like the protestors throughout the ages who have a leader shout out words to be repeated by the larger group, we, Jesus-followers, do well to mimic his voice, his motto, and his life.

Trains: Metaphor of the Christian Life

Trains charm me. They're a step back to an older generation, but they also represent the future—a cleaner, more cost-effective ride. Too bad we don't have too many of these massive machines here in the western portion of the US; I'd be riding them all the time. Maybe one day.

As most folks in the Western hemisphere may know, trains helped shape the West. A Scotsman named William Murdoch created the first prototype for the train in 1784. Then in 1804, an Englishman named Richard Trevithick engineered the first locomotive, able to pull a handful of cars. By 1825, another Englishman, George Stephenson, was credited with placing the first engine-drawn train on tracks.

From 1825 onward, trains became the standard mode of transportation in the era known as the Industrial Revolution, helping folks get to places faster, and making the men who managed and made these machines rich. The Vanderbilt, Huntington, Stafford, Hopkins, Fisk, and Pullman families all made their wealth in the train industry.

68. Eller, *The Promise*, 57.

Even President Teddy Roosevelt chose a train for his travels across the United States as early as the 1880s, showing the progress and innovation of America's future. Later, Roosevelt used trains to transport himself and fellow Rough Riders to Las Vegas, New Mexico, to have one of his first Rough Rider reunions in 1899. Why? Because it was a passageway to the Wild West that was accessible via a train, a place where two worlds collided: the old and the new.

With all the history and intrigue trains afford, for me the allure of train travel is the people that ride them.

During one train trip, I sit in car 0412. I take in visual clues and snippets of conversation to begin developing a sense of my fellow travelers. Jose is sitting next to me. The card above our seats tells me he's headed to Kansas City. He's been watching YouTube videos of a lion hunting prey. Behind me a few aisles are an Amish family, traveling back from Juarez, Mexico, where they got cheaper health care. There's a Native American gent reading the novel *Shogun*; a Japanese man traveling the Southwest decked out in Indian-inspired clothes; and college-aged African American girls heading back to Virginia from California.

To say the least, trains have an assortment of people from all walks of life.

All this diversity sort of reminds me of the church.

In 1 Corinthians 12:12, the Apostle Paul writes, "Just as a body, though one, has many parts, but all its many parts form one body, so it is with Christ. For we were all baptized by one Spirit so as to form one body—whether Jews or Gentiles, slave or free—and we were all given the one Spirit to drink. Even so the body is not made up of one part but of many."

As I look around the train, it acts as a great analogy for the body to which Paul referred. The train is one entity (though made up of different cars) heading in a particular direction. The physical body of the train is made up of many strong, metal parts: engine, wheels, rails, observation cars, sleeper cars, meal cars, etc. Likewise, the passengers on the train are an assorted lot: black, white, Asian, Native American, and Hispanic.

Diversity, movement, and strength are found on—and within—the train. And I contend these three areas also are found within the church.

Trains also give a glimpse into the Christian life. During a short trip to Chama, New Mexico, my wife Melanie and I ride the historic Cumbres-Toltec Railroad, then stay at a home run by a veterinarian and his wife, Bonsall and Wendy.

"We moved to Chama largely because of the train," they tell us. They then provide a brief history of the railroad.

> Running for sixty-four miles along the New Mexico-Colorado border, the Cumbres and Toltec Railroad was originally part of the Denver and Rio Grande Railroad service, built for mining purposes in 1881. With the decline of mining in the region the railroad closed in 1968, upon which the states of New Mexico and Colorado bought the property and began daytrip services between Chama and Antonito, Colorado. In 1988, a nonprofit group called the Friends of the Cumbres and Toltec formed, helping preserve the history and upkeep of the trains and tracks.

Not only was I impressed that our hosts left Colorado and a thriving veterinarian business to come to a sleepy town in New Mexico for a train, but I was equally impressed that Bonsall, at almost aged eighty, was still active with both his veterinary practice and his weekly excursion as a docent on the train. I wondered, *What is it about trains that fascinates people?*

Part of the allure resides in trains' nostalgia, a yearning for the good ol' days. Other people marvel at their construction—a spectacle of ingenuity and engineering. And still others view trains as practical transportation. Besides the bicycle—which is the world's most common form of transportation—trains are still one of the favored modes of transportation around the world, coming in just behind cars and buses.[69]

Since the invention of the first passenger train in 1804, trains have captivated people. I don't know if Matthew Murray—who invented the first steam-powered locomotive—or Richard Trevithick—who brought passenger trains to London—or George Stephenson—who helped develop cargo trains for railway use—would have imagined that the machine they helped cultivate would have such nostalgic power upon the world, but indeed they do.

69. Vella, "The World's Most Popular Way to Get Around."

Trains have been memorialized in books, movies, songs, poetry, art, and other forms of popular culture. It's interesting that the word *train* derives from a French word *trahiner*, a derivate of the Latin word *trahere* meaning "to pull" or "to draw." Practically, trains do pull and draw along cargo, be it people or goods, but they also have the tendency to draw us in to their majesty, memoir, and mystery.

But there's one often-overlooked aspect of the train that is just as important: as a metaphor for the Christian life. As dozens of songs will attest—from "This Train," written as a gospel song in the early 1920s, to Bob Dylan's album *Slow Train Coming*, to Tom Wait's "Down There By The Train," trains have provided a practical picture of the Christian journey. And when you add "People Get Ready," the 1965 song by Curtis Mayfield that *Rolling Stone* magazine listed as one of the greatest songs of all time,[70] trains and the Christian life go hand in hand.

With a cursory look at the use of train metaphors, one can see how they provide a symbolic description for life. One railway engineering company lists the following broad metaphors:[71]

- On the right track
- Fallen by the wayside
- Full steam ahead
- Full head of steam
- Letting off steam
- Don't blow your stack
- End of the line
- Backtrack
- On the fast track
- Wrong side of the tracks
- Light at the end of the tunnel
- Train wreck
- Plans got derailed
- Off the rails

70. *Rolling Stone*, "500 Greatest Songs of All Time."
71. Argenia Railway Technologies, "Train Metaphors."

- On rails
- Making headway
- Chugging along
- Watch your caboose

These—and many more—give a practical metaphor and meaning to the spiritual life. For the sake of this short article I'll concentrate on five songs, listed chronologically, to discuss how trains act as a metaphor for the Christian life.

The Gospel Train (1872): In this, one of the first gospel train-themed songs, the lyrics read: "The gospel train is coming/ I hear it just at hand/ I hear the car wheels moving/ And rumbling thro' the land/ Get on board, children/ For there's room for many a more." The main metaphorical device used in this song is an evangelical tool—an invitation to get on board the train, where there's plenty of room to find salvation in Christ and a future home in heaven.

This Train (1920s): First recorded in 1922, the song was made popular in differing generations by Louis Armstrong and Johnny Cash. The lyrics read, in part, "This Train is bound for glory . . . Don't ride nothing but the righteous an' the holy." Here, the train is a metaphor for the spiritual journey, where people are encouraged to ride the train toward heaven. But there's a catch to the journey: One must "ride nothin' but the righteous and the holy." Practically, the "righteous and holy" is a picture of Christ, the righteousness of God (2 Corinthians 5:21). It's upon Jesus' train that people ride. But the metaphor can also apply to personal holiness, a train full of people made holy by Christ's life, death, and resurrection. The rest of the lyrics give sway to the second interpretation, with words such as "no hypocrites, no midnight ramblers, no Jim Crow and no discrimination." Holy living is paramount. Basically, the train serves as a dual picture for Christ and righteous living, one full of justice. It's also important to note that the train described has no transportation fee; it's free, a metaphor for the gospel.

People Get Ready (1965): Written by Curtis Mayfield and later made popular by Bob Marley and Rod Stewart.[72] As one of the more fully formed train metaphors, the words bring together various previous uses of the train as a symbol of salvation, linking faith, heaven, and the redemption of sinners into a graceful declaration of thanksgiving.

72. For complete lyrics, go to: https://genius.com/Curtis-mayfield-people-get-ready -lyrics.

Slow Train (1979): Bob Dylan wrote "Slow Train" for his Grammy award-winning album, *Slow Train Coming*. Dylan didn't focus on the personal, holy living aspect of the train metaphor, per se, but gave witness to the larger cultural aspects of the train, as something bringing an ominous warning. In composing his first major album after his conversation to Christ, Dylan saw the train as a metaphor for the end times, the consummation when Christ will set all things right, with the train "just around the bend," coming soon.[73]

Down There By The Train (1990s): As the most poetic of all train songs, Tom Waits' "Down There By the Train" was released on his album *Orphans* (2006). Johnny Cash recorded the song for his *American Recordings* in 1994. In the song, Waits writes about the full spectrum of human struggle with faith, history, and doubt. Throughout the song, the train is a metaphor for possible redemption or plausible rejection, a battle with sin. To date, "Down There By The Train" is one of the most complex and beautiful train songs written.[74]

As these songs attest, the train is a powerful metaphor for the Christian life. Themes such as Jesus, redemption, perseverance, strength, holy living, sin-derailment, heaven, and end times are all manifest within the metaphor. The train provides a fine analogy for what Christians—and all people—face in times of trial, temptation, tears, and triumphs, offering an expressive glimpse into what it means to be human. So the next time you ride a train, think beyond the majesty (engineering), memoir (history), and mystery (nostalgia and romance) of the train, and realize that you are riding a metaphor for life. Consequently, ride it well, pondering the train's significance as an image for life's journey. It's worth paying attention to because, let's face it, we are all bound for somewhere.

Typewriters: Christians and Writing Machines

If I was a typewriter, I'd be a Smith-Corona Electric. First introduced in the late 1950s, the Smith-Corona Electric, when working properly, types like a dream: smooth, clean, and efficient. I own three later models, including the Electra 120 and 220.

73. For complete lyrics, go to: http://www.bobdylan.com/songs/slow-train/.

74. For complete lyrics, go to: http://www.tomwaits.com/songs/song/294/Down _There_By_The_Train/.

My generation (Generation X: 1964–1984) may have been the last to learn to type on a manual typewriter. I remember sitting in typing class at Grant Middle School, punching away on the keys, learning the QWERTY keyboard and trying hard to get as fast as I could. I was in awe when fellow students were able to get sixty words in a minute. Stunned. *If only I could reach that benchmark,* I thought. If my memory serves me correctly, I only reached forty-five words per minute. Oh, well. The only things I recall about the typewriter I trained on was that it was big and brown. I'm sure it still lives on somewhere. To be reunited with it would be a thing of beauty.

But then something happened. When our family moved to California and I started high school in 1983, there weren't any typewriters in class. Not one. Instead we had these darn things called computers. We had to learn to program on them to type a basic letter. I disliked them quite quickly. *Who wants to program in order to type?* I asked myself. *What a waste of time.* And even though my mom worked for Hewlett Packard, a computer giant, computers were slow to grow on me. During high school I was in a rock and roll band. I was one of the two main songwriters, and we made it a point to type on typewriters, not computers. Why? Because our songwriting heroes used typewriters: Bob Dylan, Tom Waits, and later, Nick Cave. Our thought was that if we wanted to be creative like the masters we mimicked, the typewriter was the place to go for inspiration.

Over the years—particularly after updated word processing came about—computers became my main tool for writing. But I still look back on my typewriter class as the good old days, the golden age of learning to express myself through the written (or typed) word.

Luckily, there is a current movement back toward typewriters. With documentaries such as *California Typewriter, The Typewriter (In the 21st Century),* and various Tom Hanks news clips, the typewriter is making a comeback. Hanks even wrote a book based around the typewriter, *Uncommon Type.* And then there's the lengthy line of books coming out about the typewriter: *The Typewriter Revolution; Typewriter: A Celebration of the Ultimate Writing Machine; Typewriters: Iconic Machines from the Golden Age of Mechanical Writing; Typewriter: The History, The Machines, the Writers; Typewriters for Writers* . . . The list goes on.

In addition to writing on my typewriter, I enjoy learning about other writers and their machines. A list provided by Xavier University is one I turn to often. From this list I've learned other writers also used the same typewriters

I use. I'm a Smith-Corona man. As mentioned above, I use the Electra 110 and the Electra 220. I have one typewriter in my office, the other at home. Other writers who have used the same typewriter as I include Truman Capote, Walter Cronkite, and Robert Caro. For the decorative typewriter, I have a 1930s Remington Noiseless (used by William Faulkner). And when you expand beyond the model to the broader Smith-Corona user family, the list grows exponentially—T. S. Eliot, Tom Hanks, Saul Bellows, etc. It's nice to have a writing family.

I'm glad I'm not the only lover of typewriters. There are plenty of people out there, growing day by day with the various Type-Out gatherings (an event where people bring their favorite typewriter to various local business to type, create, and meet people of similar interests). And there are traveling typewriter exhibits to boot, like Steve Soboroff's typewriter collection of famous writers, featured a few years back on ESPN.[75]

To get a sense of the typewriter craze, I attend a Type-Out, a meeting of typewriter enthusiasts. I talk with one of the founders, Kevin Kittle, asking him about his love of typewriters.

Kittle states that his love of typewriters began early. "I didn't like handwriting as a boy," he begins. "And because my parents owned a print shop, typewriters were readily available. My mom taught me to type as a young child."

While Kevin is speaking, I hear the click-clack of typebars hitting platens as people type on various makes and models of typewriters, set up outside a paper store.

"Because I got pretty good at typing," Kittle continues, "my mom paid me one cent per envelope to address for clients. When I look back, she paid me better than the minimum wage," he smiles. "Later, I received a typewriter as a graduation present. It all began there, I suppose."

Around this time, Kittle begins talking to an older couple. He tells them about an Imperial typewriter that has a radio embedded in its case. "This was made in England. And the radio works." Kevin hits the keys and turns on the radio. The couple is amused, nodding heads. Kevin rattles off the history of the Imperial machines.

75. Markazi, "Steve Soboroff's famous typewriter collection."

Co-founder of the ABQ Typewriter Society, Joe Van Cleave, bonds with Kittle over the mystery and majesty of the machines. They began the Type-Outs a few years ago, and have recently sought to create a society, where, Van Cleave states, "People interested in typewriters can meet over drink and food and talk typewriters." To be specific, the flyer for the society, The Albuquerque Typewriters Society, states: "Periodic meetings where we can mingle and rub elbows with enthusiasts of all ilk."

At a later Type-Out, a woman by the name of Diane Maher drove all the way from St. Louis, Missouri, to attend the meeting in Albuquerque. When I asked her about it, she told me she had a few days off and wanted to support fellow typewriter enthusiasts, adding, "How else would I get these machines to New Mexico?" She pointed to antique typewriters on the table. *A thousand miles is a long way to drive for a weekend*, I thought, but I was impressed with her commitment.

Recently, I've connected with a veritable typewriting expert (he may not think so, but to a novice like me, he's legend). The author of *The Typewriting Revolution*, Dr. Richard Polt is the manager of Xavier University's typewriter website—*The Classic Typewriter*—a cornucopia of information about typewriters. Polt happens to be a philosopher as well, with a specialty on Martin Heidegger. I suppose phenomenology and typewriters have a close affinity. What, I'm not sure—but I can feel it's there.

I've emailed Polt on a couple of occasions to see if he can identify typewriters used by some writers not on his website. Not only is Polt quick—he got Malcolm Muggeridge's Olivetti Lettera 22 upon sight—but he's friendly, as most typewriter folks are, quick to share information about the beautiful machine.

My recent email to Polt concerned theologian and Kierkegaard scholar Vernard Eller. In two photos I own, Eller is seen with a typewriter.[76] The typewriter is clearly a Smith-Corona, as the name on the back indicates. The exact model is unknown. Even Polt wasn't totally sure. His response to my email was "I'm afraid I can't be more specific either, other than to say it's a '50s model."

Yet my request concerning Eller got me thinking. What other theologians or Christian authors used typewriters? And were they as connected to them

76. See Nixon, "eBay, Vernard Eller, and The Promise."

as some writers on Polt's page? The answer is *yes*. Though not all listed below are classified as pure theologians, they are known for integrating faith within their writing from a distinctly Christian viewpoint.

Here's some to check out (many are found on the *The Classic Typewriter* site).

Wilbert Awdry: British pastor and railway enthusiast. He's best known as the author of *Thomas the Tank Engine*. The *Classic Typewriter* site notes that he wrote on an Imperial 66.

Daniel Berrigan: Priest and activist. Wrote on a typewriter, often from jail.

Wendell Berry: Poet, novelist, and environmentalist. Berry used a 1956 Royal Standard. And in his article, "Why I am not Going to Buy a Computer," he elaborates on his—and his wife's—use of the typewriter.

Lewis Carroll (Charles Lutwidge Dodgson): Anglican cleric and author of *Alice's Adventures in Wonderland*. He wrote on a Hammond No. 1.

Vernard Eller: Theologian and Kierkegaard scholar. Authored over twenty books on varying topics. He wrote on a 1950s Smith-Corona.

T. S. Eliot: American poet and Christian statesman, known for his poetry and book *Christianity and Culture*. Eliot used several typewriters, including a Smith-Corona Speedline.

William Everson (Brother Antonius): Poet, typesetter, and Dominican monk. He founded a printshop known as Lime Kiln Press. Typewriter model unknown.

Dorothy Day: Journalist and founder of the *Catholic Worker Movement*. I can't make out the model of her typewriter on *The Classic Typewriter* site, but it's there in several pictures.

Pope Francis (Jorge Mario Bergogli): Noted as writing on an Electric Olivetti.

Sylvester Dom Houédard: As one of the prominent clergy-typewriter enthusiasts, Father Houédard is attributed to creating typewriter art via his concrete poetry.[77]

77. Rawsthorn, "The Eccentric Monk and His Typewriter."

Russell Kirk: Educator, author, and Christian humanist. Online pictures show him with a typewriter.

Robert Lax: Poet and Christian mystic. Lax used a typewriter at his home in Greece.

C. S. Lewis: Christian author and apologist. Though not a typist himself, his brother Warren used a Royal Signet to type up Lewis's manuscripts.

Cormac McCarthy: The man with one of the most famous typewriters, sold for $254,500 at auction.[78] He was raised Roman Catholic and uses an Olivetti Lettera 32.

Malcolm Muggeridge: British journalist and Christian statesman. As noted above, he wrote on an Olivetti Lettera 22.

Reinhold Niebuhr: American theologian and social philosopher. Wrote on an IBM.

Flannery O'Connor: Roman Catholic author writing in the Southern Gothic genre. She wrote on a Remington Deluxe Noiseless. I own one in her honor.

J. I. Packer: English-Canadian theologian and author. Wrote on a Oliver Typewriter. As his famous story goes; he wanted a bike for his birthday, but his parents got him a typewriter: an author was born.[79]

Pope Pius XII (Eugenio Maria Giuseppe Giovanni Pacelli): As noted on *The Classic Typewriter* site, he used an Olivetti Studio 42.

John Stott: English pastor, Bible commentator, and popular theologian. All of his fifty-plus books were written using a typewriter.[80]

William Stafford: Stafford's poetry is filled with theological affinity, due to his affiliation with the Church of the Brethren. Stafford wrote on an IBM.

J. R. R. Tolkien: Catholic author known for his *The Lord of the Rings* trilogy. Wrote on a Hammond.

78. Cohen, "No Country for Old Typewriters."
79. Alcorn, "J. I. Packer and a Tale of a Typewriter."
80. *Christian Today*, "The Woman John Stott Couldn't Live Without."

Leo Tolstoy: Russian novelist and Christian philosopher. Dictated to his daughter, who typed on a Remington.

Dan Wooding: British journalist and founder of ANS news. Wooding told me he wrote on an IBM Selectric.

I'm sure there are many, many more. How I'd love to know what Hans Urs Van Balthasar typed on. Or Dietrich Bonhoeffer. I wonder if Frederick Buechner or Thomas Merton used a typewriter. Then there are people like Albert Schweitzer, shown only with a pen in hand, or A.W. Tozer. Dietrich von Hildebrand? And modern theologians like Norman Geisler, Stanley Hauerwas, Ronan Williams, or N. T. Wright—they probably use computers, but who knows?

Of course, interest in the writing machines of theologians and Christian authors may be a sub-subculture, but the history buff in me is ever so curious. And like a person's connection to a car or a favorite tea, the mode of writing used by authors has the propensity to highlight the type of person he or she is or was, emphasizing an affinity between the person's writing tool and the author. It gives us a peep into the person.

But back to the Type-Out. Looking around the fourth Semi-Annual Type-Out, kids are hitting keys with precision, grandmas giggle as they reminisce, and collectors gawk at various machines. Van Cleave and Kittle answer questions about ribbons, look over various typewriters that people bring in, and conduct a few games whereby participants win gifts, typewriters of course.

One game has partakers listen to a commentary of a horse race from yesteryear on an old record player. Each participant is given a number and typewriter to use. When the announcer on the record broadcasts the number of the winning horse, the corresponding number of the participant is able to pop a balloon with the prize written on a paper found inside. One winner of the game ended up with a newer Smith-Corona. "Really?" she exclaims. "Are you sure? This is such a wonderful gift," she says with the utmost sincerity.

And to tell you the truth, I'm glad people still think so.

Part 4

To Be Is to Belong[1]

In Memory of W. Norris Clarke, SJ

As a child I longed to climb
Trees; to get above things,
To see far and overhead.

I yearned to perceive how the
Geography fits together: the
River and fields, the houses

And streets. I sought to grasp
The farthest point. And here
I learned nothing finite will

Satisfy. So, I continue to
Look beyond the horizon,
Asking questions and

Listening to the sparrows sing.

Ideas

"Everything begins with an idea," said radio host, broadcasting journalist, and author Earl Nightingale.[2] And Nightingale may be correct. As Genesis 1:1 indicates, God created all things. And presumably creation began with an idea (or something like it within the divine realm, a unity of action and

1. *The Penwood Review*, 23.
2. Nightingale, "The Strangest Secret."

being). Along a similar line, artist Barbara Januszkiewicz stated that "creative thinking inspires ideas. Ideas inspire change."[3] As God is the exemplar of creativity and his thoughts are made visible via creation, God created change—physical existence—through his ideas.

How we understand ideas is tricky, as physicist Richard Feynman revealed in his understanding of quantum physics: "Trying to understand the way nature works involves a most terrible test of human reasoning ability. It involves subtle trickery, beautiful tightropes of logic on which one has to walk in order not to make a mistake in predicting what will happen."[4]

Ideas are dizzying, as scientist Nicola Tesla reminds us: "With ideas it is like with dizzy heights you climb: At first they cause you discomfort and you are anxious to get down, distrustful of your own powers; but soon the remoteness of the turmoil of life and the inspiring influence of the altitude calm your blood; your step gets firm and sure and you begin to look—for dizzier heights."[5]

When it comes to ideas, a head tilt is needed.

What exactly are ideas? According to psychologist Richard Haier, ideas are hard to pinpoint. As he wrote in *Scientific American*, "Every idea, like thinking in general, probably arises from a cascade of neural events, which we should be able to discern by scientific means."[6] These neural events may be detectable by neuroimaging.

Haier went on to state, "Nevertheless, neuroimaging has already had some limited success. For example, by analyzing activity in the brain while a person watches a video, it is possible to get a general sense of the content of the video. Though impressive, this feat is a long way from distinguishing the signature of a specific spontaneous thought or insight from the constant cacophony of billions of neurons firing on and off, randomly and in dynamic patterns."[7]

3. See http://www.barbaraj.info.
4. Feynman, *The Meaning of It All.*
5. Tesla, "On Electricity."
6. Haier and Conde-Martinez, "Ask the Brains."
7. Haier and Conde-Martinez, "Ask the Brains."

Translation: we don't quite know what ideas are or how they work. They are a mystery. Closely related to this mystery is thought in general. If you believe pop guru Deepak Chopra, people have roughly 70,000 thoughts per day.[8] That's a lot of thinking.

The Merriam-Webster Dictionary defines an idea as "a formulated thought or opinion," "whatever is known or supposed about something," "the central meaning or chief end of a particular action or situation," an "entity,"[9] and the list goes on.

Ideas are wide and wondrous, and they have revolutionized the world. CNN lists ideas such as farming, the unconscious, relativity, vaccination, human rights, evolution, the World Wide Web, soap, the number zero, and gravity among the game changers.[10]

Ideas are given center stage in the essays that follow. Some of them are my ideas, presented as theories, concepts, hunches, or questions. Some are the ideas of others like Pavel Florensky, Daniel Dennett, and Norman Geisler. In the end, the best way to deal with the mystery of ideas is to simply delve into them and see if they bloom like a flower after a rainstorm.

Kalokagathic: An Argument from Beauty[11]

While reading an essay on Russian avant-garde art,[12] I came upon a fascinating sentence: "the icon that is, in itself, 'proof of the existence of God.'" The quote, attributed to Russian mathematician and priest Pavel Florensky, struck me. Can art—or by extension, beauty— be evidence for the existence of God? I later purchased the book Florensky wrote, *Iconostasis*, to review the exact rendering of the reference, which reads: "There exists the icon of the Trinity by Andrei Rublev; therefore, God exists."[13] The context of Florensky's statement is found within his discourse differentiating Western art from Russian, Eastern art. After extolling the virtues of pattern, color, line,

8. NeuroSkeptic, "The 70,000 Thoughts Per Day Myth?"

9. Merriam-Webster, "Idea."

10. Mackay, "10 Ideas that Changed the World."

11. I'd like to thank Dr. Norman Geisler for reviewing my attribution of his work, ensuring my representation of his thoughts was correct. Even after his passing in 2019, his influence and legacy live on.

12. Spira, *The Avant-Garde Icon*, 20.

13. Florensky, *Iconostasis*, 68.

and light—things associated with artistic beauty, he proclaims his statement within the sphere of the icon as a witness for God. The painting he's referencing is by Russian iconographer, Andrei Rublev (1360–1428), whose Trinity is considered the apex of Russian iconographic art.

Summarizing the idea behind the phrase, one can extrapolate Florensky's quote to suggests that because a painting has both being (it is) and beauty (color, line, pattern, light, transcendence, etc.) it is an indicator of God's existence. To clarify how some perceive icons—and help focus on what follows, Orthodox theologian Peter C. Bourteneff writes, "Icons are not themselves subjects of worship; they are depictions, or translations, of the divine and heavenly realities."[14] In other words, an icon—and by extension, beauty—can translate—communicate—God's being. For Bourteneff, much like Florensky, an icon demonstrates the divine.

I think these men are correct—and I want to explain how.

Subjective

It was Margaret Wolfe Hungerford who coined the phrase, "Beauty is in the eye of the beholder," summarizing centuries of sentiment concerning beauty from Greek philosophers to Shakespeare to Benjamin Franklin.[15] The phrase suggests that beauty is subjective, a matter of personal taste and an individual assessment of an object's attractiveness—and this is true. One person's view of beauty may not be another person's.

For example, someone might look at an action painting by Jackson Pollock—with its irregular, spattered paint and nonobjective subject matter—and say, "It's so ugly!" But another person looking at the same painting may qualify it as a masterpiece, a move toward new, expressive modes of color, application, and meaning. The painting, to him or her, is beautiful.

Objective

Which person is right? As Hungerford states, *beauty is in the eye of the beholder*; it's subjective and personal. Both—the lover and hater of Pollock—would be correct within the context of subjective beauty. And there's

14. Bourteneff, *Arvo Part*.
15. Phrase Finder, "Beauty is in the eye of the beholder."

many studies showings that aspects of beauty are, indeed, subjective.[16] But I contend there is an objective side to beauty as well, not only in the object itself (such as a flower), but a mechanism in the brain that beholds beauty, inferring a metaphysical reality (how we understand and interpret beauty: ideas). This objective side of beauty leads one to postulate that beauty begets beauty, as life does life. In other words, because there is an object to behold followed by the ability to behold beauty, there must be beauty in the world.

Simply put, beauty exists—objectively and subjectively. And theologically, the existence of beauty is an indicator that there is a Beautiful One, namely, God. Or, as Maximus the Confessor implied, creation (beauty expressed) consists in the ideas of God actualized. God is perceived in beautiful things.[17]

Beauty as an indicator of God's presence can be summarized as the kalokagathic argument, which gets its name from a combination of two Greek words meaning *beautiful* (*kalos*) and *good* (*agathos*).

Ontological: Beauty Is Real

The study of being is called ontology. Ontology deals with existence and reality. Because beauty has being, we can assess it, asking questions like why is there beauty at all? Why are certain things, such as nature or music, widely considered beautiful or appealing? And what constitutes the beauty or attractiveness of a thing? How do we measure it?

There is an enormous amount of research delving into these questions, but the simple answer is: beauty is found in being, it is. Ontologically, beauty is part of reality; it exists. So, it's safe to say that if beauty didn't exist, we would be talking about it in any verifiable way. But it does, so we can talk and study it, physically (via attributes) and metaphysically.

Hence, the kalokagathic argument for beauty begins with the converse of the subjective understanding of beauty; it argues that beauty has a base in objective reality, leading to a subjective interpretation of its existence.

16. http://www.bbc.com/future/story/20150622-the-myth-of-universal-beauty.
17. See Bahrim, "The Anthropic Cosmology of St. Maximus the Confessor."

Beauty Is Universal

Because there is both an objective and subjective side to beauty, the questions posed above are difficult to answer because there is no universal criterion of what is beautiful. Many folks debate the criterion of what makes something beautiful. Even so, people across the spectrum of humanity have an inborn ability to recognize beauty, something that attracts or strikes them in accordance with their cultural or personal preference, something that leaves them in awe or pleases his or her senses. And this awareness is based on a thing's being, its objective presence, and how one interprets the thing, the subjective meaning.

Tough questions aside, it's interesting to note that—regardless of culture—people have a natural inclination for the beautiful. An African culture's view of beauty may differ from an Indonesian's, but both cultures have a sense of beauty. Beauty is universal. Though the object-subject argument is deep and wide,[18] my argument up to this point is that beauty is actual, with both an objective and subjective reality.

Biological: Brain Fine-Tuned for Beauty

Beauty's reality is something our minds confirm: there is a mechanism in the human brain that processes and understands beauty; we are born with a propensity to grasp beauty. According to neuroaesthetics (a subgenre of cognitive science), the part of the brain involved in recognizing beauty is the right anterior insula. Sensory studies demonstrate that this region is "an area typically associated with visceral perception, especially of negative valence (disgust, pain, etc.)."[19] In short, "there are general aesthetic systems that determine how appealing an object is, be that a piece of cake or a piece of music."[20]

Though there are different notions of what makes something beautiful, there is biological reason to acknowledge that our minds are wired for beauty. Beauty is; and our minds know it.

Cognitive scientists and biologists debate the role of beauty in nature; some see it as a result of evolutionary processes while others see it moving beyond

18. https://plato.stanford.edu/entries/beauty/#ObjSub.
19. Brown et al., "Naturalizing Aesthetics."
20. Brown and Gao, "The Neuroscience of Beauty."

evolutionary processes.[21] But I don't want to argue how beauty came to be—rather that it is actual; it is in the world. Beauty—or at least the ability to cognitively process and understand beauty (via synapses, etc.)—exists as a function of the mind; beauty is part of the brain's process as a biological entity.

Historical: Aesthetics

Beyond the objective-biological aspects of beauty, history is replete with men and women who wrote about and debated the beautiful.[22] The study of beauty is called aesthetics.

In the Middle Ages, Thomas Aquinas formally defined beauty as something having proportion, integrity, and clarity.[23] Aquinas built upon the thought of people like Pseudo-Dionysian and Peter Lombard. And before Dionysian and Lombard,[24] the Greeks (Plato and Aristotle's Poetics) and Romans (Plotinus) wrote about the beautiful. After Aquinas, men and women during various eras—from Kant to Kierkegaard and Hegel, expanded and augmented the arguments.[25] The debate continued in the modern era with people as far reaching as Heidegger, Dietrich van Hildebrand, and Hans Urs von Balthasar. The discussion continues today. These people, along with many other civilizations—Chinese, Indian, African, Arab, etc., deal with beauty from differing vantage points. The discussion of beauty is historically verifiable.[26] Beauty is something people around the world and throughout history have deliberated; it's trans-cultural.

So not only can we verify beauty's existence objectively and subjectively, but in history. Beauty is actual and has been a part of civilization from the known beginning, pronounced in writing, art, and music—and many other ways.

21. Jabr, "How Beauty is Making Scientists Rethink Evolution."

22. The study of beauty is called aesthetics; for a history of aesthetics, see Bredin and Brienza-Santoro, *Philosophies of Art and Beauty.*

23. See Eco, *The Aesthetics of Thomas Aquinas.*

24. Eco, *The Aesthetics of Thomas Aquinas.*

25. See Bredin and Brienza-Santoro, *Philosophies of Art and Beauty.*

26. Bredin and Brienza-Santoro, *Philosophies of Art and Beauty,* 15.

Kalokagathic Argument

Because beauty is real, the kalokagathic argument for beauty follows the thought processes of many classical arguments for the existence of God, but it has a special relationship to ontological and teleological arguments: reasoning from being and from design, respectively.

Norman Geisler wrote, "The mere concept of God as an absolutely Perfect Being demands that He exist."[27] This is what's known as the ontological argument. Geisler went on to outline his ontological argument in a syllogism, or logical argument that uses deductive reasoning:

1. If God exists, we must conceive of Him as a Necessary Being.

2. But by definition, a Necessary Being cannot not exist.

3. Therefore, if a Necessary Being can exist, then it must exist.[28]

A Necessary Being is necessary for existence. Nothing can't create something, but someone can create something. And this someone, historically understood, is God. Geisler went on to state, "While the ontological argument cannot prove God's existence, it can prove certain things about His nature, if God exists."[29] So if God exists, as the ontological argument advances, then he exists perfectly.

And embedded within God's perfect existence is beauty. Because beauty exists, it must have come from somewhere; beauty begets beauty. Because beauty is real, it points to a greater being, namely God. Why? It follows that as being begets being and life must come from life, so beauty must come from beauty—as mentioned above.

Homing in on the connection between beauty and God, Geisler pointed out that "the attribute of beauty in God is based in the idea of being. It can also be derived from His causal connection with His creation."[30] Geisler explained: "Being (reality), insofar as it is knowable, is true. Being, insofar as it is desirable, is good. And Being, insofar as it is pleasure, is beauty. So, again, beauty in God is that aspect of His Being which, when perceived by his creatures, provides a sense of overwhelming pleasure and delight."[31]

27. Geisler, *Systematic Theology*, 1:35.
28. Geisler, *Systematic Theology*, 1:35.
29. Geisler, *Systematic Theology*, 1:35–36.
30. Geisler, *Systematic Theology*, 2:239–240.
31. Geisler, *Systematic Theology*, 2:239.

Put another way, because there is a Necessary Being in whom is beauty, it follows that his beauty is reflected in his creation, in physical reality. And because of God's impartation of beauty, humans can bask in beauty, both objectively and subjectively.

Then there's the teleological argument. As Geisler summarized, "The teleological argument reasons from design to an Intelligent Designer."[32] His syllogism for the teleological argument is as follows:

1. All design implies a designer.
2. There is great design in the universe.
3. Therefore, there must have been a Great Designer of the universe.[33]

As in the ontological argument, where being begets being, the teleological argument posits that a Designer begets design. And if there is design in the human brain (the most intricate biological entity known to humankind[34]), and part of the design of the brain is structured for beauty, then it follows that beauty must have come from a designer. God is the source and cause of beauty.

In short, because God is beauty and designed beauty, he manifests beauty in reality, both objectively in the functioning of our brains and in the object (creation), and subjectively in our ability to grasp and conceptualize beauty.

So, here is a simple syllogism summarizing the kalokagathic argument from beauty:

1. If beauty exists, it must be conjoined in a Necessary Being which cannot not exist.
2. Consequently, beauty, as an attribute of a Necessary Being, cannot not exist; it is actual.
3. Beauty exists; therefore, we must conceive of beauty as real, rooted in reality as an attribute of a Necessary Being as conveyed through creation.

To sum it all up, beauty is; therefore, God exists.

32. Geisler, *Systematic Theology*, 1:31–34.
33. Geisler, *Systematic Theology*, 1:31.
34. *The Independent*, "The Human Brain is the most complex structure."

In the striking words of Florensky, "There exists the icon of the Trinity by St. Andrei Rublev; therefore, God exists."

Syllogistic renderings aside, why all this beauty-speak? The reasons are manifold: as an indicator of God's existence—as Florensky inferred—as a means to fully appreciate the arts and sciences, and more practically, because several of the articles below deal with beauty and similar themes. Beauty is—be it in nature, painting, or math, so let's behold it as it is, a conduit to the Creator. Or maybe it's as simple as rock poet Patti Smith states, "For art sings of God, and ultimately belongs to him."[35]

Avant-garde Iconography: A Protestant Paints

You'd think that the Russian history course I took my first year in college would have mentioned Pavel Florensky. Sadly, I don't recall hearing the name. I first caught a reference to him in the early 1990s in relation to his martyrdom in communist Russia, where he died in a web of intrigue under Vyacheslav Molotov's regime on the heels of Joseph Stalin's rise to power. What I didn't know at the time was that Florensky was a brilliant polymath, mathematician, art theorist, and priest, considered by some the da Vinci of Russia.

Since then, Florensky has become to me an example of a man who used his full faculties for the cause of Christ, a hero for those of us who admire the two streams of knowledge: faith and reason (though unified in God's—and Florensky's—economy). As an artist, I also look to Florensky's deep insight into the nature of art in uncovering the essence of spiritual reality. As an art theorist, Florensky paved the way for a modern view of art (relying heavily on ancient interpretations), helping outline an understanding of abstract fields of artistic expression.[36]

Florensky was born in 1882 and graduated from seminary in 1908, being ordained to the ministry in 1911. Between 1914 and 1924, Florensky edited Christian publications, wrote scientific articles, attempted to interpret Einstein's theory of relativity in geometric forms, and continued his pastoral care. Florensky married and had children, loving both his wife and kids with unfettered devotion.[37]

35. Smith, *Just Kids*, epigraph.
36. See Spira, *The Avant-Garde Icon*.
37. See Pyman, *Pavel Florensky*.

Things changed for Florensky when the communist uprising—the October Revolution of 1917—took Russia by storm. By March 1918, the Bolsheviks controlled the government, leading to the formation of the Soviet Union in 1922. Florensky did much of his later scientific work under the watchful eye of the newly established Soviet party.

After the communist takeover, Florensky was exiled to Novgorod, a prison camp, but allowed to return to Moscow where he was given a position as a scientist, working on physics and electrodynamics. Florensky's witness for Christ never wavered under communist rule. He continued to wear his pastoral garments and refused to denounce his Christian faith.

Even though his scientific work was held in great esteem, Florensky was accused of agitation, arrested on February 26, 1933, and sentenced to ten years in a labor camp under Stalin's newly enacted criminal codes.

While Florensky was in the labor camp, the Soviet authorities continued to use his scientific mind for research on seaweed. Yet more accusations were fronted against him, and in 1937, he was sentenced to death. Along with hundreds of other prisoners, Florensky was taken by train to a camp near St. Petersburg and murdered by a firing squad on December 8, 1937. The world lost a brilliant mind, but the Lord received a faithful witness.

Florensky's influence has continued to expand since his death, particularly in artistic circles. His view of the spiritual nature of art is valued and greatly pondered. For example, in his essay "Reverse Perspective," he argued that for a full-orbed view of reality, a painting must have a spiritual understanding, something that reverse perspective (where objects closer to the viewing plane are depicted as smaller and objects farther away are depicted as larger) helps accomplish.

For Florensky, there was more to art than just images taking up space on a canvas; there was the essence of the image, that which the image represents and points to. Thus, art has both a physical and metaphysical nature. Florensky argued that ancient Christian art—particularly icons—help the viewer, in this case the Christian, attain a spiritual, metaphysical perspective of the artwork. The reverse perspective of icons helps a person understand that there is more to life than just the physical components presented on the canvas; there are the metaphysical or spiritual elements of our existence as well, that which transcends the canvas. And though Florensky argued for traditional

iconography, his thoughts have been expanded to included abstraction and other areas, expressing the spiritual component of art.

When it came down to it, Florensky wanted people to know—be it through art, mathematics, or science—that the physical world is not all there is. There is a spiritual reality, a heavenly kingdom of God that works in concert with the physical world. No wonder the materialistic, atheistic communist regime wanted to rid the world of Florensky's voice. But a government can't silence the truth of what God continues to do through Florensky and people like him.

As one influenced by Florensky's ideas of art, I head to an Orthodox church to better understand the role of the icon.

"When we kiss an icon, it's like kissing a friend," a guide told my wife, Melanie, and I during a visit to St. George Greek Orthodox Church in Albuquerque. "It's a communion of Christians—past, present, and future that we recognize. We're the body of Christ." The woman points out some of the iconography around the room, including the preeminence of Christ and the Trinity in Orthodox imagery. She is passionate in her faith, emphasizing that she doesn't worship images—she worships Jesus, but she uses the icons as reminders of God's presence. In other words, icons aren't items of worship but windows to God, a way to bridge the physical and metaphysical.

For some Protestants, discussing icons can be like someone slurping a soda during a movie: it can grate on the nerves. But not for me. As one who is influenced by Florensky's thoughts on art, I can appreciate what the ancient Christian artists were aiming at: seeking transcendence—communion with Christ—through the use of art.

To understand this, allow me quick word on the tradition of iconography.

The practice of icon painting was established in the second to fourth centuries AD. Icons are a painterly means to represent biblical truth, causing us to look beyond the image to the image of God in Christ. As an early church council inferred, whatever a doctrine says with words, the icon carries with lines and colors.[38] Icons are not meant to be perfectly realistic portrayals of biblical events but physical representations that reveal metaphysical truth, a type of spiritual perspective that looks beyond this world. As Andrew Spira

38. See Seventh Ecumenical Council.

put it, "The definitive characteristic of icons goes beyond artistic or socio-
logical significance; it lies with their metaphysical identity."[39]

Icons are emblems of God's eternal ideals, portraying his thoughts made vis-
ible. They typify transcendent reality: a means to ponder God's works as they
take on physicality through his creation. The most sublime biblical represen-
tation of this concept is the incarnation of Jesus Christ. In fact, the Apostle
Paul used the Greek word *eikon* to describe Christ (see Colossians 1:15).

Over time, religious painting became codified through the different branch-
es of Christianity, most notably Eastern Orthodoxy (including Russian) and
Roman Catholicism. Rome's use of icons caused some skirmishes between
the iconoclasts (those who rejected images) and icon painters. But by the
late 800s AD, the controversy died down, with both Eastern and Western
churches pursuing art as a means of spiritual renewal and discipline.

Because of Protestantism's emphasis on Scripture, some branches in Prot-
estantism have historically not been overly friendly toward icons, view-
ing them as idolatrous or the making of a graven image. This accusation
would be warranted if icon painters were worshiping the icon. However, as
mentioned above, the historical basis of icon painting was not to worship
the painting but to use it as a window to heaven through which one can
worship God in spirit and truth, pondering his being, essence, and work
in history and creation.

Over the years, many Protestant churches, while not incorporating icons in
their worship, have at least become tolerant of the practice, seeing painting
as a way to make God's actions in history and nature visible. Many Protes-
tant churches often use other modes of painting or imagery to teach Chris-
tian truth (think of stained glass windows or biblical paintings on a wall or
book, or photographs of the Holy Land).

Now a few thoughts on distinctive facets of iconography.

Elements such as perspective, line, color, text, geometric shape, and symbols
are all important factors in icon painting. In his essay "Reverse Perspective,"
Florensky defined some key concepts:

- *Razdelki* are the lines found in icons. As Florensky put it, "The lines
 of the razdelka express a metaphysical schema of the given object, its

39. Spira, *The Avant-Garde Icon*, 8.

dynamic, with greater force than its visible lines are capable of. . . .
Once outlined on the icon they represent in the icon painter's concep-
tion the sum total of the tasks presented to the contemplating eye."[40]

- *Ozhivki* are the life-giving lines, accentuating the life of an object.

- *Dvizhki* are lines used to heighten the object.

- *Otmetiny* are the markings, including the text.

Underscoring the importance of perspective—via lines and symbol, the
Dormition Orthodox Monastery wrote, "Icons are not three-dimensional.
Perspective in the icon does not exist. The attempt is made to suggest depth,
but the frontal plane is never abandoned, because the icon is not a repre-
sentation of our conscious world, but an attempt to suggest the beauty of
the Kingdom of God. Natural objects are therefore rendered in a vivid but
symbolic, sometimes an abstract manner, because spiritual reality cannot be
represented in images, except through the use of symbols."[41]

As noted, symbols are important in iconography. Though there's some
variation of interpretation of symbols, symbolism is prominent in most
iconography. At the basic level, a symbol uses one object (such as a red
flower) to represent another object (the death of Christ), as metaphors do
with the written word.

A common symbol used in iconography is color. Colors can convey certain
meanings: gold is Christ and his divinity; white refers to purity and eternal
life; purple means Christ's royalty; red is humanity, activity, and Christ's
blood; blue is the heavenly kingdom; green refers to the earth, Scripture,
and growth; brown means poverty; yellow is sadness at the tomb; and black
is death and void.

Another important symbol used in iconography (though not always imple-
mented) is text, helping articulate the power of the Word—both Christ and
the Bible. In many icons you'll find text that illuminates the image.

Additional symbols are shapes. Concerning the importance of shapes, An-
drew Spira wrote, "The significance of geometrical shapes in icons is not
merely symbolic. It is ultimately rooted in an ancient tradition of under-
standing the complexity of the phenomenal world by seeing it in terms of

40. Florensky, *Beyond Vision*, 5–6.
41. See "Readers Guide to Orthodox Icons."

the coherent numerical relationship that inform it."[42] Geometric aspects express the reality of theology—the unity of God within his triune nature (touched on in an article below).

So, if line, color, text, shape, and symbolism is important in iconography, what makes an icon avant-garde?

Avant-garde is a French word that means *vanguard* or *advanced guard*. Avant-garde is associated with groups or individuals who experiment or take a radical, non-traditional approach to something. Historic, avant-garde icon painting is influenced by traditional icon painting but goes beyond traditional Christian subject matter (rendering of biblical scenes or saints), using modern methods—abstraction, form, color, and line—to communicate transcendence. Modern avant-garde–influenced iconography developed primarily in Russia, as expressed in the writing and work of Wassily Kandinsky (1866–1944), Kazimir Malevich (1879–1935), and Nikolai Obukhov (1892–1954).[43]

I'd argue that avant-garde iconography, like traditional iconographers, uses color, line, shape, symbol, and text—infused with theological inferences—to make an affirmation of adoration, an act of worship. Avant-garde iconography is not just non-objective, abstract art (or whatever form the piece takes), but an attempt to render and wrestle with the truth, beauty, and goodness of God. With avant-garde iconography, the medium and message are conjoined, a modern means to communicate biblical transcendence, a method where the daily meets the divine, the physical meets the metaphysical. Like all iconography, avant-garde iconography is a testament of devotion.

As a devotional painter, I fall within this grouping in my approach; I'm not a traditionalist, but experimental. In New Mexico there's a tradition of painters called santeros (those who paint and sculpt religious-themed art). I see avant-garde iconography on par with santeros or icon painters: a quest to portray Christian truth and beauty via abstraction and, at times, simple forms. How I accomplish this is through line, color, symbol, and text. In some of my art, text—including numbers—is vital. It helps symbolize Jesus (the Word), the Bible (the word), and creation (the world). In other pieces of art, I often name the work after a notable Christian who either died

42. Spira, *The Avant-Garde Icon*, 90.

43. These artists inspired several modern movements such as Abstraction, Minimalism, Color-field, Hard-edge, Op-art, Concrete, Word, and Pop art.

or was born on that particular day, thereby conjoining the non-objective-abstraction to a historical event through words. In my objective-based art (representational), I use simple forms (such as a flower) mixed with text to accomplish a similar result. Bottom line: the essence of a painting is connected to the iconographic tradition, not necessarily in content (subject matter), but in concept.

Though I personally don't use icon paintings in worship or venerate them as the Orthodox do, painting is a spiritual discipline through which I seek meaning, a yearning to understand God and his Word and world. I use avant-garde icon paintings as a way to ponder physical and metaphysical reality, an intellectual journey that has spiritual dividends. Artists like Max Cole—highlighted in an earlier piece—takes a similar road: a trek for transcendence.

The historicity of icon painting is important to the church; it allows Christians to flesh out metaphysical concepts through artistic, physical means. For me, painting provides personal renewal. It's been said that true icon painters pray the painting into existence. Similarly, I find I get more prayerful when painting; it's a meditative and thoughtful practice, affording me time to be still and think, contemplating God's nature and his relationship to the world.

Through each iconographic movement, the intent seems to be similar: to ponder the profound nature of God, to communicate physical and metaphysical truth, and to seek transcendence in the process. Avant-garde iconography is no different; it is a means to consider Christ.

When it comes down to it, icon painting investigates the heavenly by looking to a human: Jesus, the *eikon* of God. By painting, icon artists—and those who employ similar concepts—are given a glimpse of the eternal here on earth.

Atheism: A Packed Pulpit with Daniel Dennett

Daniel Dennett has a mighty beard, full and fantastic. It's a beard you'd imagine an Old Testament prophet wearing. The only difference is that Dennett doesn't believe in God and considers the Old Testament a very human work.

As he wrote in his book *Breaking the Spell: Religion as a Natural Phenomenon*, "Part of what makes Jehovah such a fascinating participant in stories

of the Old Testament is His kinglike jealousy and pride, and His great appetite for praise and sacrifices."[44] In short, Dennett wouldn't trust the Old Testament God, whom he sees as anthropological—or any god, for that matter—if you paid him.

But several inches up from Dennett's mighty beard is a magnificent brain that has been trained to think deeply on a host of subjects. As a philosopher and cognitive scientist, Dennett has written engaging works on philosophy, science, morality, and religion. His book *From Bacteria to Bach and Back* is a nice summation of his varying interests. Many theists know Dennett as one of the "four horsemen" of New Atheism—along with Richard Dawkins, Christopher Hitchens, and Sam Harris—whose polemic against religion is evangelistic.

But as Dennett reminded the packed house at the Lensic Performing Arts Center in Santa Fe, New Mexico, one night in May 2017, "I'm the white sheep of the group"—he "takes religious people very seriously."

Beard and brains.

This alone was enough for me and a few friends—archaeologist Dr. Steven Collins, apologist Grant Bresett, and Anglican clergyman Jonah Kelman—to attend the lecture at the Lensic given by Dennett and his colleague, University of Santa Barbara neuroscientist Dr. Michael Gazzaniga.

I first heard about the event, titled *Caught in the Pulpit: Exploring the Journey from Religion to Reason*, from the Santa Fe Institute (SFI). I knew I had to attend from the quip in their newsletter alone: "What does it mean to struggle with the idea that there is no God when your life has been devoted to preaching that there is?" I'm not moving toward atheism (far from it), but I was intrigued to hear what Dennett and Gazzaniga had to say about the topic, particularly since *Caught in the Pulpit* was using an artistic means to communicate the message: a play written by Gazzaniga's daughter Marin Gazzaniga based on interviews she had with clergy.

To be fair, I enjoyed the evening—I'm a sucker for intelligent discussion in any field. And I was particularly impressed with SFI president Dr. David Krakauer, whose penetrating questions didn't let reason or religion off the

44. Dennett, *Breaking the Spell*, 265.

hook. But I couldn't disagree more with certain implications of the event, which were inconsistent and sent confusing messages.

First was the subtitle: *Exploring the Journey from Religion to Reason*. If my education serves me correctly, reason (the sciences) and religion are not enemies but two fields worthy of study, comrades in the tantalizing pursuit of truth. It only takes a cursory look at history to see that a number of men and women have used both reason and religion to discover reality: Albertus Magnus, Nicolaus Copernicus, Johannes Kepler, Galileo Galilei, René Descartes, Blaise Pascal, Isaac Newton, Lise Meitner, Francis Collins, and others.

In my training via Thomistic philosophy, faith and reason are best friends, a unified approach to knowledge and understanding. I've taught both science and theology at the secondary level, taking seriously Augustine's axiom: "Our freedom is this: to submit to truth."[45] So, in my mind, there is no journey from one to the other; faith and reason are two wings of an eagle, giving flight to humanity's understanding of existence from differing but complementary perspectives. They may disagree at times, but Truth will always win in the end.

There was also the irony of how the information in the event was communicated. The fact that art was used to make certain points about atheism conveyed a conundrum. If I believed the underlying premise of atheism that there is no God, that the universe came into being through a fortuitous series of chance encounters, then there is no metaphysical significance or purpose to life beyond what humans assign to it. As Dennett said elsewhere, "We [humans] are meaning-makers."[46]

But if there really is no ultimate purpose or meaning to life, then it doesn't matter what value humans place on something, be it art, a play, a lecture, ideas, or a book. If mind and matter are nothing more than accidents in the abyss, then the *Caught in the Pulpit* event was a farce—as is everything else: one big mishap, a mistake. Who cares what Dennett, Gazzaniga, Krakauer—or anyone, for that matter—thinks? The meaning they attempt to convey is meaningless. Why sponsor an event ripe with meaning if there is no meaning? Why all the planning, preparation, thinking, acting, information, and production if it's futile?

45. See Brown, "Augustine on Freedom and God."
46. Mehta, "Daniel Dennett."

This was where *Caught in the Pulpit* became really inconsistent: to deny or push aside meaning (or its suitors: truth, purpose, etc.) is self-defeating. You can't have meaning and non-meaning. There is meaning in the statement "There is no ultimate meaning" just as the statement "There is no truth" is a truth statement. And the statement "There is no purpose" is a statement of purpose. The view promoted by atheists—that there is no ultimate meaning to life—would have to be wrong to be right, breaking the law of noncontradiction. As the much-used idiom reminds us, *you can't have your cake and eat it too.* There's either meaning or there's not; there's fact or there's not.

Contrary to what anyone says, there is meaning—both physical and metaphysical—to life; to live is to have being and to have being carries meaning.[47] As the Thomistic philosopher Joseph Owens reminds us, "Being, therefore, is what actually makes any object a thing . . ." and "Without existence, either real or cognitional, nothing else matters for a thing. Being, rather, is the primary consideration in meaning."[48] What someone like Dennett or Gazzaniga thinks about something does not determine reality; rather, reality should determine what we think, and it begins with being; and there is something rather than nothing. If what Dennett and to a lesser degree Gazzaniga were saying during the conference carried any weight, there must be some kind of metaphysical meaning, or everything they said was a yarn, unintelligible in any real, instructive way. In short, it appeared that both Dennett and Gazzaniga are inconsistent atheists.[49]

A further conundrum arose with the use of art. Krakauer drew specific attention to art and beauty, recognizing the arts "serve a purpose to bring meaning to our life." In one question, he asked the esteemed doctors what they made of meaning, beauty, and art. Neither Dennett nor Gazzaniga

47. Just as biological life begets life, physical meaning (what humans ascribe to something) carries with it metaphysical meaning (involving thought, knowledge, etc.). For the word *meaning* to carry any meaning, it must convey a metaphysical understanding of what it means. In other words, there must be a *meaning*—an idea, concept, or definition—to *meaning*; it must have a real or cognitive sense of being. So, the word *meaning* has both physical meaning (the brain processes and thinks it) and metaphysical meaning (the idea or concept of the word). It's like a number: it has a physical manifestation (there is one of something) as well as a metaphysical nature (a number is not a thing per se, but a concept assigned to an object for use: counting, labeling, etc.).

48. Owens, *An Elementary Christian Metaphysics,* 22, 44.

49. Many atheists live and work as though there is meaning and purpose to life even while saying there is none; they live a life of existential incongruity. But I don't blame them—or Dennett, Gazzaniga, or Krakauer (who defined himself as an *igtheist*: no point in discussing the matter). Who wants to live as though life is futile? Our very being tells us otherwise.

answered his question in any direct fashion. Krakauer stated he "never heard a satisfactory answer to the question" and didn't want to subject the arts to "rational reduction."

Krakauer's inference is correct: art is a signpost to meaning, both physical and metaphysical. There's a physical side to art (the medium and matter used and our brain and bodies that creates it), but there's also a metaphysical side. Art inherently expresses thoughts, ideas, emotions, intelligence, essence, and worldviews. When someone creates art, they're saying, "Look at this. This is important. Derive something from it. Be moved by it." If an artist doesn't believe this, then why create art? It's pointless. Go do something morose. When I sit down to paint, I don't say, "Another meaningless activity." No—I ask myself, "What does this mean? How does it make me feel? Is it any good?" If art has no metaphysical meaning and is void of purpose, ideas, and truth, then it would be ineffectual.

But art isn't ineffectual. And the portions of Marin's play used in *Caught in the Pulpit* proved the point. The play played on our feelings; it sought to sear and sooth—and it communicated meaning. So, the play's inclusion in the lecture was either was a mordant moment of incongruity or a purposeful ploy to call into question the role of art and beauty in an atheistic worldview. If existence doesn't have ultimate meaning, then why use a medium—such as a play or drama—that conveys meaning? In short, the vehicle that drove the point of the lecture weakened that very point. To misquote Marshall McLuhan, the medium undermined the message. If atheism is true, then why use art to derive meaning out of something that—at the heart of an atheistic worldview—is meaningless?[50]

Besides the incongruity of the overall message, the evening was a night well spent. *Caught in the Pulpit* was a call and response between the play and speakers: a short performance and then comments by Dennett and Gazzaniga based on questions posed by Krakauer. The actors in the play did a wonderful job communicating the real angst many clergy have concerning their private faith and public façade. Stage manager Matt Sanford and lead actress Elizabeth Wiseman put together a fine performance. And though we only got glimpses of the script—Marin selected eight case studies for the play—the writing was provocative.

50. Art inherently connotes meaning and purpose, pointing to the mind of an artist. Information (a script, words, ideas, cells, DNA, a painting, etc.) has to come from somewhere. What makes more sense than using art to platform atheism is using art to showcase God's existence.

There are many mysteries to faith (as there are to science), some of which lead to doubt. But doubt does not demand that there is no God. Rather, it's a metaphysical mind-set that sharpens our finite awareness. To doubt is to be a human.

I asked Dr. Steven Collins, Grant Bresett, and Jonah Kelman their thoughts on the evening.

Dr. Collins said, "I thought the night was intriguing, raising interesting questions. But as a working scientist—and not a trained philosopher like Dennett—my angle is different. Folks like Dennett want to argue over ideas. I'd rather focus on the evidence. For me, the overarching question is: What does the evidence display; what does it tell us? And evidence can derive from a host of fields, be it historical-archaeological, biological, chemical, geological, and the like. I want to see the evidence before I argue over ethereal concepts. The truth is we could argue all day long. But at the end of the day, someone has to come forward with some concrete evidence to validate his or her perspective.

"Dennett is full of rhetoric and deductive offerings in defense of atheism and Darwinian evolution, but I noticed in his Santa Fe discussion and in his recent book, *From Bacteria to Bach and Back*, that he always includes a disclaimer for every hypothesis he offers—in essence: we don't yet have evidence for this idea, and there are others [equally intelligent atheists] who disagree and posit different approaches. In other words, Dennett is long on words and short on the harder aspects of reality.

"Overall the evidence given by Dennett and Gazzaniga was not fully articulated; a night like this was not the place for a scientific presentation. And I'm aware of others who are discovering things contrariwise concerning the brain—or at least interpreting the evidence differently—to what Dennett and Gazzaniga are seemingly proposing. The neuroscientist Dr. Mario Beauregard comes to mind. If I understand his research correctly, Beauregard demonstrates that spiritual experiences can derive from outside of the brain as much as from within the brain.

"Furthermore, some of the clergy interviews conducted by Linda LaScola and written by Marin Gazzaniga in the play were with people steeped in an older, higher critical perspective of the Bible. Without getting into the details, they have an outdated view, unaware of many current discoveries in Near Eastern studies and archaeology. To put it bluntly, folks in higher critical

circles do not have a faith founded on fact. The nineteenth century higher critical view of the Bible taught to fledgling ministers in most seminaries is fallacious at its core. Anyone—like several of the individuals portrayed this evening—who would jettison the Bible and theism based on that approach to the Bible is very, very sadly in the dark vis-á-vis the facts.

"In short, I firmly hold that the evidence for God's existence is much greater than the evidence against God's existence. I won't bore you with the minutiae, but complex information must derive from somewhere; nothing can't create something. As an archaeologist, when I discover something in the soil, I don't say, 'Oh, look, this just appeared out of nowhere.' No. I say to myself, *How did this get here? What civilization was present? What were the conditions and timeframe?* Evidence demands an inquiry; artifacts require investigation; information points to intelligence. I prefer to position theism versus atheism with Ockham's razor: the best theory of anything is the one requiring the least number of secondary and tertiary hypotheses to support it. All Dennett has are theories burgeoning with secondary and tertiary hypotheses, without a single toehold in the real world. But which way does the evidence point? In the end, I think the evidence points to the fact there is a God. Biblical theism, in particular, is simple and elegant, and explains why the real universe is the way it is."

I turned to apologist Grant Bresett (MA, Biola University; MA, Southern Evangelical Seminary) for insight. "Let me start with the bottom line," Bresett began. "The event was a brilliantly executed, highly entertaining, and well-acted hit-piece on Christianity. Interestingly, Islam or other Eastern religions were never mentioned. Bottom line: I enjoyed the entire evening. It was a fascinating glimpse into the world of atheist evangelism; they are as dedicated in their mission as any Christian missionary. In *The Art of War,* Sun Tzu said, 'All warfare is based on deception.' I asked myself, *What tactic did the* Caught in the Pulpit *production use?* The answer? The night was undergirded with the assumption that Christianity is false. *Caught in the Pulpit* framed the debate as faith versus reason, science versus mythology.

"The interviewer in the play, Linda, asserted anti-Christian statements like, 'We know Christianity is based on myths and the Gospels were written by anonymous authors.' My response: these are assertions, not arguments. Linda doesn't explain why these things are true; she simply asserts them. I would respond by saying that the manuscript evidence of the eyewitness testimony of the Bible is overwhelming compared to all other works of antiquity; the Bible is a reliable source. There is strong evidence that the

Gospels were written by eyewitnesses or writers who had access to eyewitness of the resurrection.

"Apologist Ravi Zacharias explains that every worldview must answer the following: origin, meaning, morality, and destiny. The president of SFI, David Krakauer, boldly asked Dr. Dennett and Dr. Gazzaniga why religion did ask the big question of life, but science did not. Krakauer asked why science was filled with technocrats and dullness. He asked them how science could answer the question for meaning. Both doctors were dumbfounded. They had no coherent answer for the meaning of life.

"My response to questions like these is that Christianity has far more explanatory power when pondering the big questions of life than atheism. Christianity best explains our origin, that God created us; meaning, that we were made for healthy and satisfying relationships with God and each other; morality, grounded in the eternal and unchanging nature of God; and destiny in that God proved His love for us by Jesus' death on the cross. Jesus' resurrection proved that we too will be raised to live with the perfect God in His perfect heaven in perfect relationship with Him and each other."

Grant concluded, "As an apologist, I noticed several tactics that were employed in *Caught in the Pulpit* to discredit Christianity. One is the straw man. Real Christianity was never engaged in the play or panel's responses; the interviewees did not seem to understand a Biblical worldview. Two, he who frames the argument wins. The argument was falsely framed as science versus religion, faith versus reason, myth versus science. Christianity was defined as myth. It was asserted, not argued. Three, it was asserted and assumed that there is no evidence for Christianity, which there is. *Caught in the Pulpit is* a brilliant tactic to simply deny the existence of evidence rather than engage the evidence."

Finally, I got insight from Jonah Kelman (MLitt, University of Glasgow), an Anglican clergyman.

"I attended this event knowing nothing of Dr. Dennett or Dr. Gazzaniga and, regrettably, far too little of the impressive Santa Fe Institute. I am grateful that this event was put on. Many things struck me during the amalgam of dramatized reading and interviews: disagreement, sympathy, and unexpected agreement.

"The types of faith backgrounds represented in the play were peculiar. I was left with the impression that none of the interviewees highlighted in the play represented a form of historic, orthodox, catholic Christianity. The Pentecostal preacher, for example, recounted his coming to faith: he described it in retrospect as a mix of emotion, energy, and stage production. It was sensual, passionate, and communal. It gave him belonging, somewhere he fit. It coincided with his own aspirations to be at the front of the stage; it gave him power. And then there was the Episcopal priest and the lone 'believer' in the play. Irrespective of belief, neither affirmed the virgin birth. This was peculiar to me, as this in their purported belief did not represent Christianity at all.

"As to sympathy, my heart went out to the Church of Christ preacher who began to doubt his faith as his wife was diagnosed with a severe illness. His doubt had to be kept secret because of his peer group (his own life was cloistered around only those who believed; this is dangerous) and his believing family. To make public his doubts—or worse, his lack of faith—meant being cut off from all society as he knew it, even to fears of disownment and divorce. This, to me, is both sad and a public admonishment to the church. Doubt is not the opposite of faith; it is a stage within it. If our church cannot support her people when they doubt, then such a falling away is inevitable and lamentable."

When asked about the representation of theists portrayed in the play, Jonah stated, "Nearly all attacks were against a particular form of Western Christendom, with the exception of one Jewish rabbi. Many critiques against Christianity would not have remote application to adherents to the Eastern Orthodox communion. Further, religions outside of the Judeo-Christian worldview were not mentioned. I am left wondering why. What I was hoping was a critique of religious belief, by way of clerics beset by burnout or rationale, yet still compelled to serve by going through the motions. The emphasis of the play was very Western."

Concerning Dennett's emphasis on scientific consensus to determine truth, Kelman said, "Dennett articulated a few points which were implicitly against religious belief but were ironically accurate expressions of Christian orthodoxy. As an example, Dennett asserted that truth in science is founded upon a consensus, that the assertion of one scientist does not establish the new truth which forms the basis of textbooks. It takes continued testing and reaffirmation from the scientific community. This is the reason for peer review in academia: the pursuit of nonindividual

truth. In the age of individualistic Christianity, truth, like the rest of society, is delegated to individual persuasion. The basis of faith for the one holy, catholic, apostolic church affirmed in the Nicene Creed—the most concise, authoritative definition of Christianity—is that of consensus."

Kelman concluded, "This event represented a challenge for Western Christendom, for which our own survival demands that we adapt; this has been coming for some time and represents an opportunity for complete revitalization of authentic faith. The Episcopal priestess mentioned during the play that, for her parishioners, 'religion is in a box' and accounts for why she does not challenge their belief with unbelief. This is, regrettably, the expression of faith of those who have Christianity in their culture but not Christianity as their culture. But it is not necessarily a faith that has been tested. Faith is not a compartment that forms a complete life (along with a happy life, a nice house, a good job and investment account, etc.); faith is life itself, or it is nothing. The challenge facing Western Christendom is reshaping a passive, cultural faith into one that is the very foundation of worldview. This is perhaps one of the more exciting developments in our current zeitgeist: we are given the opportunity to be a part of the *refining* of the fittest."

We got it all during the event: a beard, brains, beauty, and some bracing questions. The night was still one of meaning, even if it was a mess of contradictions. *Caught in the Pulpit* did pose real struggles for some clergy: how to reconcile doubt with ministry. And though I completely reject the underlying premise—that religion is based on myth—the inferences suggested throughout the night are worth answering.[51] In the end, however, I wasn't swayed one step toward atheism.

Who'd have thought one would walk away from atheists ever more the theist?

51. For more, see the following resources:
- Philosopher Dr. William Lane Craig on Dennett and Dr. Richard Dawkins: https://www.youtube.com/watch?v=NaimhCgnjN4; https://www.youtube.com/watch?v=Uaq6ORDx1C4.
- Biochemist Dr. Michael J. Behe on evidence for intelligent design in biochemistry: http://www.discovery.org/a/51.

Consecrated Space: A Conversation
with Artist Jeff LeFever

Artist Jeff LeFever and I are sitting in the lounge car of the Southwest Chief, the Amtrak train that travels between Los Angeles and Chicago. We're about to discuss Jeff's newest books and artwork when a passenger interrupts us. Over the next hour or so, Jeff and I don't get a peep in, but we do hear stories of how our new friend met his wife, how he makes movies, and how his leg was healed in a Pentecostal service. We smile, nod, and listen. Jeff imparts some wisdom, and our new friend says, "[Expletive] you're so amazing!" So it goes traveling on a train.

Our new acquaintance did get something right: Jeff—and his artwork—is amazing!

When we arrive at our destination—Kansas City—our first few days are spent with my family, conducting life as gentleman farmers. We plant potatoes, tend the chickens, and eat homemade meals. When we do finally find the time to discuss Jeff's artwork and books, it's as we stroll the halls of the Nelson-Atkins Museum of Art, one of America's finest institutions dedicated to art. We soak in the atmosphere, have tea with my wife, Melanie, and peruse the fabulous exhibits, particularly taken with the photography of Richard Learoyd.

In a way, the Nelson-Atkins Museum is a type of sacred space—an institution founded to promote culture and artistic expression in a building set apart for contemplation and knowledge. These key words—sacred space, expression, and contemplation—are part of LeFever's vocabulary as well, framing his artistic pursuits for which he has an unbridled passion.

Since 2003, LeFever has dedicated his talents to capturing sacred space through photography and artwork. He's traveled the world in search of the moments where the daily meets the divine in churches, gardens, junkyards, and cemeteries, as his books show.

While sitting in the Nelson-Atkins Museum, and later through email, LeFever begins to explain how his books *SCRAP*, *FloraGlossia*, *Instant Icons*, and *The Consecrated Space* expound the concept of sacred space. The dialogue that follows is a condensed version of our *Consecrated Space* discussion, carried on over a two-month period.[52]

52. A version of this conversation was published in LeFever's *The Consecrated Space*. Used with permission.

Brian: Jeff, several facets of your *Consecrated Space* text struck me. First, as an artist you were able to capture the essence of why consecrated space is important. Second, as one who's spent time in many of the consecrated spaces in Europe and the United States, your insight was personal, demonstrating intimate experience with the space. These two characteristics, essence and experience, really shine through in your words.

I was particularly impressed with the concept of a "visual language." You wrote, "Visual art is a language of its own and is received by us differently than words by being palpable and potent in fixing an idea's longevity . . . tangibly representing God's kingdom and loving sovereignty." Furthermore, you liken art and beauty to a visual "vocabulary," stating, "A created space that uses a visual vocabulary to expressly articulate God's interaction with His creation reinforces each soul's process toward union with God through both design and function." Great insight.

Jeff: Thanks, Brian. I believe these purposeful spaces are important to create and maintain. I found, and still find, that many people objectify particular church and cathedral spaces, leading to arguments against the cost of the "things."

While documenting and exploring consecrated space, I had to wrestle with these arguments. I became very conscious of them: money spent on things over people, and the Torah commandments. There had to be a different value in the arts that was being missed in these arguments against aesthetically articulating a consecrated space.

In the end, I wanted to show how a consecrated space (Christian spaces in particular) is more than an expensive object or a place of idols.

What I found is that these spaces are intentionally created to serve on many levels, using a language of aesthetics. I also noticed that they involve many in the community to see these structures made. It can be an immersive approach for a community. Not many people realize this.

At that point, such expression as a physical space is an extension of the congregation's love for God and for their community—it is a gift and an offering. It isn't just any old place to meet. These spaces also house great community outreach and charity when that is the intentional mission of the church (clergy and congregation).

I found that the articulated aesthetic is a language that speaks of God and our relationship with him to our whole person—not only the intellect, but all our senses.

Beauty takes us by the hand and leads our spirit into what is being expressed. It's our great privilege to create something beautiful and lasting at this level for our communities—something that will last for ages.

Brian: It is more than an object. Like an Orthodox icon, consecrated space is a window to God, a means to understand him and appreciate him more fully. I also appreciate your use of the word *immersive*. Consecrated space can engulf us in the wonder of God.

Jeff: And beyond that, the consecrated space engages all our senses, amplifying our sense of place in the moment and in our memory. It is an experience as much as it is an encounter. The space speaks with an aesthetic language that envelops us. It's a language of beauty. As a clergyman, educator, and creative, do you think beauty an archaic language or a language worthy of being spoken by a church environment?

Brian: I do think beauty, as a language, is worthy of being spoken in church. Why? Because beauty is from God. In this sense we are speaking his language. Furthermore, beauty reflects the two realms of existence: physical and metaphysical. Language has non-physical properties (meaning, ideas, imagination, etc.) and physical properties (we write it down). And with these two facets of language kept in mind, here are three things to ponder about the notion of language, particularly as it relates to beauty.

One, language is part of God's essence, his nature; God is self-communicating. In this sense language is metaphysical, beyond the physical. Second, God writes his language down; this is the physical act of language.

Under the second area it's good to note three sub-points of what God writes: the world (creation, his thoughts made visible), the word (Bible), and *the* Word (Jesus, the "icon," incarnation of God). Beauty is found in all three sub-points of God's language, but in Christ in particular, as the express image of beauty.

And the third part of language is human's participation with it, the communication between God and humanity and humanity with the created world, and humanity within itself.

If you were to put the speech of beauty sequentially—to use your analogy of language theologically—it'd go something like this: God is beauty, he speaks/creates via beauty, we listen/learn about his beauty, and we co-create, speaking to him what he spoke to us.

It's like a love letter: God writes beautifully, and we write back, hopefully with beauty, truth, and goodness in mind. There's a mutual exchange between God and humanity; beauty is integral.

Jeff: That is very poetic: a love letter, a mutual exchange of beauty happening between God and humanity—a language of love—and it is relational. God is relational.

Brian: Yes. Those are key words, too—*mutual exchange*. I think beauty is part of our experience with God, a common interchange within the community of being. It begins with God, extends to humanity, and returns back to God.

Jeff: In my book's text, I focused my writing to capture a sense of encounter without delving into principles of aesthetics or the deep theology of consecrated space. Brian, how do you further define beauty within that theological paradigm—as something beyond a personal self-preference or as something popularly yet narrowly defined as only "pleasing the senses"?

Brian: I like that you kept your writing focused on encounter, for at its heart, beauty is an encounter with something or Someone. So, I agree with you: to say that art is relegated to that which "pleases the senses" doesn't do it justice; it is narrow. There is so much more to beauty. So, for the sake of broadening the conversation with theological terms, I may say something like this: beauty is an attribute of God. Along with his infinity and transcendence, beauty is connected to his ineffability, exuding his splendor, glory, and eminence as the First Cause and Necessary Being of all creation.

If that's not enough, here's another thought: as an attribute, beauty deals with God's very nature, his essence; it's who he is. Because God is one (or simple, as we'd say in classical theology), beauty is who the Lord is in his being, a pure and perfect person as expressed through his attributes. As God is love (or any other attribute), so, too, is he pure splendor and magnificence, the essence of that which is beautiful.

God is beauty. And because God is beauty, all creation—his thoughts made visible—is a reflection of his beauty.

Jeff: How would you bring this into an analogy that is also practical to everyday living—something that anyone can simply appreciate in seeing this particular prototypical essence of God?

Brian: You mentioned that your book of consecrated space photographs is a "cut diamond, and each selected photograph is a facet splitting and reflecting the spectral colors of the brighter divine light." So, let me extend the prism analogy to God. If I held up a prism with little light, you'd see only a triangular, clear, glass-like object. But if I held up the prism to a ray of light, colors emit. So, too, with God: he is one, unified, and simple, encompassing all attributes within himself. But from his being extend his attributes, his colors, if you will, for the world to enjoy: God's attributes are everywhere seen and experienced. And because beauty is inherent in God and from God, all beauty is like God. When we study art, aesthetics, we in essence are studying the works of God's wonder in the world.

Jeff: You recently pointed me to Balthasar, who I am finding enlightening when discussing beauty as it relates to love. When you first discovered his writing, what made you consider beauty differently? What did you find moving?

Brian: Oh boy, Jeff; you've opened up an area of delight. So much can be said about the various theologically minded aestheticians that we don't have enough time to discuss. But three come to mind: Dietrich von Hildebrand, Hans Urs von Balthasar, and Nicholas Wolterstorff.

To briefly answer your question: I do find Balthasar's thoughts quite moving. And though I don't agree with him on every theological point, I am engrossed with his discussion on beauty.

Generally, Balthasar was concerned with the transcendentals (a subsection of philosophy): unity, truth, beauty, and goodness. What makes Balthasar engaging, at least theologically and aesthetically, is that he began the conversation with beauty and not truth. For Balthasar, beauty was the springboard to discuss the Lord; it was the door one enters to encounter God. There's a great quote from him that summarizes it well:

> Before the beautiful—no, not really before but within the beau-
> tiful—the whole person quivers. He not only "finds" the beauti-
> ful moving; rather, he experiences himself as being moved and
> possessed by it.[53]

When people discover the Lord they discover the essence of beauty within
world and word—exemplified in Jesus—both of which lead to goodness
and truth.

In the end, I think Balthasar challenges our first principles in how we ap-
proach God. Maybe our understanding within the contemporary world
should begin with beauty, leading to truth (right thought) and goodness
(right living).

Jeff: For Balthasar, then, we are first struck by beauty and captivated, or
as you quoted, "possessed by it." It's a bit like falling in love with someone
beautiful and growing deeper in love as we interact and come to know that
person in truth and goodness over time and through experience. If I am
understanding what you quoted, we are not outside that beauty as God is
not outside creation. We are within beauty: one with it. And being moved by
and in that love changes us. We are possessed and changed by beauty. And
as you said earlier, God is beauty.

Brian: Yes. We fall in love with God, the Beautiful One. But beauty is not
the end; it integrates truth and goodness, wrapped up in a unified under-
standing of existence. In this sense we are part of God's expressed beauty,
goodness, and truth in the world, engulfed in his acts, his language of love
and community.

Jeff: And it is this love that changes us at our core, transforming our motives
and our behavior. Our expressed beauty becomes a door, not an end—it
actually has a relational fluidity.

When you said that for Balthasar, "beauty was the springboard to discuss
the Lord; it was the door one enters to encounter God," that had me think-
ing of what Abbot Suger poetically wrote about the literal doors one entered
to his Abbey Church, St. Denis:

> Whoever thou art, if thou seekest to extol the glory of these doors,
>
> Marvel not at the gold and the expense but at the craftsmanship of the work.

53. Balthasar, *The Glory of the Lord*, 247.

> Bright is the noble work; but, being nobly bright, the work
>
> Should brighten the minds, so that they may travel, through the true lights,
>
> To the True Light where Christ is the true door.
>
> In what manner it be inherent in this world the golden door defines:
>
> The dull mind rises in truth through that which is material
>
> And, in seeing this light, is resurrected from its former submersion.[54]

Suger understood the relationship of beauty to truth and goodness and especially artful beauty applied to church space: how the transcendentals could be communicated in form. He lived them through overseeing how the choir for the Abbey Church of St. Denis was amended—which led to the first achievements in the new French style and ultimately the Gothic style.

Brian: So much more could be unpacked regarding Suger. And you are right with your assessment of consecrated space: it is akin to the transference of beauty into a physical space.

I also appreciate that you inferred that his appropriation of theology led to an innovative and creative expression, a new art form: Gothic. When we think deeply about God, creativity often is the fruit.

Jeff: You mentioned Hildebrand earlier. He identified the beautiful as having an aesthetic value in its "thingness" or form as a first power of beauty being a primitive form—like the red paint or its chemical properties and how they appear. But the beauty that strikes us as sublime is a second power of magnitude to primitive beauty that surpasses a thing's "aesthetic capacity," becoming sublime—as if we connect to something greater, transcendent even: a beauty that does not seem proper to its parts, or even to the sum of its parts.

Brian: Well stated. Hildebrand borrowed his idea of form from Aquinas. It's the idea that beauty has its beginning in being. Being becomes more beautiful when it exudes or "shines out," as Hildebrand would say. Beauty springs from both God and man, from our very beings. As made in the image of God, humans "shine out" the beauty invested in us by the Lord.

Speaking of the transcendentals, Jeff, I like the fact that in your text you link beauty to the transcendentals. You say, "The applied visual arts embody our biblical understanding into solid form with which we can repeatedly engage

54. Marissa, "Light Upon Light."

through our senses and upon which we can intellectually and emotionally reflect. Unity, truth, and goodness, three of the transcendental universals to living a life well, are perfected in beauty—making art and aesthetics essential to the intentionally crafted church building if it is to seriously reflect those universals as an extension of the church body."

In other words, the transcendentals are not just ideas, but ideals to live. Would you agree?

Jeff: I would, and I try to do this with my creative work. When I wrote what you quoted, I was thinking of people who join together to build a church of great aesthetic value honoring God, something solid that serves generations across time. I remember reading the onsite displays for the design and construction of Amiens Cathedral, which related that even the least talented of townspeople, who were as equal in heart and devotion, also pitched in by hauling stone in wheelbarrows to help see the cathedral built. It is a massive cathedral. The construction involved all types of people at all levels of skill during its fifty-year build (1220–1270). Whether that history of the cathedral I read on display was true or a fanciful exaggeration of medieval community, I was impressed by the notion of open communal involvement. I was reminded of the Jewish community under Nehemiah building the walls of Jerusalem after their return from Babylonian exile—or before that return, building the second temple under Ezra. People were living these ideals within a God-centric paradigm. Meaningful structures were also made as a result that reflected their religious belief.

Years later I visited a small Lutheran church in Mission Viejo, California. This church was a fairly standard cinder block–type Protestant church with a stage, but it had beautiful windows. The church had commissioned a stained glass artist with funds that they had collected and saved. That artist designed the church's stained glass windows, but he did not make them. Instead, the congregation built the windows under the artist's guidance and supervision, and then a professional crew installed the finished glass art.

In those examples, all types of people with varying skill levels were physically involved in the act of consecration—making something permanently special to honor God and serve the generations to come. Such participation is an engaging act of worship and giving. These are fine exhibits of that "love letter" you mentioned, Brian, that mutual exchange between God and man: co-creating with God in the language of beauty.

Brian: Good examples of the mutual exchange of love between God and people: God gives and people respond. And in the case of Amiens and the Lutheran church, the people responded via the language of consecrated space, speaking in the realm of beauty within a designated place for awe and adoration. The people gave a gift of art to the Artist. At its heart, consecrated space is, as you stated, an act of worship.

Jeff: You mentioned Aquinas in relationship to Balthasar, and knowing that you are an avid Thomist while I have a very basic understanding of Thomas Aquinas, could you expound his thoughts on beauty and the transcendentals?

Brian: The transcendentals have been part of universal thought since the beginning; all cultures have dealt with them on one level or another. But it was Thomas Aquinas who first helped shape our understanding of beauty as both an objective reality and a subjective experience.

Aquinas believed and taught that beauty held certain properties: proportion, integrity, and clarity. I won't get into the nuances of those three words—tomes have been written to expound them—but I can venture to say that Aquinas helped define the West's understanding of beauty.

Jeff: How do Aquinas's conclusions relate to church spaces in our commercialized culture?

Brian: I think Aquinas' thoughts can help inform our understanding of how we appreciate beauty within consecrated space. Maybe our contemporary culture is no longer as concerned with harmony, splendor, order, and such. But I do think there are nuggets of Aquinas's understanding of beauty found in our society.

To the four characteristics presented by Aquinas—what I'd call *streams*—I'd add a few more to augment or intensify Aquinas' understanding of beauty. What I'd add are: *transcendence* (spiritual), *immensity* (philosophical), *intelligence* (cognitive), and *sorority* (community). For me, the seven streams—proportion, integrity, clarity, transcendence, immensity, intelligence, and sorority—help clarify our contemporary understanding of beauty. And these streams ultimately flow from and back to God.

And to clarify a bit further: by *transcendence*, I mean art that helps us transcend the nature of a thing, a metaphysical understanding of an object, leading to the possibility of a spiritual understanding.

Immensity carries the idea of something profound or insightful, an understanding of art and form that carries an idea or intuition with broader philosophical or social implications. Immensity makes one want to contemplate art or revisit it.

By *intelligence*, I mean that the work displays thought, built on an understanding of the medium and process and at times the history of the particular creative expression as a linear language. Does the artwork exude intelligence and interest of form?

Sorority is largely the effect of art: bringing community and togetherness through creativity, be it for two persons or two million.

Jeff: You said that art can help us "transcend the nature of a thing, a metaphysical understanding of an object, leading to the possibility of a spiritual understanding." I feel some of that falls upon the viewer to have the eyes— and perhaps the will—to see. I am fond of saying that we only see what we are looking for.

Something that helps me "see" is a mind-set of "anagogical seeing." That can easily fall into confirmation biasing, so like everything, one must be conscious of what they are doing. Seeing anagogically suggests seeing beyond a physical manifestation to the spiritual that lies beyond that material thing. It's a bit like seeing God's intricacy in the design of flora, finding in them a voice of order and repeated expression of mathematical ratios creating one type of visual beauty that reveals God's "signature," if you will.

And as we observe, we find it in more than just visual things—function too, and the interrelatedness of things throughout nature as you have also been saying with providence and the physical/metaphysical relationships.

By the way, I see no conflict between science (physical) and religion (metaphysical) that isn't man made. Anagogical seeing is a form of interpreting our physical world as connected to the spiritual of which we are rarely aware.

I believe the best of the arts achieve this and are also a blend of the physical and the metaphysical as you pointed out earlier in the conversation when talking about language.

Brian: As an artist, you understand the interrelationship between the physical aspects (the medium and materials you use, etc.) and the metaphysical aspects (the meaning, interpretation, etc.) of art. I do think much of what I'm discussing is found in the understanding of the viewer, his or her worldview. But whether or not they recognize it, there is a metaphysical quality to beauty, that which transcends the purely physical. So, I'd agree: there is a link between the physical and metaphysical as we discussed.

This is the reason why I think we need truth, beauty, and goodness working in harmony: they reinforce and provide a solid foundation, much like a three-legged stool. The transcendentals act as a balance to any one facet of thought, kind of like checks and balances in the executive, legislative, and judicial branches of the US government. The transcendentals broaden our scope of understanding by providing a framework, asking questions of our conclusions in each area and hopefully providing more robust answers.

On this note, I'd agree with you: there is no separation between science and religion, properly understood and defined. In the end, both fields conjoin the true, beautiful, and good. And on the most fundamental level, there is unity between science and religion: being and essence—there is something rather than nothing. The transcendentals provide the framework to ask why this is so within each field.

Jeff: The three-legged stool analogy helps visualize a stable and well-balanced system to ably check against the potential fantasy and confirmation biases that can easily result from using anagogical thinking alone. Being open to new discoveries is helpful too.

Speaking of which, here is something I read in an article on Picasso in the May 2018 issue of *National Geographic*. The article brought up a study of neuroaesthetics conducted by Edward Vessel, a neuroscientist at the Max Planck Institute for empirical aesthetics in Frankfurt.

In the study, the tests found from brain scans that the participants' "Default Mode Network" of the brain was most activated from looking at the most moving and strikingly beautiful or arresting artworks. It is the DMN of the brain that "allows us to focus inward and access our most personal thoughts

and feelings." The article stated it as unusual for a balance of outward view-ing and inward contemplation—that it is a "unique brain state." The author stated that this is a "special relationship between viewer and art, bringing the works alive."[55]

When I read this, I reflected on a church's use of art in special space and how that engages a viewer's mind—how a person is stimulated by the visual viewing of exceptional art and architecture, focusing inward while looking outward. This describes the contemplative state as experienced in some of the great church spaces and is a perfect example for the value of a visual language in a religious space when expressed at a high level of intentional and scripturally specific visual beauty. Science and religion provide the in-tentional consecrated space as a nexus where the physical and metaphysical naturally connect as an expression and a service.

Brian: When I hear of a study like this, it reminds me that there is a deep connection between the physical and metaphysical; they are conjoined. Creativity and ideas are metaphysical; it is beyond our physical categoriza-tion. These qualities go beyond the physical, but also have a basis in the physical—our brain. Yet it's not merely bound to our brain; it's unleashed on the world as non-physical properties, causing other metaphysical occur-rences to happen: ideas, thinking, reasoning, and further imagination.

Again, a mutual exchange of being is occurring. And because creativity has a deep connection to our brains, it is not just a formless reality. There is a physical-metaphysical dynamic interaction with creativity, which brings us back to your idea of a visual language. Creativity is a language, exuding both metaphysical properties and physical properties.

It's a metaphysical language that culminates in our brains through physi-cality—and ultimately through a physical expression (art)—but takes flight outside our brains (via thought, interpretation, meaning, purpose, etc.).

I suppose it's the age-old debate of Platonic versus Aristotelian thought, idealism versus realism. Do we discover truth (there is truth outside of us, waiting to be found), or do humans create truth (truth is only what people prescribe it to be)?

55. Hutton, *The Beautiful Brain*.

I guess I'd be Platonic in this sense—we discover the truth of God—though I'm firmly rooted in a realist position as well, hence my Methodological Realism leanings.[56] For me, Realism via Thomistic thought is the perfect balance, a moderate realism. I believe in a metaphysical reality, a truth outside ourselves with which our consciousness intersects via the physical, our body and brain.

I also believe in physical reality: creation, as understood through the sciences. It goes back to the "two books of God" concept espoused in the Middle Ages: the book of creation and the book of the Bible. And the conduit of understanding, the intersection of the two books, is the brain: reason. So, it's poignant that you bring up the study. It's all very fascinating.

Jeff: Yes. The age-old Platonic-Aristotelian debate. That reminds me of Raphael's famous Vatican fresco concerning philosophy, *The School of Athens*, with the center image representing Plato pointing up, and Aristotle gesturing downward to earth.

Brian: Exactly. Raphael's painting expressed it well, giving a visual representation of an ongoing philosophical discussion.

Jeff: And what is particularly interesting is that mural sits across from Raphael's lesser known though equal in scale and, in my opinion, more interesting fresco *Disputa* (also referred to as *Disputation of the Holy Sacrament*). Renaissance thinking blended Hellenic humanism with medieval theology, and it can be seen expressed by the two murals on opposite walls of the same room balancing each other in consideration. These paintings serve as an example of types of art that expressed the ideas of the times, allowing room for thought and conversation. At the time, this was a topic stimulating discussion within the faith.

As a place where ideas can meet, a church can be bold beyond dogmatism. I feel there is no better place to regard deep thoughts of our humanity.

Given your interest in the arts and education, and your working position as clergyman, how would you address the church space as a nexus where the physical and metaphysical can connect, especially in terms of revealing our humanity in a God-centric relationship?

56. See Gilson, *Methodical Realism*.

Brian: Consecrated space is certainly a place where ideas meet. Synagogues and churches have always been a place to discuss, think, and contemplate the big questions of life. It's sad to me that many churches don't encourage questions. Luke 2 is the only place in the Bible where Jesus was a student, and when we take a careful look at the text, we learn that he sat among the teachers, listened, and asked questions. Verse 52 reveals the effects of the learning: Jesus grew in wisdom, stature, favor with God, and favor with man; he grew as a whole person. Space dedicated to God is a place for thought, questions, and listening. Jesus is our example for this.

I think you spelled out nicely the nexus of consecrated space in your introduction. It is a place where the physical and metaphysical interact, the heavenly and earthly. But let me expand the quote I referenced above. You wrote, "A created space that uses a visual vocabulary to expressly articulate God's interaction with His creation reinforces each soul's process toward union with God through both design and function. As spaces set aside to be different from the world, they leave us at 'the border of human experience,' opening us to a reality beyond the entropic world in which we live. These are places of particular beauty, exalting God's majesty and able to transport willing souls away from their everyday busyness and pain."

There's a lot in this text: union with God, an opening to godly reality, and a place set apart to do so. To me, that's a great definition of consecrated space—a place "set aside . . . opening us to a reality beyond the entropic world." Consecrated space is a place where the physicality of life (brains and bodies) works in conjunction with our will, emotions, and spirit via worship. Consecrated space is where the two—physical and metaphysical—kiss and embrace.

Maybe this is a good place to ask: In all your travels and experience in consecrated space, have you found your definition to be true?

Jeff: Yes, in myself for starts: I have been realigned, centered within the biblical context of these special places—like splashing my face with cool, clear water.

Regarding other people, however, I witnessed people of all kinds interacting with these aesthetic, liturgical spaces. People brought their lives in and laid them at the altar in prayer and with offerings, reaching out for that reality beyond our shared entropic worldly condition, hoping God would intersect with them at the level of their own lives. These spaces seemed to amplify their petitions and praise. They were often there alone. There was often no

service in progress, though maybe the altar lamp was lit. I was moved by their actions and faith.

The spaces that the people entered remembered their brokenness to the holy of holies; their desire for connection was palpable. They were there for restoration, whether theirs or another's. In some situations, I watched people travel from one liturgical art to another, blessing, touching, kissing (usually in the Orthodox churches), dancing, or praying to themselves from one chapel altar to another. I was just humbled by the activity that occurred in the places I was in. And this was between masses or church services of any kind. Once in Paris, I stopped photographing at St. Nicolas Du Chardonnet as a good-sized group of individuals who had randomly gathered with Bibles and rosaries took places throughout the nave and started conducting what looked like an autonomous mass in French. No priests—no communion. I had no idea what was happening; at the time, I had never seen such a thing. I sat down out of respect as they faced the altar, standing, singing, sitting, saying doxology. . . . I sat there for an hour. There are so many experiences that flood my memory, experiences that can be found on any ordinary day in the life of a consecrated space.

Such inspiration doesn't happen from entering the Department of Motor Vehicles. I've yet to see someone moved to their knees in tears praying to God at a celery bin in the grocery store.

Have you been moved in some extraordinary way from an encounter with a consecrated space, Brian?

Brian: Yes, I have had many experiences within consecrated space. I'll use one of my early memories as an example. In my elementary and junior high years, I attended a high Presbyterian church with my family. The pastor was Dr. David Poling. My mom sang in the choir. I regularly went to church early with my mom, arriving before the services began. I remember waiting in the sanctuary as she practiced with the choir. I sat in wonder and awe of the architecture, the music—the organ, choir, instruments—and the art: stained glass windows and handmade quilted cloth banners.

It made an indelible impression on me, so much so that after the service began, I wandered around the building, at times sitting behind the raised, enclosed lectern listening to the sermon and music. It had a profound influence on my senses; it seemed as though it was just God and me. It was an aesthetic baptism, very enchanting.

Jeff: And that's it. That is what such a space does for so many and why they are necessary. I am happy to hear you experienced that.

I have heard some great personal anecdotes in my travels documenting the spaces—stories that range from a private conversation at a party with a professed agnostic who was a former Hells Angels bouncer to a sermon from a priest at the Church of All Nations in Jerusalem. That was less a conversation I had than a speech I witnessed. It was at a time I was wondering if it mattered that I continue voicing the need for art and intentional beauty to be a permanent inclusion of a church space. I was in the Old City of Jerusalem at the time. I prayed for a sign to show me that beyond my feelings on the topic, there is indeed a value for art, aesthetics, and consecrated space. That day became a day where the things I planned to do seemed blocked and the churches I had scheduled to shoot were unexpectedly closed. By late afternoon I found myself unscheduled at the Church of All Nations in the garden of Gethsemane, built over the rock where it is said Jesus prayed in agony the night before his arrest. As timing would have it, I arrived right at the moment a Roman Catholic priest began speaking to a special group he brought on his first trip to Israel. A mid-aged man, he said a mural of Jesus praying in the garden of Gethsemane moved him as a boy to become a priest. Because of that painting, which made such an indelible impression on him and influenced his life direction, he had always dreamed of giving a sermon at this very rock—and now, after all this time, it was happening. And he was tearing up.

As I watched him say this, I had my confirmation of the value of art and aesthetics to churches—impeccable. This all occurred at a beautiful consecrated space set aside for a special purpose on the rock on which Jesus anguished over what was to come, and the priest was speaking on the very topic of my concerns. An artwork he had encountered changed his life in a way that inspired him to bless the lives of others, many of whom were now with him before me in Jerusalem. And he affected me too—and so did that experience in ways I am not sharing—all from a painting. As a boy, he knew the biblical text, but it was the painting that moved him to the priesthood.

Brian: Fabulous story. God used a particular situation to remind you of your calling as an artist. It is remarkable, the interconnectivity humans play in one another's lives, doing the things we are gifted and led to do: we impact individuals in inexplicable ways. And we never know how the Lord will use the things we have done to touch the lives of others. But you must share a little about the Hells Angels man; that caught my attention.

Jeff: Okay, I will try to make it quick. The conversation was long and took place at a bar/restaurant outdoor patio in LA County. I had related to him a story of a gallerist and friend of mine who was a proud and liberated atheist—my friend was slamming the fiscal cost for building the Cathedral of Our Lady of the Angels (Los Angeles). We argued the value of the space and its function, beyond the dollars spent. Finally I asked my friend if he had ever had an indelible experience in a consecrated space. After thinking about it, he replied he had, in a grotto in Paris where something unexpectedly came over him and he sat in silence for a long while (rare for him). My friend then added to our value debate that if I offered him $5,000 to erase his memory from that experience, he wouldn't take the money. He made my point that such spaces have a value beyond dollars in feeding the spirit.

To this story, the Hells Angels guy (who may not have been an actual member in the organization but had been a bouncer at one of their clubs) said he was agnostic, didn't like church or churches, and never went. His wife was Catholic, and they had taken a cruise to New Zealand where upon going ashore he found himself struck by Christchurch Cathedral. It left an impression on him he had never forgotten (and who knows where that encounter could lead—I was struck in Milan by Il Duomo in 1985 and eighteen years later I started to document these spaces).

Consecrated space is that unique and that important. I started using the term *consecrated* instead of *sacred*, as *sacred* is overused and commercialized, too diverse with diffused meaning. *Consecrated* suggests intentional action whereas *sacred* does not. Would you distinguish the two, or are they interchangeable for your use?

Brian: I'd say there is a difference between *sacred* and *consecrated*. *Sacred* is a general term of holiness, with broader connotations of worship and veneration. I suppose the sacred does not have a specific geographical location. You can commune with God anywhere: in prison, in the wilderness, at home. But with consecrated space, there is a deliberate geography to the sacred, a place set apart for worship, contemplation, and awe. So sacred is borderless whereas consecrated space has borders but leads the soul to the borderlands of the spiritual. In the end, both have similar effects: a reach for God. The difference may come down to geography, space, and place.

Just looking at the words from a definitional standpoint tells us what consecrated space is. The word *consecrated* means *set apart, holy, sacred*, and *devoted*. Space is a geographical area, or more specifically "the height, depth,

and width within which things exist and move." Together the definition of consecrated space is a place set apart for holy or devoted activity. You spell this out very nicely in your introduction. And the quote by Father John Sewell gives the concept a grander vision: a place set aside as a drama. I like that.

Jeff: Father John was an unexpected gift for me while I was in Memphis, Tennessee. St. John's Episcopal Church in Memphis has rare murals executed by Polish artist John Henry DeRosen in 1951–1953. Father John takes great delight in having those artworks as part of the church. He is very aware of and interested in beauty and its role in our lives, in religion, and in religious liturgy.

Ultimately, he cares for the souls of people, which is another aspect of the consecrated space: those ministering from these spaces express God's love in action. Father John shared a beautiful vision for his congregation, relating good liturgy to theater, saying, "Worship is the great dance of grace, and each person has a crucial part that no one can perform for them. Each absence diminishes the dance, for each has a unique gift to give the whole." Father John also told me, "The beautiful strikes our senses as true and authentic. I believe that creation did not end in the past but continues. As stewards we are called to conserve and protect creation. Not all are painters or composers, but a life well lived with integrity is perhaps the greatest art form."

Everyone has a part, the artists included, for theirs is also an important role as vehicles through which such beauty is expressed into the world. And when expressed in the church as a permanent thing, not a temporary show, something extraordinary takes place, like Father John's "performance."

Brian: Father John ties the true, beautiful, and good all together as a drama of being—of participation. We all contribute on some level. Our conversation so far reminds me of another conversation we had on our way to look at a sanctuary of a Norbertine Abbey in Albuquerque. The discussion was about beauty as part of existence. Although a dull building isn't as beautiful as a Gothic cathedral, it still contains beauty at its base level; there's participation on all levels. This reminds me of what Hildebrand described as the first power of beauty: the beauty of being. The Gothic cathedral, on the other hand, has both the first power of beauty in its "thingness" and also brings splendor by its second power of beauty: it "shines out." It is the intentionally designed and ordering of base material that moves us. I do believe that sublime beauty moves beyond being; some things are more beautiful than others.

Once beauty is set apart or devoted for a specific purpose—in the case of a church, to glorify God—beauty is elevated to its highest form: brilliance. It illuminates and enlightens the place. When we worship God, we are eliciting that which we were created for: fellowship and love, a mutual exchange of persons in communion. In this sense, beauty is more than that which pleases the senses, but that which aims to please God: we worship God with what he's bestowed upon us, beauty included. When beauty is used in the service of God, the author of beauty and being, we give that beauty back to God. In other words, what God created and is—pure being and beauty—has come back to honor and praise him. It's like the oxygen cycle, a natural sequence of life. For me, beauty within a church is saying, "This is ultimate loveliness— the Lord—and I want to give him back what he's given me." Worship is a spiritual cycle of love between the Lover and beloved.

Jeff: I am saddened that the beauty of so many cathedrals and churches is seen from a view tainted by the corrupted intentions and egos of certain religious authorities in the past who misused the spaces to profit from the poor and the easily misled. It's a stain of human nature that remains to this day in many guises to acquire wealth and numbers through fear and promise. Yet the beauty of these places and their artifacts endures regardless. Another thing to consider is that we would not have the great religious art available to us today had that art not been commissioned into the service of the church.

I hope conversations like Father John's lead many to creative consecration of their church spaces with a new understanding, appreciation, and desire to serve through the arts. That is a key consideration for designing a church space, if splendor is an important thing to communicate: What aesthetic then can best result in splendor? How best do we make mutual being from a space that isn't like everywhere else? It is a fine goal as collaboration between clergy and creatives, ultimately becoming a great gift for the community.

Consider a spatial artwork that resulted from such a collaboration between creatives and clergy: Christ the Light Cathedral. The church's Omega Window is an innovative departure from stained glass in that it consists of fifty-three feet of laser-perforated aluminum that reimagines the Christ in Majesty relief façade from Chartres Cathedral. The aluminum wall/window allows light to enter the sanctuary through the Christ in Majesty image while at night, light from within the cathedral projects the Christ in Majesty image out to the street. It makes quite an impression and is an achievement by the union of creative art with the theologically practiced.

Brian: Though I have not personally been in the presence of the Omega Window at Christ the Light, I've seen pictures. With examples such as the Omega Window, the profound nature of consecrated space comes through, extending our understanding of beauty as a means of worshiping God.

The Omega Window is, as you noted, increasing our past notions of beauty by bringing them into our present realities. It's a theological, historical, and unifying connection from the medieval to the modern.

It's sort of creedal, passing along beauty from one generation to another. And the symbolism manifest in the window—from the creative use of light, the unifying image of Christ emanating luminance, and the surrounding architecture—all reflects the various streams we discussed earlier (proportion, integrity, clarity, transcendence, immensity, intelligence, and sorority). The window symbolically reminds the congregants that God is here, a mutual exchange of love between the human and divine.

Jeff: That mutual exchange of love—God to humanity, humanity to God: a cyclic continuum of being—a relational oneness, like a marriage (of which there are plenty of biblical analogies). It is in light and good will of this harmonious relationship you have been describing that I see permanent artful expression being the visual fulfillment to a community and especially for a church building—its bloom and brilliance. I have witnessed visual art, and spatial aesthetics serve in value as an immersive and tangible language reinforcing belief, educating minds, soothing souls, and strengthening identity. For me, a church space without beauty is a dove in darkness. Beauty belongs with truth and goodness. There is different interactivity and relational respect toward a space that is active in the aesthetic language of mutual love · versus a space that is not.

Brian: That's wonderful imagery, Jeff: "a dove in darkness." That is basically it. We can't see or appreciate the dove unless we shine the light and let brilliance ensue through consecrated space. I think we should let truth, beauty, and goodness lead in answering the question why we should bring beauty into church. In doing so, we bring truth and goodness with it. And when truth, beauty, and goodness lead, we see art loosened from the grasp of pretty and pleasing pictures to the awesome nature of God in all his splendor and attributes, pain and suffering included. By letting truth, beauty, and goodness inform art, our artistic sensibilities will have freedom as well, incorporating an appreciation for the arts that goes beyond pleasantries to various profound expressions—be it abstract (the truth of

the color, form, and technique), realism (the truth in representation, perspective, etc.), or any of the various "isms" of movements found within the arts. Let God's truth, beauty, and goodness reign in a church, and the church will be the better for it.

Mathematics and Theology: Icon Numbers

I haven't always been interested in mathematics. The lowest grades I received in school were in math, and I often worked hard to get out of math class ("Mom, I have a headache" was a common excuse). But with the help of a tremendous math teacher in college and with some hard work, I came to love math—even though I'm still not particularly good at it.

So, what caused the transition from hate to love? I began to see that math is worthy of wonder. It is a practical and elegant language of humanity. True, math is fastidious by nature, but it also holds beauty and mystery. And the more I read about the field, the more I respect it.

Many people don't realize how important mathematics and its cousin geometry is to theology. Early Christian theologians—including Ignatius of Antioch (c. 100), Justin Martyr (c. 155), Irenaeus (c. 160), Theophilus of Antioch (c. 185), and Tertullian (c. 200)—used mathematical concepts and verbiage to make their theological points.[57]

For example, Justin argued that Jesus "was not only in name distinct from the Father, as the light is from the sun, but was 'numerically distinct' too."[58] In explaining the Trinity, these theologians also displayed a fundamental understanding of a triunity (later represented by a triangle), which requires a general understanding of numbers and geometric shapes.

Later, Augustine of Hippo (c. 380) likened mathematical concepts to knowledge about God, as summarized by Adam Drozdek: "First, infinity is an inborn concept which enables any knowledge. Second, infinity can be found in the purest form in mathematics, and thus mathematics is the best tool of acquiring knowledge about God. Third, God is neither finite nor infinite and his greatness surpasses even the infinite."[59]

57. See Kelly, *Early Christian Doctrines*.
58. Holden, ed., *The Harvest Handbook of Apologetics*, 410.
59. Drozdek, "Beyond Infinity," 127.

By the time of Anselm of Canterbury (c. 1075), the use of mathematical constructs, largely through logical presentations, was in full effect. From Anselm's work came the ontological argument for God's existence, which was given a cleaner mathematical construct by the mathematician and logician Kurt Gödel (1906–1978) and was recently verified to be a confirmable equation by German computer scientists.[60]

In the high Middle Ages, the interconnectivity of math, reason, and faith gained ground across Europe due to the influence of the liberal arts approach to education, which blended together various academic fields. Theological thinkers began to use mathematical language more readily.

From roughly 1200 on, mathematical concepts grew in importance in theological discussion, as evidenced by Albertus Magnus (c. 1240) and his student Thomas Aquinas (c. 1250), as well as Robert Grosseteste (c. 1200) and Roger Bacon (c. 1250).

But it was in the works of Johannes de Sacrobosco (c. 1221) and Nicholas of Cusa (1401–1464) that mathematics came to have a prominent role in theological discourse. According to John Freely, Cusa used "mathematics and experiential science in his attempts to determine the limits of human knowledge, particularly the inability of the human mind to conceive the absolute, which to him was the same as mathematical infinity."[61]

From this point on, math became both a scientific and theological language through the work of people like Johannes Kepler (1571–1630), Blaise Pascal (1623–1662), and Isaac Newton (1642–1727), continuing today through people such as John Lennox, William Dembski, and others.

I'm intrigued by the interrelationship between theology and math, so I'm always on the lookout for a convergence of the two. An event at the Santa Fe Institute some time ago got me thinking of an equation that Kurt Gödel first proposed in a letter to John von Neumann in 1956: $P = NP$. P stands for polynomial time; NP stands for nondeterministic polynomial time.

The basic question $P = NP$ poses is whether a problem can be simultaneously proposed and solved, asked and answered, or at least quickly verified.

60. Knight, "Computer Scientists 'Prove' God Exists."
61. Freely, *Before Galileo*, 205.

To date, the equation remains unsolved but if discovered may help in a host of computer-related endeavors and solve some complexity theory issues.

The details of the equation are beyond what I can comprehend. But one of the broader questions it elicits for me is whether God uses mathematics—the reality he invented—to order and direct his universe, particularly as it relates to providence, will, and teleology. Does God both propose and present a solution via a mathematical means, or at least calculated via math? What if numbers provided a blueprint for the unique nature of every human being?

In pondering this last question, I came up with a concept I deemed Icon Numbers (INs).

In Colossians 1:15, the Apostle Paul used the Greek word *eikon* to describe Jesus as the exact image of God. In Hebrews 1:3, the author used *charaktér* in a similar way: the word refers to an engraving or stamped figure that represents an exact copy or image.

Could it be that every human being has an exact image, equation, or number for our life—an IN? I know this might make it sound like we're just some numerical product code, but the ramifications are fascinating.

I propose that an IN is the unique numerical configuration of all external and internal physical properties that make up an individual being from conception to death. This includes the smallest cells to the largest organs of a person, combined with all the numerical configurations of geographical movement, including all micro and macro movements (from blinking an eye to flying across the globe). In short, every person has a corresponding number to his or her life.

Both of these areas (physical and geographical) would need to be translated to numbers via elemental properties (what we're made of) and movement coordinates. Then, the equation for an IN could be written as such:

$$P + G = IN$$

As you can imagine, every person's number would be different, for no two people are exactly alike in both physical and geographical constitutions (not to mention a person's unique soul—their personality and metaphysical self).

There's are a couple of theological ramifications to the IN concept.

One, it would help define how God, through mathematical precision, was able to create the world. Numbers exist outside of God as something he uses, they are the effects of his actions upon the world: God spoke, and it was. This doesn't mean God is a stoic Mathematician in the sky. Math is not God, but a product of his imagination. God is the cause of everything in existence, but he is also indivisible and intimate. Keep this in mind: God is precise and personal, not a nebulous numerical protractor. But numbers can help conceptualize God's creation.

Two, IN may help in understanding the ebb and flow of free will and predestination. There's an intriguing synergism between God's work and human work that's inherent in the IN concept. If we as humans can alter the P and G numbers, are we thereby helping write our IN, the equation of our lives? Or does God control all of it (and if he does, is he then responsible for the wrong actions or bad choices we make)? The age-old free will vs. predestination question could be rephrased in mathematical terms.

Let's develop this thought a tad more: Though we can't change much of our physicality (P)—at least on a macro level (we can change our physical appearance but not our species, for example)—our geographical movement (G), from birth to death, is another thing. Every human being has free will—the God-given ability to think and make rational or irrational choices and respond to the natural world. So how does this free will interact with God's sovereignty—his supreme authority and control? We normally qualify this as a mystery (which it ultimately is, in our understanding), but I'm humbly suggesting that there may be a divine mathematical basis behind it, or at least a mathematical means to understand it.

Theologically, God is sovereign—God knows every single person's final P and G numbers. Any action a human takes (such as getting a face-lift or sex change for P, or any geographical movement one can imagine for G), God is in full knowledge of that action and can accommodate it in that person's equation, simultaneously arriving at both the solution and validation, the final IN. It's divine mathematics.

Put another way, the end product of the IN equation will always equal itself because God already knows the final numbers for P and G. Our free will is part of God's equation, so to speak, and our IN will always be the sum of what God computed: God simultaneously knows the problem and solution. God's action is his knowledge at work in, and in harmony with, the created

order, and vice-versa. And just maybe math can show this, particularly the equation Gödel proposed, P=NP.

Practically speaking, a human being helps write the numerical sequence for her or his life through the choices they make (free will). Each person is not exactly the "bard of his own existence," as a Cormac McCarthy character states in *Cities of the Plain*, but we are co-mathematicians in formulating the equation of our lives, helping finalize our IN through movement, will, and action until our death—and maybe through eternity. The end sum will always be equal to itself; the end total will always be in accordance with God's final solution and verification. In short, life is a maze of math, monitored—and maybe calculated—by God.

On a larger scale, how would all these INs relate to and interact with the larger cosmology of the universe as understood through mathematics? Do all IN sequences throughout history help define a mathematical code that God created? And how does God relate to that mathematical code, if it exists? It hurts my head to think about these things.

But it goes back to the $P = NP$ equation: Does God provide the solution and verification of all equations simultaneously, fitting them into his greater unified purpose? And if so, can God's action—like his creation—be measured in mathematical terms? The answer seems to be *yes* (but only God would know the final equation or sequence for all things).

As I was pondering Icon Numbers—ensuring that I wasn't crazy, I came across a book titled *Tough-Minded Christianity*.[62] In it, I found a chapter written by Dr. Peter Zöller-Greer, professor of computer science and engineering at the University of Applied Sciences in Frankfurt am Main, Germany. The title? "Logic, Quantum Physics, Relativism, and Infinity."

In the chapter, Zöller-Greer provided the mental spark that gave some credence to my IN concept. I was smitten with Greer's thought process.[63] So, I decided to reach out to the good doctor via email. To my surprise, he replied.

62. Dembski and Schirrmacher, eds., *Tough-Minded Christianity*.

63. I discovered that in addition to thriving as a cutting-edge mathematical-theologian, Zöller-Greer used to be a pop composer in the eighties. It's rare to find an astute scientist who is also a marvelous musician, but Zöller-Greer is just that, a harmonious combination of scientist and artist.

Zöller-Greer, who read my musings, wrote, "I guess we have similar thoughts on this Theoretically one can use the DNA code and represent its ATGC [a framework proposed in his work] codes numerically and construct a (large) number that could represent your 'IN.'"

He then introduced me to some of his ideas: "Your 'murmurings' as you call them correspond with what I called the 'Path' of a human being in my article you've read. I have used this in a more mathematical way in an older article I wrote about the problem of time.[64] In my argument, you see the definition of a unique 'Path' PF for every being in the universe. This PF is a compound of all space-time coordinates and the structure of its matter from life to death. One of the theorems I did postulate, 'the path of two individuals never intersect,' is exactly what you wrote . . . concerning this issue."

Comparing Zöller-Greer's work to my own musings feels like comparing the Mona Lisa to a stick figure. But I was humbled that my ideas were not just gibberish to him. To get the full rendering of Zöller-Greer's ideas, you must read his work.

Though my concept of Icon Numbers is an ongoing thought exercise, it continues to intrigue. Even if I'm wrong in my theory, I believe that seeking God through his handiwork is a quest worth taking—a discovery of endless gratification. And when we finally see God face to face, I know we'll have all eternity to learn about bigger, better, and brighter concepts as we discover the intricacies of God's creativity in the universe and beyond. God's ideas endure, endless in extent and enjoyment, a pleasure worth pursuing.

64. See Greer, *Genesis, Quantum Physics and Reality.*

Epilogue

You've done it—you've stayed with me as I've unpacked some of what I've discovered of Christ in culture. I'm sure there was some head-tilting along the way.

I don't want to end this book with just more information, but a call to transformation. I want you to be equipped to go out into the world and experience all that God has for you to discover.

Using tilt as an acronym, here's a guide to help you do just that:

T *Take the Time.* To appreciate a cultural event or something in the world—be it nature, art, music, architecture, dance, poetry, drama, a lecture, etc.—time is of the essence. First, you must take the time out of your schedule to attend an event. Second, you need to take time to learn about what you'll be viewing or listening to. Then you can take the time to let the work or experience infuse your senses, allowing it to say what it needs to say and deciding whether you agree with its conclusion. If that takes fifteen minutes, that's fine. If it's four hours, so be it.

Simply put, you won't be able to find Christ in culture if you don't carve out the time to do so. Keep an eye out—both in-person and on the Internet— for local gallery openings, poetry readings, book signings, lectures, education demonstrations, and concerts. I make it a practice to check our local newspaper and the alternative press—magazines and other printed material produced in the community. Most cities, states, and countries have tourism departments that highlight cultural events in a particular region. Ensure you know the outlets that will afford you inlets to the cultural world.

I *Investigate.* Once you have taken the time to participate, investigate the person behind the event or piece of art. Familiarize yourself with their worldview and philosophy of life. Before the Internet, you had to go to the

library to do this. Now with the library in your pocket via a smartphone, it usually doesn't take much time. And if you can't find something online, ask around. Go to an actual library. Talk to people who are familiar with the topic. The bottom line is to pursue truth.

Investigation is discovery and examination; it's about seeking wonder. As Thomas Aquinas reminds us, "Wonder is the desire of knowledge."[1] I like to put a face to what I'm seeing, so I often wonder about the maker of a composition or piece of art. And that wonder brings me closer to God's world.

L *Listen.* Once you've carved out time and investigated a cultural event, stop and listen to what those around you are saying about it—whether that's the curator of the gallery, your friend, the guide in a museum, the person next to you, anyone. Listening is part of learning, and learning helps us discover truth.

Here are few good rules of thumb when listening:

- Be respectful and kind, even if you don't agree with someone or something.
- Check your expectations at the door; make sure you listen before you ask questions or make judgments.
- Evaluate what you heard or saw in light of the Bible.

If you're viewing a piece of artwork, listening is still important. Here are some ideas on how to listen using the various elements of art:

- Form: What does the artwork look like? Does it use shapes, textures, or figures? What medium is used?
- Balance: Is there balance in the composition, or is it offset?
- Color: Are the colors bright, subdued, pastel, plain, etc.?
- Symmetry: Is there perspective? Is the work flat or textured?
- Subject: What is it of? If abstract, what might be the artist's feeling or experience?
- Name: What is the name of the piece? Why is it called that?

You can also approach and appreciate art according to the properties Thomas Aquinas suggested:

1. Aquinas, *Summa Theologiae*, I-II, 32, viii.

- Actuality: that which is rooted in being, form, and action. Does the artwork have action or movement?

- Proportion: Is the work harmonious and symmetrical?

- Radiance: this is what makes the work stand out, its unique factors or that which emanates from the object.

- Integrity: this is the wholeness of the object. Is the work integral and complete?[2]

Then there's Professor Edmund Burke Feldman's four steps of art appreciation:

- Description: What is seen in the work?

- Analysis: What relationships exist with what is seen?

- Interpretation: What is the content or meaning of what is seen?

- Judgment: What is your evaluation of the work?[3]

And if you don't like any of these listening devices, here's how art educator and historian, Terry Barrett, summarizes it: "subject matter + medium + form + context = meaning,"—as stated in his book *Interpreting Art: Reflecting, Wondering, and Responding*.[4]

If theses don't resonate, plenty has been written on the subject.[5] My point is that whether something makes an audible sound or not, we still must listen. Listening engenders an attitude of understanding, enjoyment, and wonder.

T *Tell*. After taking time, investigating, and listening, tell others what you learned—become a learner by teaching. Telling someone what you discovered helps you internalize and assess your discoveries more fully; you'll gain a greater awareness into the subject, improving your knowledge and understanding of it. Bottom line: talk about it.

2. See Eco, *The Aesthetics of Thomas Aquinas*.
3. See Feldman, *Art as Image and Idea*.
4. Barrett, *Interpreting Art: Reflecting, Wondering, and Responding*, 199.
5. For more, see the following resources:
 - Walford, John E. *Great Themes in Art*, Prentice Hall, 2001.
 - Barrett, Terry, *Criticizing Art: Understanding the Contemporary*, McGraw-Hill, 1999.
 - Barrett, Terry, *Why Is That Art? Aesthetics and Criticism of Contemporary Art*, Oxford University Press, 2007.

So, there it is; some practical advice on how to tilt your head. I must confess, I've had a head-titling experience writing this book; I hope you've had one reading it, whether you agree with my suppositions or not.

I conclude where I began each section, with a poem. In "Kicking a Stone" all four elements—people, places, things, and ideas—are present. The person I'm holding in the poem is my daughter, Sutherland; the place, Camp Peaceful Pines in California; the thing, a stone; the idea, togetherness and awe, things I hope you learn as you tilt your head, finding the grace of Christ in culture.

Kicking A Stone [6]

She and I kick, one
swoop at a time, a stone
towards Peaceful Pines
Creek. I hold her, pink,
as we watch the stone
retreat from my boot. A
giggle and awe.

The sun trickles through
the pines, a presence with
beams of cordiality, knowing the
waters well. These mountains
hold memories of becoming,

they hum gently a song of
tribute. Our persistence
is triumphant as we give
the last kick; a goodbye. The
stone falls into the center of the
creek. We watch the water
ripple over its form, and silence is us.

6. A version of this poem was originally published in Arnold, ed., *The 2nd Annual Poetry Anthology.*

Bibliography

Adams, Henry. *Tom and Jack: The Intertwined Lives of Thomas Hart Benton and Jackson Pollock*. New York: Bloomsbury, 2009.

Alcorn, Randy. "J. I. Packer and a Tale of a Typewriter." *Eternal Perspectives Ministries*, March 7, 2011. https://www.epm.org/blog/2011/Mar/7/ji-packer-and-tale-typewriter.

Andy Warhol: Peer Assessment 2. Retrieved February 24, 2020. https://warholessays.tumblr.com/post/867090044/andy-warhol-1982-1987the-last-supper-the-big/amp.

Aquinas, Thomas. *Summa Theologiae*, I-II, 32, viii. http://www.newadvent.org/summa/2032.htm.

—————. *An Introduction to the Metaphysics of St. Thomas Aquinas*. Introduction by W. Norris Clarke. New Jersey: Gateway Editions, 1953, 1997.

Argenia Railway Technologies. "Train Metaphors." Retrieved September 10, 2019. http://www.argeniarailwaytech.com/train-metaphors.html.

Arnold, Angelique, ed. *The 2nd Annual Poetry Anthology: California Poets Celebrate National Poetry Month*. Modesto, CA: Tin Whistle, 1998.

Augustine of Hippo. *On The Trinity. Sacred Texts*. https://www.sacred-texts.com/chr/ecf/102/1020739.htm.

Baier, Simon. *Kazimir Malevich: The World as Objectlessnes*. Berlin: Hatje Cantz, 2014.

Bahrim, Dragos. "The Anthropic Cosmology of St. Maximus the Confessor." *Journal for Interdisciplinary Research on Religion and Science* 3 (July 2008). https://www.academia.edu/1851007/The_Anthropic_Cosmology_of_St_Maximus_the_Confessor.

Balthasar, Hans Urs von. *The Glory of the Lord: A Theological Aesthetics*. San Francisco: Ignatius, 2009.

Barrett, Terry. *Interpreting Art: Reflecting, Wondering, and Responding*. New York: McGraw Hill Higher Education, 2003.

Beta Music. "The Vault: Remembering the Birds: Wovenhand's David Eugene Edwards." 2005. http://www.betamusic.com.sg/Vault%20Woven%20Hand%20Interview.htm.

"Bishop Gerald Kennedy on 'The Marks of a Methodist.'" MethodistThinker.com, April 19, 2010. https://methodistthinker.com/2010/04/19/podcast-bishop-gerald-kennedy-on-the-marks-of-a-methodist.

Bottoms, Stephen J. *Playing Underground: A Critical History of the 1960s Off-Off-Broadway Movement*. Ann Arbor, MI: University of Michigan Press, 2006.

Bouteneff, Peter. *Arvo Part: Out of Silence*. Yonkers, NY: St. Vladimir's Seminary Press, 2015.

Bradford, Wade. "Themes of Sam Shepard Plays: 'True West,' 'Buried Child,' and Others." Thought Co., March 2, 2018. https://www.thoughtco.com/true-west-by-sam-shepard-overview-2713462.

Bredin, Hugh, and Liberato Brienza-Santoro. *Philosophies of Art and Beauty: Introducing Aesthetics.* Edinburgh: Edinburgh University Press, 2000.

Broncano, Manuel. *Religion in Cormac McCarthy's Fiction: Apocryphal Borderlands.* New York: Routledge, 2014. https://www.researchgate.net/publication/290593467_Religion_in_Cormac_McCarthy's_fiction_Apocryphal_borderlands.

Brown, David. *Divine Generosity and Human Creativity: Theology through Symbol, Painting, and Architecture.* Abingdon: Routledge, 2017.

Brown, Montague. "Augustine on Freedom and God." Saint Anselm College. https://www.anselm.edu/sites/default/files/Documents/Institute%20of%20SA%20Studies/4.5.3.2h_22Brown.pdf.

Brown, Stephen, and Xiaoqing Gao. "The Neuroscience of Beauty: How Does the Brain Appreciate Art?" *Scientific American,* September 27, 2011. https://www.scientificamerican.com/article/the-neuroscience-of-beauty/.

Brown, S., X. Gao, L. Tisdelle, S. B. Eickhoff, and M. Liotti. "Naturalizing Aesthetics: Brain Areas for Aesthetic Appraisal Across Sensory Modalities." PubMed.gov, September 1, 2011. https://www.ncbi.nlm.nih.gov/pubmed/21699987.

Bunge, Gabriel. *The Rublev Trinity: The Icon of the Trinity by the Monk-painter Andrei Rublev.* Crestwood, NY: St. Vladimir's Seminary Press, 2007.

Bychkov, Oleg V., and James Fodor. *Theological Aesthetics after Von Balthasar.* Abingdon: Routledge, 2008.

Caldecott, Stratford. *Beauty for Truth's Sake: On the Re-enchantment of Education.* Grand Rapids: Brazos, 2010.

Carpenter, David A. *William Stafford.* Western Writers Series. Boise, ID: Boise State University, 1986.

Christian Today. "The Woman John Stott Couldn't Live Without." *Christian Today,* September 25, 2014. https://www.christiantoday.com/article/the-woman-john-stott-couldnt-live-without/40880.htm.

Cloud, David W. "The Religious Affiliation of Rock and Roll Star Buddy Holly." Retrieved September 10, 2019. https://www.adherents.com/people/ph/Buddy_Holly.html.

Cohen, Patricia. "No Country for Old Typewriters: A Well-Used One Heads to Auction." *The New York Times,* November 30, 2009. https://www.nytimes.com/2009/12/01/books/01typewriter.html

Colores. NM PBS. May 26, 2018. https://www.newmexicopbs.org/productions/colores/may-26-2018/.

Constas, Maximos. *The Art of Seeing: Paradox and Perception in Orthodox Iconography.* Alhambra: Sebastian, 2014.

Danto, Arthur C. *Andy Warhol: Icons of America.* New Haven, CT: Yale University Press, 2009.

Davis, Mark. "R. Crosby Kemper Jr. dies in California." *Kansas City Star,* January 3, 2014. https://www.kansascity.com/news/local/article335212/R.-Crosby-Kemper-Jr.-dies-in-California.html.

Dembski, William, and Thomas Schirrmacher, eds. *Tough-Minded Christianity: Honoring the Legacy of John Warwick Montgomery.* Nashville: B&H Academic, 2008.

Dennett, Daniel. *Breaking the Spell: Religion as a Natural Phenomenon.* New York: Viking Adult, 2006.

———. *Darwin's Dangerous Idea: Evolution and the Meanings of Life.* New York: Simon & Schuster, 1995.

———. *From Bacteria to Bach: The Evolution of Minds.* New York: W. W. Norton & Company, 2017.

Derk, Peter. "A Tiny Peek At Cormac McCarthy's New Novel." *Lit Reactor*, August 2015. https://litreactor.com/news/a-tiny-peek-at-cormac-mccarthys-new-novel.

Dillenberger, Jan Daggett. *The Religious Art of Andy Warhol.* New York: Continuum, 1998.

DiLorenzo, Thomas. "The Culture of Violence in the American West: Myth versus Reality." *Independent Institute*, Fall 2010. http://www.independent.org/publications /tir/article.asp?a=803.

Dreishpoon, Douglas, and Stephen Zaima. *Max Cole: Works 1970–2017.* Santa Fe: Radius, 2019.

Drozdek, Adam. "Beyond Infinity: Augustine and Cantor." Laval théologique et philosophique 51.1 (February 1995). https://www.erudit.org/fr/revues/ltp/1995-v51-n1-ltp2151/400897ar.pdf.

Dunn, Jeff. "Tom Waits and Theology." November 24, 2011. http://www.internetmonk. com/archive/tom-waits-and-theology.

ECF. "The bicycle as a tool for social equity." European Cyclist Federation, March 1, 2018. https://ecf.com/news-and-events/news/bicycle-tool-social-equity.

Eco, Umberto. *The Aesthetics of Thomas Aquinas.* Cambridge, MA: Harvard University Press, 1988.

Edmondson, Todd. "Priest, Prophet, Pilgrim: Types and Distortions of Spiritual Vocation in the Fiction of Wendell Berry and Cormac McCarthy." PhD diss., University of Louisville, 2011. https://ir.library.louisville.edu/etd/390/.

Edwards, Lin. "Estimate of Flowering Plant Species to be cut by 600,000." Phys.org, September 23, 2010. https://phys.org/news/2010-09-species.html.

Eller, Vernard. *The Promise: Ethics in the Kingdom of God.* New York: Doubleday, 1970.

Ellul, Jacques. *On Politics, Technology, and Christianity.* Eugene, OR: Wipf and Stock, 2005.

Evdokimov, Paul. *The Art of the Icon: A Theology of Beauty.* Redondo Beach, CA: Oakwood, 1989.

FBI: News. "Crime Statistics for 2013 Released." November 2014. http://www.fbi.gov/ news/stories/2014/november/crime-statistics-for-2013-released/crime-statistics-for-2013-released.

———. "Latest Crime Statistics Released." September 2016. https://www.fbi.gov/news/ stories/latest-crime-statistics-released.

Feldman, Edmund Burke. *Art as Image and Idea.* New York: Prentice-Hall, 1967. As summarized in "Feldman's Model of Art Criticism." http://www2.gvsu.edu/ hipshean/resources/Feldman%27s%20Model%20Crit.pdf.

Fellowship of Quaker Artists. "Quaker Artists." October 20, 2011. http://fqa.quaker. org/sandman.html#Turrell.

Feynman, Richard P. *The Meaning of It All.* Lecture, 1963. http://search.chadpearce. com/Home/BOOKS/8773894-Meaning-of-It-All-by-Feynman-Nobel-Laureate. pdf.

Florensky, Pavel. *Beyond Vision: Essays on the Perception of Art.* London: Reaktion, 2002.

————. *At the Crossroads of Science and Mysticism: On the Cultural-Historical Place and Premises of the Christian World Understanding.* Brooklyn: Semantron, 2014.

————. *Iconostasis.* Redondo Beach, CA: Oakwood, 1996.

Frederick, Jim. "The Protester." *Time Magazine,* December 11, 2014. http://content.time.com/time/person-of-the-year/2011/.

Freely, John. *Before Galileo: The Birth of Modern Science in Medieval Europe.* New York: Overlook Duckworth, 2012.

Frye, Steven. *Cormac McCarthy.* Columbia, SC: University of South Carolina Press, 2009.

Galli, Mark. "Neo-Orthodoxy: Karl Barth." *Christian History* 65 (2000). https://www.christianitytoday.com/history/issues/issue-65/neo-orthodoxy-karl-barth.html.

Geisler, Norman. *Systematic Theology.* Volumes 1–4. Minneapolis: Bethany House, 2002.

Getty Research Institute. "Frederick Hammersley Archive." http://www.getty.edu/research/special_collections/notable/hammersley.html.

Gilson, Étienne. *The Arts of the Beautiful.* New York: Charles Scribner's Sons, 1965.

————. *Forms and Substances in the Arts.* Champaign, IL: Dalkey Archive, 2001.

————. *Methodological Realism: A Handbook for Beginning Realists.* San Francisco: Ignatius, 1990.

Glisson, James, ed. *To Paint Without Thinking: Frederick Hammersley.* San Marino, CA: The Huntington Library Press, 2017.

Golding, John. *Paths to the Absolute: Mondrian, Malevich, Kandinsky, Pollock, Newman, Rothko, and Still.* Princeton, NJ: Princeton University Press, 2000.

Govan, Michael, and Christin Y. Kim. *James Turrell: A Retrospective.* New York: Prestel USA, 2013.

Green, Bob. "Then There is the war of the common men." *Chicago Tribune,* February 19, 2002. https://www.chicagotribune.com/news/ct-xpm-2002-02-19-0202190016-story.html.

Greer, Peter Zöller. *Genesis, Quantum Physics and Reality.* The American Scientific Affiliation, March 2000. https://www.asa3.org/ASA/PSCF/2000/PSCF3-00Zoeller-Greer.html.

Haier, Richard, and Susana Conde-Martinez. "Ask the Brains: What are Ideas? Does Confidence Affect Performance?" *Scientific American,* June 1, 2008. https:www.scientificamerican.com/article/what-are-ideas/?redirect=1.

Halliday, David. "What Tom Waits Can Teach Us About Brokenness." *Relevant Magazine,* November 1, 2016. https://relevantmagazine.com/culture/what-tom-waits-can-teach-us-about-brokenness/.

Hammett, Chad, ed. *2 Prospectors: The Letters of Sam Shepard and Johnny Dark.* Austin, TX: University of Texas Press, 2013.

Hildebrand, Dietrich von. *Aesthetics: 1.* Steubenville, OH: The Hildebrand Project, 2016.

Hill, Jacob. "Birds as Environmental Indicators." EnvironmentalScience.org. Retrieved in September 2019. https://www.environmentalscience.org/birds-environmental-indicators.

Hoffmann, Carla Schulz, and Corinna Thierolf. *Andy Warhol: The Last Supper.* Berlin: Hatje Cantz, 1998.

Holden, Joseph, ed. *The Harvest Handbook of Apologetics*. Eugene, OR: Harvest House, 2018.

Hopper, Jessica. "Gov. Bill Richardson: 'I've Decided not to Pardon Billy the Kid.'" December 31, 2010. http://abcnews.go.com/US/governor-bill-richardson-pardon -billy-kid/story?id=12513542.

Hoskyns, Barney. *Lowside of the Road: A Life of Tom Waits*. New York: Three Rivers, 2009.

Hostetler, Bob. "Pray Like Jazz." June 3, 2016. https://www.guideposts.org/faith-and-prayer/prayer-stories/pray-effectively/pray-like-jazz.

Howison, Jamie. *God's Mind in that Music*. Eugene, OR: Cascade, 2012.

Huang, Leslie. "The Life and Works of F. Scott Fitzgerald." Concordia International School, Shanghai. March 6, 2019. https://library.concordiashanghai.org/Fitzgerald.

Hutton, Noah. *The Beautiful Brain: Art and the Default Mode*. Columbia University, February 17, 2014. https://italianacademy.columbia.edu/sites/default/files/press/ attachment/A%20recent%20symposium%20presented%20by%20Columbia%20 and%20NYU%20explored%20what%20happens%20in%20our%20brains%20 when%20we.pdf.

Independent, The. "The Human Brain is the most complex structure." *The Independent*, April 2, 2014. https://www.independent.co.uk/voices/editorials/the-human-brain -is-the-most-complex-structure-in-the-universe-let-s-do-all-we-can-to-unravel -its-9233125.html.

Inge, John. *A Christian Theology of Place*. Farnham, Surrey, UK: Ashgate, 2003.

Italie, Hillel. "Bob Dylan turns his Nobel lecture with praise for Buddy Holly." *The Seattle Times*, June 5, 2017. https://www.seattletimes.com/nation-world/bob-dylan-turns-in-his-nobel-lecture-with-praise-for-buddy-holly-others-listen-to-the-audio/.

Jabr, Ferris. "How Beauty is Making Scientists Rethink Evolution." *The New York Times Magazine*, January 9, 2019. https://www.nytimes.com/2019/01/09/magazine/ beauty-evolution-animal.html.

Jackson, Charlotte, ed. *Frederick Hammersley*. Santa Fe: Art Santa Fe, distributed by the Museum of New Mexico Press, 2009.

Jacobs, Jay S. *Wild Years: The Music and Myth of Tom Waits*. Toronto: ECW, 2006.

Januszkiewicz, Barbara. http://www.barbaraj.info.

Jefferson, Thomas. *The Writings of Thomas Jefferson*. Vol. 1. Edited by H. A. Washington. New York: H. W. Derby, 1861.

———. *The Writings of Thomas Jefferson*. Vols. 15–16. Edited by Albert Bergh. Washington, DC: The Thomas Jefferson Memorial Association, 1907.

Jenkins, Logan. "44 Years After Closing, Heritage Musicians Muster For MB Hoot." *The San Diego Union-Tribune*, October 9, 2017. http://www.sandiegouniontribune. com/news/columnists/logan-jenkins/sd-me-jenkins-heritage-20171009-story. html.

Jodidio, Philip. *Architecture Now!* Slovenia: Taschen, 2007.

Jongbloed, Andrea. "4 Misconceptions about Mental Illness and Faith." *Relevant Magazine*, December 1, 2014. http://www.relevantmagazine.com/god/church/4-misconceptions-about-mental-illness-and-faith.

Josyph, Peter. *Cormac McCarthy's House: Reading McCarthy Without Walls*. Austin, TX: University of Texas Press, 2013.

Kahn, Michaela. "Max Cole: The Long View." April 2018. https://charlottejacksonfineart. tumblr.com/post/172109529175/max-cole-the-long-view-april-6-may-6-2018.

Kandinsky, Wassily. *Concerning the Spiritual in Art*. Rev. ed. Mineola, NY: Dover, 1977.

Kattenberg, Peter. *Andy Warhol, Priest: The Last Supper Comes in Small, Medium, and Large*. Leiden: Brill, 2002.

Kelly, J. N. D. *Early Christian Doctrines*. Peabody, MA: Prince, 2004.

Knapp, Peggy. *Chaucerian Aesthetics*. New York: Palgrave Macmillan, 2008.

Knight, David. "Computer Scientists 'Prove' God Exists." ABC News, October 27, 2013. https://abcnews.go.com/Technology/computer-scientists-prove-god-exists/ story?id=20678984.

Kosky, Jeffrey L. *Arts of Wonder: Enchanting Secularity—Walter De Maria, Diller + Scofidio, James Turrell, Andy Goldsworthy*. Chicago: The University of Chicago Press, 2013.

Laing, Olivia. "Agnes Martin: The Artist Mystic Who Disappeared into the Desert." *The Guardian*, May 22, 2015. https://www.theguardian.com/artanddesign/2015/ may/22/agnes-martin-the-artist-mystic-who-disappeared-into-the-desert.

Lannan Foundation. "Drawing, Reading and Counting." August 5, 2015. https://lannan. org/events/drawing-reading-and-counting.

LeFever, Jeff. *The Consecrated Space: A Mosaic. An Essence*. Deluxe ed. San Francisco: Blurb, 2018.

Legal Information Institute. 16 U.S. Code § 703. Ithaca, NY: Cornell Law School. https://www.law.cornell.edu/uscode/text/16/703.

Lewis, C. S. *Present Concerns*. London: Harper Collins, 1986.

Lexico, Oxford. "Beauty." Retrieved in September 2019. https://www.lexico.com/en/ definition/beauty.

Lifton, Amu. "Ben-Hur: The Book That Shook the World." Washington, DC: National Endowment for the Humanities. https://www.neh.gov/humanities/2009/november december/feature/ben-hur-the-book-shook-the-world.

Lilley, James D. *Cormac McCarthy: New Directions*. Albuquerque: University of New Mexico Press, 2002.

Lin, Edward. "Estimate of Flowering Plants Species to Be Cut by 600,000." *PSY.org*, September 23, 2010. https://phys.org/news/2010-09-species.html.

Lindberg, Richard. "I Adore Chicago. It Is The Pulse of America." *Chicago Tribune*, August 25, 1996. https://www.chicagotribune.com/news/ct-xpm-1996-08-25-96082 60001-story.html.

Lisle, Laure. *Portrait of an Artist: The Biography of Georgia O'Keeffe*. New York: Washington Square, 1980.

Louver, L. A. *Frederick Hammersley: Paintings and Works on Paper*. Los Angeles: LA Louver, 2017.

Luther, Martin. "Do Not Be Anxious About Your Life." Quoted from Renovaré. https:// renovare.org/articles/do-not-be-anxious-about-your-life.

Mackay, Mairi. "10 Ideas that Changed the World." CNN, December 12, 2008. http:// edition.cnn.com/2008/WORLD/europe/11/21/tenthings.changedtheworld/ index.html.

Magni, Maddalena, Mattioli Rossi, Emanuela Poletti, and Richard Vine. *Max Cole*. Milan: Charta, 2000.

Malevich, Kazimir. *The Non-Objective World*. Chicago: Theobald, 1959.

Maltz, Michael, R. Roth, and Douglas Eckberg. "Homicide Rates in the Old West." 2011. http://www.academia.edu/4673371/Homicide_Rates_in_the_Old_West.

Mann, William E. *Augustine's Confession: Philosophy in Autobiography*. Oxford: Oxford University Press, 2014.

Marissa. "Light Upon Light: Abbot Suger and the Invention of Gothic." October 3, 2012. https://mediaevalmusings.wordpress.com/2012/10/03/light-upon-light-abbot-suger-and-the-invention-of-gothic/.

Markazi, Arash. "Steve Soboroff's famous typewriter collection has many stories to tell." ESPN, September 3, 2015. https://www.espn.com/mlb/story/_/id/13558197/steve-soboroff-famous-typewriter-collection-tells-stories-joe-dimaggio-john-lennon-ernest-hemingway-others.

Maritain, Jacques. *Art and Poetry*. New York: Philosophical Library, 1943.

————. *Art and Scholasticism: Essays*. Minneapolis: Filquarian, 2007.

Markazi, Arash. "Steve Soboroff's Famous Typewriter Collection Has Many Stories To Tell." ABC News, September 3, 2015. https://abcnews.go.com/Sports/steve-soboroffs-famous-typewriter-collection-stories/story?id=33511864.

Martinez, Jack. "New Cormac McCarthy Book 'The Passenger,' Unveiled." *Newsweek*, August 15, 2015. https://www.newsweek.com/cormac-mccarthy-new-book-363027.

McCarthy, Cormac. *The Road*. New York: Knopf, 2006.

————. *The Sunset Limited*. New York: Knopf, 2006.

McClendon, James William, Jr. *Witness: Systematic Theology, Volume 3*. Nashville: Abingdon, 2000.

Mehrabian, Albert. *Nonverbal Communication*. Abingdon, UK: Routledge, 2007.

Mehta, Hemant. "Daniel Dennett: We Are Meaning Makers.'" *Friendly Atheist*, December 2, 2010. https://friendlyatheist.patheos.com/2012/12/02/daniel-dennett-we-are-meaningmakers/.

Merriam-Webster. "Idea." https://www.merriam-webster.com/dictionary/idea.

Merrill, C. S. *Weekends with O'Keeffe*. Albuquerque: University of New Mexico Press, 2010.

Miller, Donald. *Through Painted Deserts: Light, God, and Beauty on the Open Road*. Nashville: Thomas Nelson, 2005.

Mises Institute. "FBI: US Homicide Rate at 51-year Low." June 15, 2016. https://mises.org/blog/fbi-us-homicide-rate-51-year-low.

Momaday, N. Scott. *Against the Far Morning: New and Selected Poems*. Albuquerque: University of New Mexico Press, 2011.

Moon, Shane Phoenix. "Meaning and Morality in the Works of Cormac McCarthy." MA thesis, Wright State University, 2015. https://etd.ohiolink.edu/!etd.send_file%3Faccession%3Dwright1431165514%26disposition%3Dinline.

Muir, John. *John Muir: Nature Writings*. New York: The Library of America, 1997.

————. *My First Summer in the Sierra: Part II*. *The Atlantic Online*. First published in February 1911. https://www.theatlantic.com/past/docs/unbound/flashbks/muir/muirfeb.htm.

Muir, John, and Michael B. Branch. *John Muir's Last Journey*. Washington, DC: Island, 2001.

Mundik, Petra. "Religion in Cormac McCarthy's Fiction: *Apocryphal Borderlands*." *The Cormac McCarthy Journal* 13 (2015). https://muse.jhu.edu/article/593117.

Myers, Ben. "Tom Waits: Theologian of the Dysangelion." December 31, 2007. http://www.faith-theology.com/2007/12/tom-waits-theologian-of-the-dysangelion.html.

NeuroSkeptic. "The 70,000 Thoughts Per Day Myth?" May 9, 2012. http://blogs. discovermagazine.com/neuroskeptic/2012/05/09/the-70000-thoughts-per-day-myth/#.XXfDzyV7ns1.

Niebuhr, H. Richard. *Christ and Culture.* New York: Harper & Row, 1951.

Nightingale, Earl. "The Strangest Secret." Retrieved August 2019. https://edisciplinas. usp.br/pluginfile.php/3402848/mod_resource/content/1/16Earl_Nightingale_ The%20Strangest%20Secret-Nightingale.pdf.

Nixon, Brian. "A Culture To Itself." *The Penwood Review* 3.1 (Spring 1999) 22.

———. "Alcee and the King of the Instruments." *Crossmap News,* June 20, 2005. https:// www.crossmap.com/blogs/alcee-chriss-and-the-king-of-instruments.html.

———. "Blink." *The Penwood Review* 20.1 (Spring 2016) 27.

———. "eBay, Vernard Eller, and The Promise." *Sloppy Noodle,* November 6, 2012. http://www.sloppynoodle.com/wp/ebay-vernard-eller-and-the-promise/.

———. "For Riley and the Angels." *The Penwood Review* 22.1 (Spring 2018) 22.

———. *The Master Teacher: Developing a Christ-based Philosophy of Education.* Santa Ana, CA: Calvary Chapel Publishing, 2007.

———. "To Be Is to Belong." *The Penwood Review* 21.2 (Fall 2017) 23.

Official Web Site of the Cormac McCarthy Society. "Biography." June 3, 2019. https:// www.cormacmccarthy.com/biography/.

Owens, Joseph. *An Elementary Christian Metaphysics.* Houston: University of St. Thomas Press, 1985.

Pace Gallery. "Agnes Martin." http://www.pacegallery.com/artists/290/agnes-martin.

Page, Tim. "'Summerfare' Offers Choir Festival." *New York Times,* July 30, 1986. https:// www.nytimes.com/1986/07/30/arts/summerfare-offers-choir-festival.html.

Paprocki, Joe. "What Is the Significance of Mountains in the Bible?" *Busted Halo,* October 12, 2018. https://bustedhalo.com/ministry-resources/what-is-the-significance-of-mountains-in-the-bible.

People For Bikes. "Statistics Library: Participation Statistics." http://peopleforbikes.org/ our-work/statistics/statistics-category/?cat=participation-statistics.

Petrova, Yevgenia. *Malevich's Suprematism and Religion.* New York: Guggenheim Museum Publications, 2011.

Pew Research Center. "Public Trust in Government." April 11, 2019. https://www. people-press.org/2019/04/11/public-trust-in-government-1958-2019/.

Phrase Finder. "Beauty is in the eye of the beholder." Retrieved in September 2019. https://www.phrases.org.uk/meanings/beauty-is-in-the-eye-of-the-beholder. html.

Pieper, Joseph. *Only the Lover Sings: Art and Contemplation.* San Francisco: Ignatius, 1990.

Poling, John D. *Painting With O'Keeffe.* Lubbock, TX: Texas Tech University Press, 1999.

Potts, Matthew. *Cormac McCarthy and the Signs of Sacrament.* New York: Bloomsbury Academic, 2015.

Prather, William. "Absurd Reasoning in an Existential World: A Consideration of Cormac McCarthy's *Suttree.*" University of Texas at El Paso Press, El Paso, TX, 1995. https://www.tib.eu/en/search/id/BLCP%3ACN019010793/Absurd-Reasoning-in-an-Existential-World-A-Consideration/.

Presse-France. "U.S. Murder Rate Higher Than Nearly All Other Developed Countries: FBI Data." September 13, 2013. http://www.rawstory.com/rs/2013/09/u-s-murder-rate-higher-than-nearly-all-other-developed-countries-fbi-data/.

Publications International. "16 Unusual Facts About the Human Body." May 2019. https://health.howstuffworks.com/human-body/parts/16-unusual-facts-about-the-human-body9.htm.

Pyman, Avril. *Pavel Florensky: A Quiet Genius.* New York: Continuum, 2010.

Ramos, Alice M. *Dynamic Transcendentals: Truth, Goodness, and Beauty from a Thomistic Perspective.* Washington, DC: The Catholic University of America Press, 2012.

Rawsthorn, Alice. "'The Eccentric Monk and His Typewriter." *New York Times,* December 17, 2012. https://www.nytimes.com/2012/12/17/arts/design/the-eccentric-monk-and-his-typewriter.html.

"Readers Guide to Orthodox Icons." Retrieved in September 2019. https://iconreader.wordpress.com/about.

Recording Academy. "Grammy Awards: 'Tom Waits: Artist.'" Retrieved February 24, 2020. https://www.grammy.com/grammys/artists/tom-waits.

Reed, Arden. *Slow Art: The Experience of Looking, Sacred Images to James Turrell.* Berkeley, CA: University of California Press, 2017.

Republican, The. Red Wing, Minnesota, July 30, 1881. http://www.rarenewspapers.com/view/583910?imagelist=1.

Robinson, Roxanna. *Georgia O'Keeffe: A Life.* New York: Harper & Row, 1989.

Robson, David. "The Myth of Universal Beauty." *BBC,* June 23, 2015. http://www.bbc.com/future/story/20150622-the-myth-of-universal-beauty.

Roland, Terry. "In Memory of Buddy Holly: The Day the Music Still Lives." Retrieved in May 2011. http://www.tollbooth.org/2009/features/bholly.html.

Rolling Stone. "500 Greatest Songs of All Time." December 2004. https://www.rollingstone.com/music/music-lists/500-greatest-songs-of-all-time-151127/

Rookmaaker, Hans. *The Complete Works of Hans Rookmaaker, Volume 2: New Orleans Jazz, Mahalia Jackson and the Philosophy of Art.* Carlisle: Piquant, 2002.

Rothfork, John. "Redemption as Language in Cormac McCarthy's *Suttree.*" *Christianity and Literature* 53 (2004). https://www.researchgate.net/publication/276450660_Redemption_as_Language_in_Cormac_McCarthy's_Suttree.

Roudané, Matthew. *The Cambridge Companion to Sam Shepard.* Cambridge: Cambridge University Press, 2006.

Ryan, Tom. "Cormac McCarthy's Catholic Sensibility." Retrieved in June 2019. https://www.thefreelibrary.com/Cormac+McCarthy%27s+Catholic+sensibilty.-a0163865178.

SamShepard.com. "About Sam." Retrieved February 24, 2020. http://www.sam-shepard.com/aboutsam.html.

Sanders, Samantha. "Why Donald Judd Brought Art to Marfa, Texas." Artists Network. Retrieved August 2019. https://www.artistsnetwork.com/magazine/donald-judd/.

Schaeffer, Francis A. *Art and the Bible.* Downers Grove, IL: InterVarsity, 2006.

———. *How Should We Then Live? The Rise and Decline of Western Thought and Culture.* Old Tappan, NJ: Fleming H. Revell, 1976.

———. *Pollution and the Death of Man.* Wheaton, IL: Tyndale House, 1970.

Schaff, Philip. *Nicene and Post-Nicene Fathers, Volume 9.* Peabody, MA: Hendrickson, 2004.

Schmidt, Jenny Lind. "Singing and Sojourning." *World Magazine,* September 27, 2018. https://world.wng.org/2018/09/singing_and_sojourning.

Schweitzer, Albert. *Memoirs of Childhood and Youth.* Syracuse, NY: Syracuse University Press, 1997.

Sevier, Christopher Scott. *Aquinas on Beauty.* Lanham, MD: Lexington, 2015.

SFI Bulletin 28.2 (Fall 2014). https://www.santafe.edu/news-center/news/sfi-bulletin-sfi30-foundations-frontiers-announce.

Shakelford, K. "Jeremy Begbie: What Can Jazz Teach Us about Being a Christian?" October 16, 2014. https://www.allaboutjazz.com/jeremy-begbie-what-can-jazz-teach-us-about-being-a-christian-jeremy-begbie-by-k-shackelford.php.

Siedell, Daniel. *God in the Gallery: A Christian Embrace of Modern Art.* Grand Rapids: Baker Academic, 2008.

————. *Who's Afraid of Modern Art?: Essays on Modern Art and Theology in Conversation.* Eugene, OR: Cascade, 2015.

Shepard, Sam. "About Sam." Retrieved in June 2019. http://www.sam-shepard.com/aboutsam.html.

————. *Rolling Thunder Logbook.* Kindle ed. London: Bobcat, 2017.

Smith, Patti. *Just Kids.* New York: HarperCollins, 2010.

Smith, Warren Cole. "Patriarch—Dr. J. I. Packer." December 1, 2009. https://virtueonline.org/patriarch-dr-j-i-packer.

Spira, Andrew. *The Avant-Garde Icon.* New ed. London: Lund Humphries, 2008.

Sproul, R. C. *Lifeviews.* Grand Rapids: Revell, 1986.

————. "The Spirit in Creative Expression." https://www.ligonier.org/learn/series/the_holy_spirit/the-spirit-in-creative-expression.

Stafford, Kim. *Early Morning: Remembering My Father, William Stafford.* Minneapolis: Graywolf, 2002.

Stafford, William. *A Scripture of Leaves.* Elgin, IL: Brethren, 1989.

————. *The Answers Are Inside the Mountains.* Ann Arbor, MI: The University of Michigan Press, 2003.

Stanford Encyclopedia of Philosophy. "Beauty." First published September 4, 2012; substantive revision Oct. 5, 2016. https://plato.stanford.edu/entries/beauty/#ObjSub.

Sullivan, Steve. *Encyclopedia of Great Popular Song Recordings.* Volume 1. Lanham, MD: Scarecrow, 2013.

Stott, John. *Birds our Teachers: Biblical Lessons From a Lifelong Bird Watcher.* Peabody, MA: Hendrickson, 2011.

Strong, James. *Strong's Concordance.* https://www.biblestudytools.com/concordances/strongs-exhaustive-concordance/

Tate Museum. "Five Ways To Look At Malevich's Black Square." Retrieved September 10, 2019. http://www.tate.org.uk/context-comment/articles/five-ways-look-Malevich-Black-Square.

Taroutine, Maria. *The Icon and The Square: Russian Modernism and the Russo-Byzantine Revival.* University Park, PA: The Pennsylvania State University Press, 2018.

Tertullian. "Prescription against Heretics." In *Ante-Nicene Fathers,* edited by Alexander Roberts and James Donaldson. Peabody, MA: Hendrickson, 1994.

Tesla, Nikola. "On Electricity." *Electrical Review,* January 27, 1897. http://www.tfcbooks.com/tesla/1897-01-27.htm.

"The Way of the Rain: A Live Multidisciplinary Performance." http://thewayoftherain.org/.

Republican. Red Wing, Minnesota, July 30, 1881. http://www.rarenewspapers.com/view/583910?imagelist=1.

Ulaby, Neda. "Marfa, Texas: An Unlikely Art Oasis In a Desert Town." NPR, August 2, 2012. http://www.npr.org/2012/08/02/156980469/marfa-texas-an-unlikely-art-oasis-in-a-desert-town.

"U.S. Population, 1790–200: Always Growing." Retrieved in September 2019. http://www.u-s-history.com/pages/h980.html.

Vahdati, Seyed Mohammad Hosseini-Maasoum Mahnoosh. "The Postmodernist Rendition of Myth in the Selected Plays of Sam Shepard." *International Journal of Humanities and Social Science* 2.21 (November 2012) 246–55.

Vella, Matt. "The World's Most Popular Way to Get Around." *Forbes Magazine*, August 9, 2012. http://fortune.com/2012/08/09/the-worlds-most-popular-way-to-get-around/.

Viladesau, Richard. *Theology and the Arts: Encountering God through Music, Art, and Rhetoric.* Mahwah, NJ: Paulist, 2000.

Viral Nova. "These 20 Facts About You Are Pretty Strange, But Also Fascinating." *ViralNova*, May 24, 2015. http://www.viralnova.com/strange-body-facts/.

Voorhis, Dan Van. "The Gospel According to Tom Waits." April 15, 2014. https://www.1517legacy.com/1517blog/danvanvoorhis/2014/04/the-gospel-according-to-tom-waits.

Voragine, Jacobus de. *The Golden Legend: Readings on the Saints.* Princeton, NJ: Princeton University Press, 1993.

———. "Of St. Augustin, Doctor and Bishop." *The Golden Legend*, Vol. 5 (1470), retrieved May 22, 2019. http://www.intratext.com/IXT/ENG1293/_P6C.HTM.

Welborn, Grace Pleasant. *Devotions on Trees of the Bible.* Grand Rapids: Baker, 1966.

Westzsteon, Ross. "The Genius of Sam Shepard." *New York Magazine*, November 24, 1980. https://books.google.com/books?id=VuUCAAAAMBAJ&printsec=frontcover#v=onepage&q&f=false.

Wilgress, Lydia. "Watching Garden Birds is good for your mental health research shows." *Telegraph*, February 25, 2017. ww.telegraph.co.uk/news/2017/02/25/watching-garden-birds-good-mental-health-research-shows.

Williams, Matt. "10 Interesting Facts About Earth." *Universe Today*, Space and Astronomy News, May 27, 2016. https://www.universetoday.com/14382/10-interesting-facts-about-planet-earth/.

Winters, John. *Sam Shepard: A Life.* Berkeley, CA: Counterpoint, 2017.

Wolchover, Natalie, and Elizabeth Peterson. "15 Weird Things Humans Do Every Day, and Why." *Live Science*, April 8, 2011. https://www.livescience.com/33197-10-weird-behaviors-humans-do-every-day-why.html.

Wolterstorff, Nicholas. *Art in Action: Toward a Christian Aesthetic.* Grand Rapids: Eerdmans, 1987.

Wood, Margaret. *Remembering Miss O'Keeffe.* Santa Fe: Museum of New Mexico Press, 2012.

Worthington, Danika. "Christo pulls plug on controversial 'Over The River' public art installation, citing new 'landlord' Trump." *Denver Post*, January 25, 2017. https://www.denverpost.com/2017/01/25/christo-over-the-river-project-halted/.

Wright, Nicholas Thomas. *Paul for Everyone: The Prison Letters.* Louisville: Westminster John Knox, 2004.